IMAGES
of America

ZION

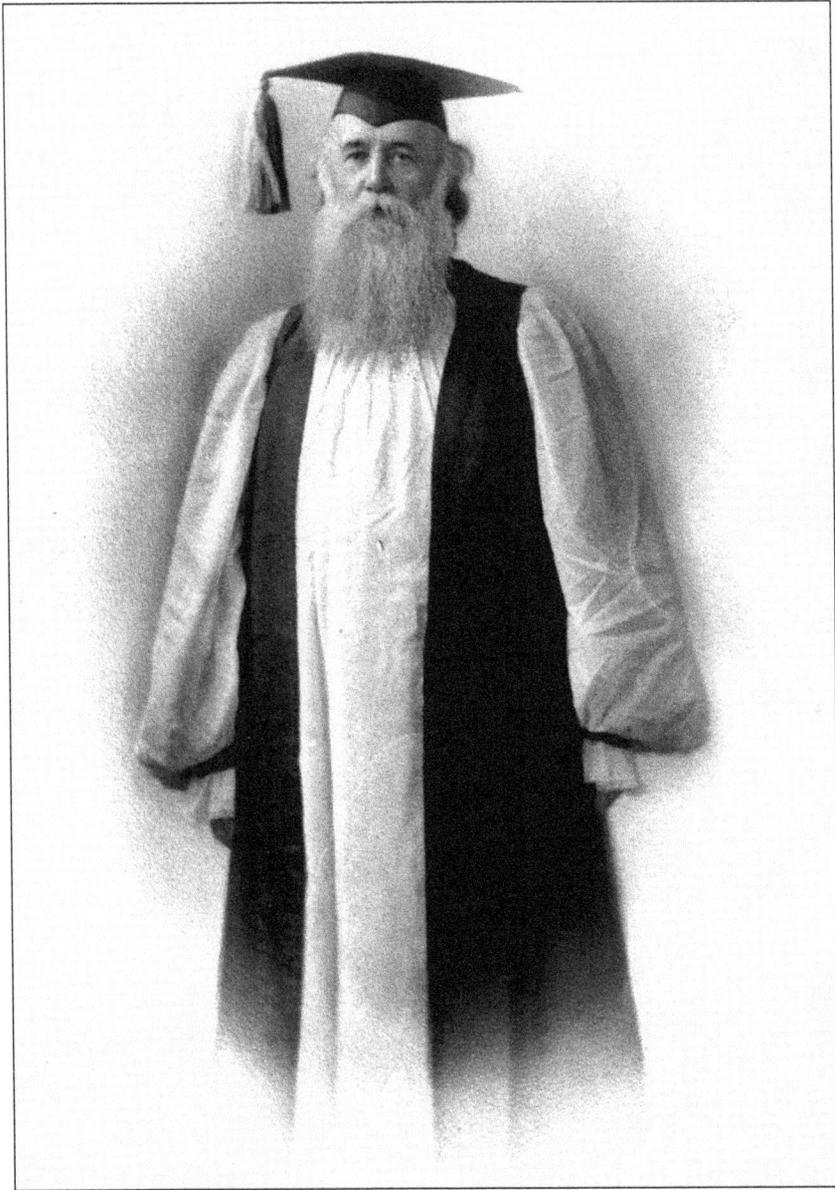

The city of Zion, Illinois was founded by Dr. John Alexander Dowie, a minister of the gospel, a divine healer, a visionary, and a church and community leader. He was of Scottish heritage, lived and ministered in Australia, and gained respect and recognition while living and preaching in Chicago. Then, driven by high ideals and the dream of "heaven on earth," he made Zion City his home.

On the cover: The Zion Lace Factory manufactured lace from 1901 until 1907, when it was purchased by Marshall Field and Company. Lace machines and skilled labor to operate them were brought from England to Zion City. After manufacture and inspection of the lace, any flaws detected were marked and then mended by hand. These seamstresses perform this tedious task in the mending room of the Zion Lace Factory. (Courtesy of Zion Historical Society.)

IMAGES
of America

ZION

Zion Historical Society

ARCADIA
PUBLISHING

Published by Arcadia Publishing
Charleston SC, Chicago IL, Portsmouth NH, San Francisco CA

Library of Congress Catalog Card Number: 2008925863

For all general information contact Arcadia Publishing at:
Telephone 843-853-2070
Fax 843-853-0044
E-mail sales@arcadiapublishing.com
For customer service and orders:
Toll-Free 1-888-313-2665

Visit us on the Internet at www.arcadiapublishing.com

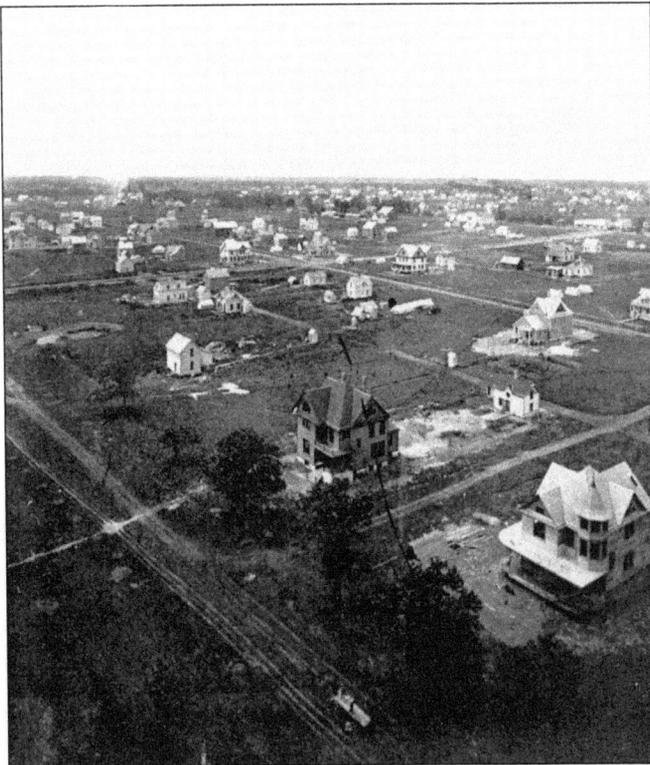

By the summer of 1901, more than 40 homes had been built in Zion City, and many more were in various stages of construction such as the one in the foreground (right). This aerial view of Zion City was taken at Twenty-sixth Street and Edina Avenue looking southwest.

CONTENTS

ACKNOWLEDGMENTS

One could spend hours touring historic Shiloh House, home of Zion's founder, perusing its photograph collection. Since 1967, both the house and the collection have been maintained by the Zion Historical Society. Shiloh House wouldn't have so many original furnishings on display or boast such a fine photograph collection if former and present residents and their families and friends hadn't recognized the significance of preserving Zion's past. Having made this realization, they generously donated furnishings, artifacts and photographs to the Zion Historical Society. We sincerely thank all our donors.

There are a few individuals who are deserving of acknowledgement. Publication of this book would have been difficult without the research and historic writings of the late Philip L. Cook, author of *Zion City, Illinois—Twentieth-Century Utopia*. His book was an invaluable resource. Katie Paul, longtime Zion resident and Zion Historical Society board member, played a part in photograph identification and some of her written histories were referenced. Diane Burkemper, Zion Historical Society board member, invested many hours in the "nuts and bolts" of the publication, selecting photographs, writing captions, and organizing the photographs and layout. Carol Ruesch, Zion Historical Society president, initiated the project and provided the much-needed moral support to keep it moving forward.

Although the vast majority of these photographs are the property of the Zion Historical Society, Christ Community Church in Zion and the Zion Park District provided photographs as well. We are grateful for their courtesy in allowing us to review their collections and present their photographs in this publication.

INTRODUCTION

The city of Zion was founded by Dr. John Alexander Dowie. His interest in the North Shore area originated during the World's Columbian Exhibition in Chicago in 1893. He had a tabernacle near the midway and held services, gaining many converts during the fair. He also gained notoriety as a divine healer. He began to explore the surrounding area for land, upon which to build a city that would be dedicated to God. The rules of living would be holy and strict. It would be a self-sufficient communal society. It would be a community where God would rule and man would prosper.

Dowie secured an option on a vast land tract on the shores of Lake Michigan midway between Chicago and Milwaukee, hired engineer Burton Ashley, and set about the task of planning his "Coming City." Zion is unique in that it is one of only a few cities that was laid out on the drawing board before even a spade of soil was turned. Attention was given to every detail, including topography, elevations, lot dimensions, drainage, refuse disposal, an alley system, utilities, roads, board sidewalks, and the specific locations of parks, industrial and commercial areas, educational institutions, and most importantly, the temple. The Christian Catholic Church, housed in Shiloh Tabernacle, would occupy the temple site and General Overseer Dowie would be the ultimate church and community leader.

Incorporated in 1902, Zion was created as a theocracy. Dowie believed that authority and power came from God, not from man, and that the rule of God would bring peace and blessing. The Christian Catholic Church owned all the property and provided all city services. Residents were granted 1,100-year leases on the property, but the titles remained with the church. The church owned the lace industry, the baking and candy industries, the building industry and lumberyard, and a large department store that provided all the community's needs. Educational institutions were controlled by the Christian Catholic Church and served Zion children from kindergarten through college. The Bible was the principle textbook. Zion was governed by blue laws. Doctors, drugs, liquor, tobacco, and pork and pork products were considered unclean and were prohibited. Residents violating these restrictions could find their land leases rendered null and void. Dowie had visions of Zion reaching a population of more than 200,000.

Zion began to suffer from financial distress, and Dowie's career and reputation were declining. Zion went bankrupt and fell into receivership in 1906, and the church no longer owned anything. The political affairs of the city were in turmoil. Dowie's health began to fail, and before his death in 1907, he appointed Rev. Wilbur Glenn Voliva as his successor. General Overseer Voliva, a Theocrat Party member, attempted to keep the theocracy alive but met resistance from a group who had broken away from the Christian Catholic Church and called

themselves "Independents." Reverend Voliva rallied his supporters and was able to buy back many of the lost industries and the Shiloh Tabernacle from the receiver. The Theocratic Party dominated politically until the mid-1930s, but not without conflict with the Independents. Both Independents and Theocrats claimed to be heirs to Dowie's theocracy. The result was a bitter and often violent partisanship in religious and political affairs. General Overseer Voliva became sole owner of the Zion Estate in 1911. He controlled the city, its politics, and the industries that were not sold while in receivership and maintained the right to enforce the old Dowie land leases. Zion prospered until the Great Depression caused a second declaration of bankruptcy for the Zion industries. Failing industries were sold, and others closed.

In the late 1930s, with the changes in the financial condition of the city and the development of a community-based educational system, the former Theocrats and the Independents began working together. All that remained of the original theocracy was the principles still lingering in the minds of its supporters. General Overseer Voliva continued to preach at the Christian Catholic Church until his death in 1942.

Dowie dreamed of building a community that was "heaven on earth." While that is an impossibility, to his credit, he was able to envision, plan, and build a self-sustaining city in a matter of less than 10 years. He created a community with high family morals, where concern for your neighbor and sharing your wealth were the rules of the day. Zion was to be free from evil and the ungodly influences of the outside world. Even though some would say that Dowie's utopian venture was a failure, he was successful in leaving behind a legacy of strong, spiritual, community-minded ideals that have been passed down from generation to generation.

One

DR. JOHN ALEXANDER DOWIE, FOUNDER OF ZION

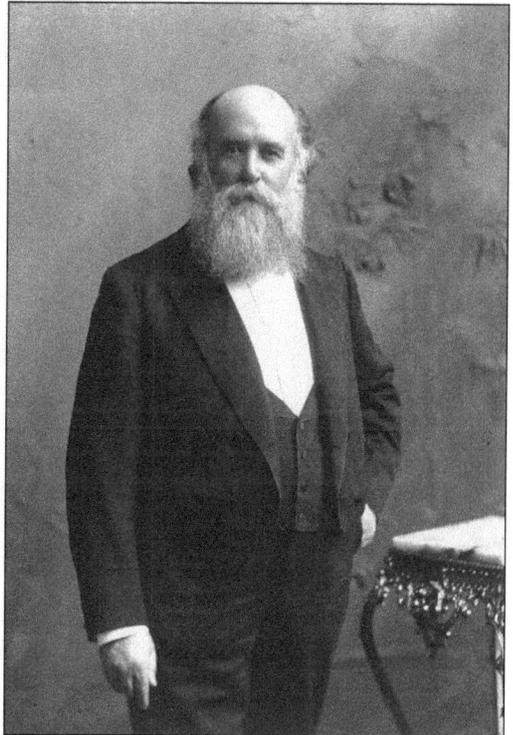

Dr. John Alexander Dowie was the founder of the city of Zion, Illinois. He was short in stature, being only five feet, four inches tall. He weighed close to 200 pounds. He wore a full beard, and with his bald head, he appeared older than his actual age. Being a Scotsman, he had a slight accent, but it generally went unnoticed when he addressed his audience.

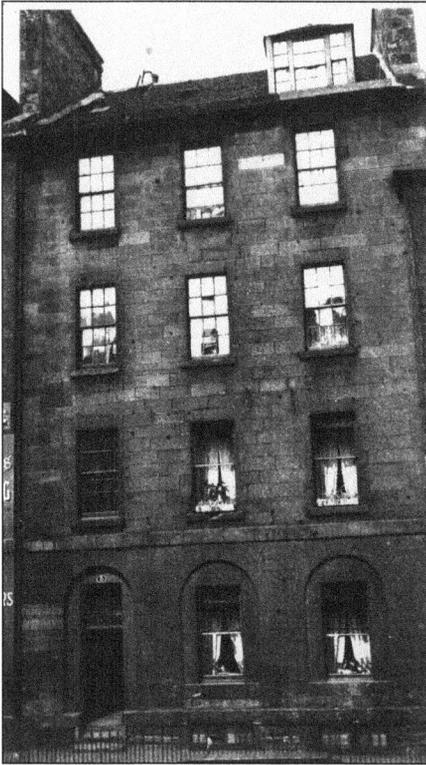

The uppermost floor of this modest building in Edinburgh, Scotland, was the birthplace of John Alexander Dowie on May 25, 1847.

Dowie entered the ministry in Australia at the age of 29. This would be the first of many robes he would wear in his world famous ministry.

Dowie married his cousin, Jane Dowie, of Adelaide, Australia on May 26, 1876. They had three children; Gladstone, Jeannie, and Esther. Jeannie died at an early age from an unidentified illness. Jane was the Christian Catholic Apostolic Church overseer in charge of women's work and the social needs of Zion City.

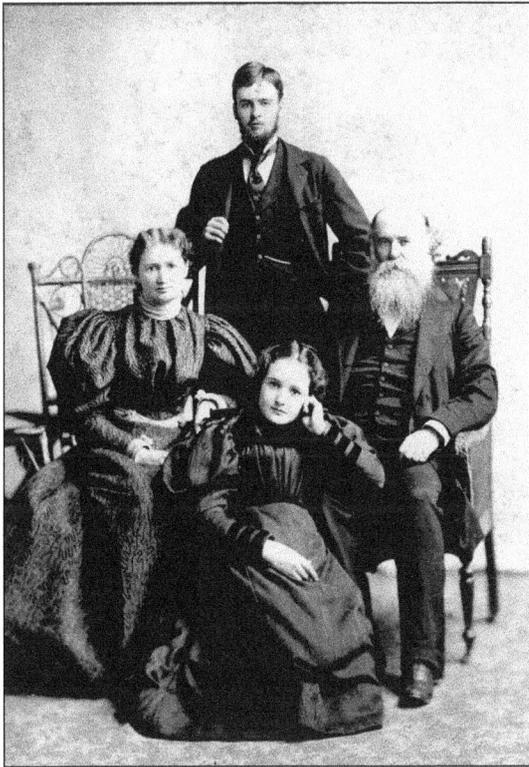

This family portrait of Zion's "First Family" was taken in 1899 in Chicago before the family moved to Zion. Dr. John Alexander and Jane Dowie are seated. Their son, Gladstone, is standing and their daughter, Esther, is kneeling on the floor at their feet.

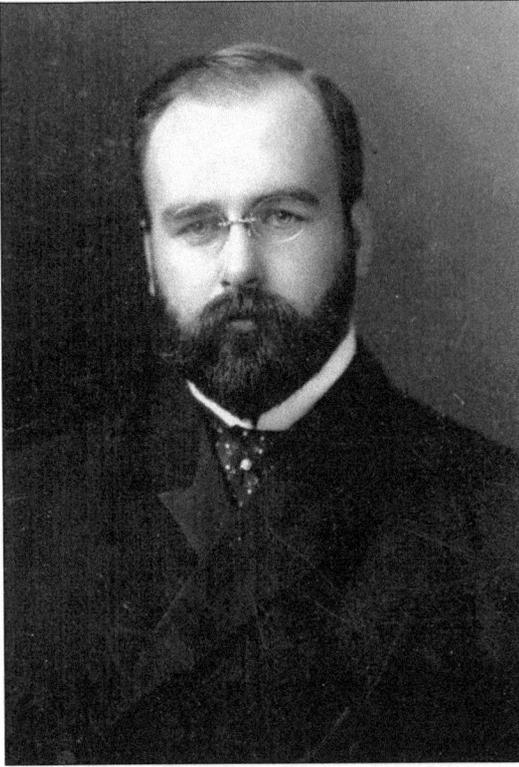

In the fall of 1877, Alexander John Gladstone Dowie, Dr. John Alexander Dowie's first child, was born. He was named for W. E. Gladstone, prime minister of the British Parliament, a man for whom John had great respect as a Christian leader. Gladstone was a lawyer and later became an Episcopal minister. He died in 1945 and is buried in the family plot in Lake Mound Cemetery in Zion. This photograph was taken in 1900.

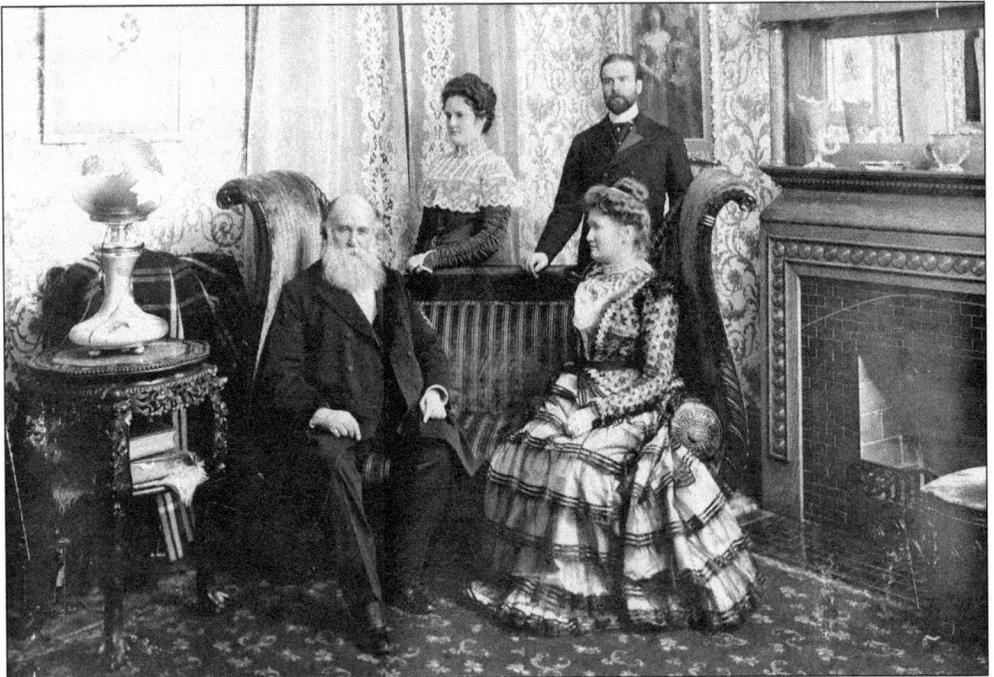

In 1893, John decided to make Chicago his permanent headquarters. The family is shown here in their residence, an apartment on Twelfth Street. John and wife Jane are seated on the settee while their daughter, Esther, and son, Gladstone, stand behind.

Esther, the youngest daughter of John and Jane Dowie, died at age 21, at the Dowie's Chicago residence from burns suffered as the result of the use of alcohol to fuel a lamp to heat a curling iron. John strictly forbade the use of alcohol in any form, so Esther locked her bedroom door, thus delaying efforts to save her. She was buried in Lake Mound Cemetery in Zion City with an estimated crowd of 7,000 in attendance.

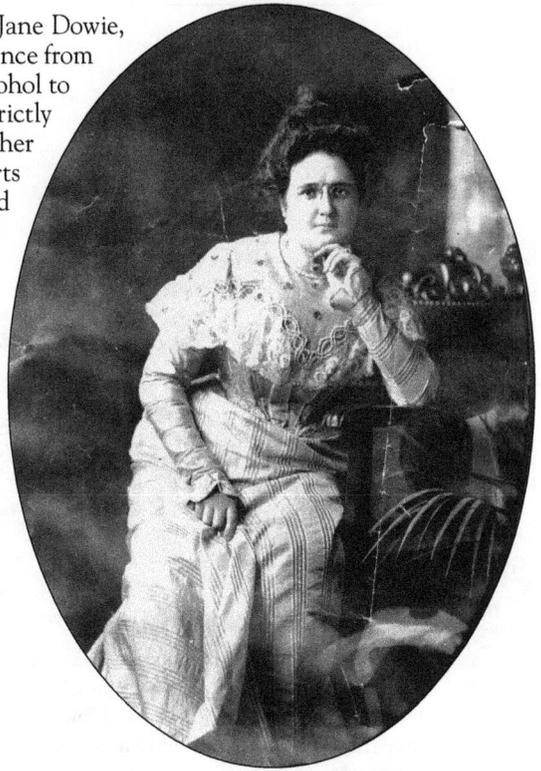

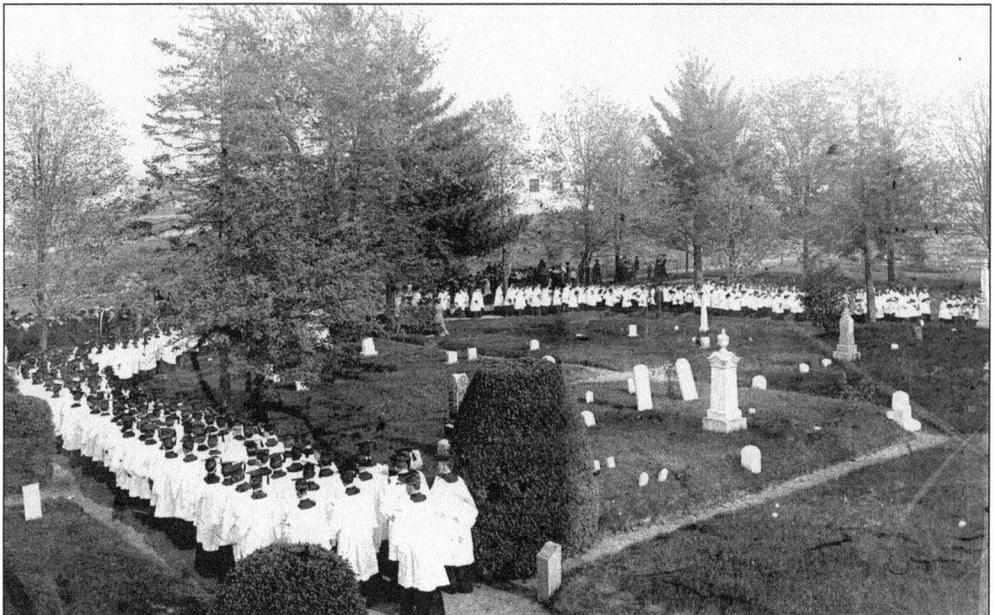

Upon the death of Esther, two special trains transported church members and friends to Zion from Chicago for the funeral services, which were to be conducted by John. An estimated crowd of 7,000 gathered at the Lake Mound Cemetery in Zion. The processional included the members of the Christian Catholic Apostolic Church White-robed Choir as shown in this photograph taken May 16, 1902.

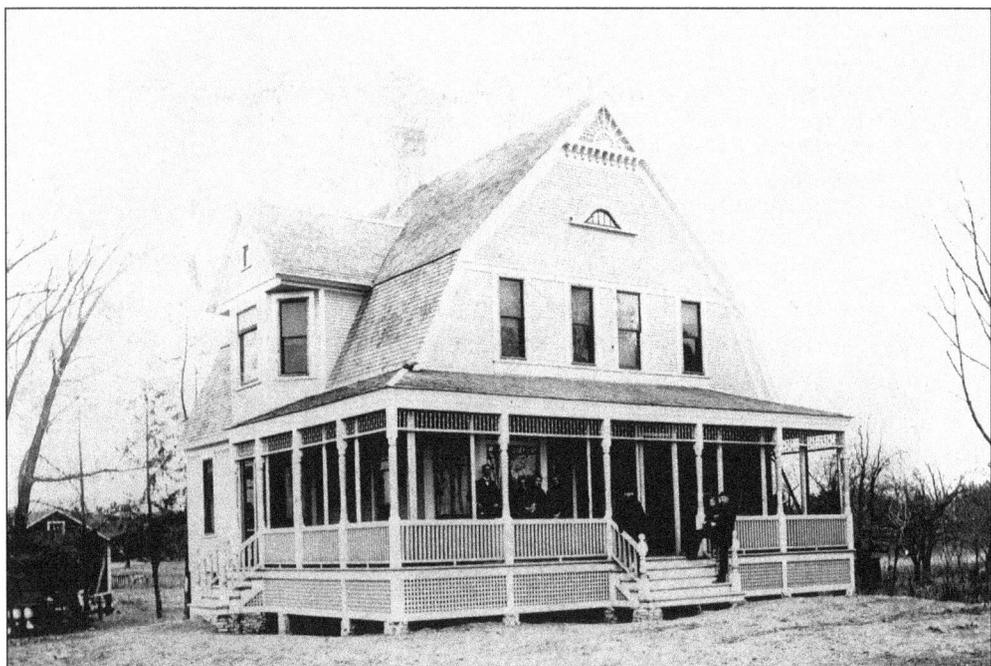

Temple Cottage stood in the 2600 block of Sheridan Road on the west side. Before 1900, it was the Nelson Cole family farm. Dr. John Dowie purchased the property and lived there while Shiloh House, his permanent home, was under construction. Church offices were also located there. The surveyors and engineers worked there while laying out the new city.

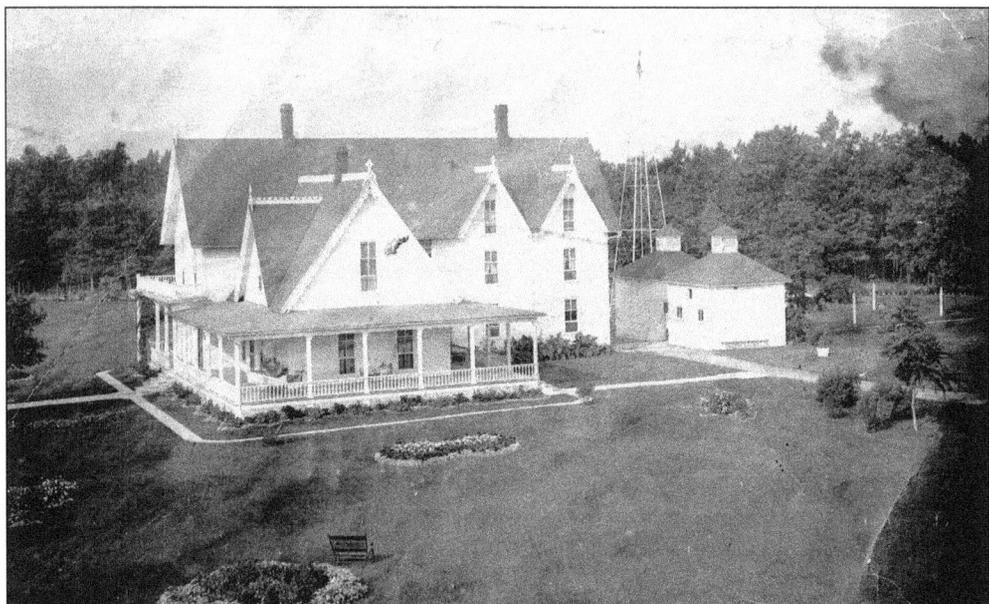

In 1898, Dowie acquired a summer home on White Lake near Montague, Michigan. It was named Ben Mac Dhui after a mountain in Scotland, Dowie's birthplace. In 1902, 300 members of the church choir traveled by lake steamer for a weekend retreat at the estate, during which Dowie held services in a tent. An estimated crowd of 3,500 from nearby towns satisfied their curiosity.

In 1902, Dowie's family residence, Shiloh House (right), was completed. It is a three-story, 25-room mansion built on the corner of Shiloh Boulevard and Elisha Avenue at a cost of $90,000. It is constructed of red brick and Indiana limestone. It was designed by Paul Burkhardt, an architect born and educated in Switzerland, thus explaining the evidence of a Swiss Chalet design.

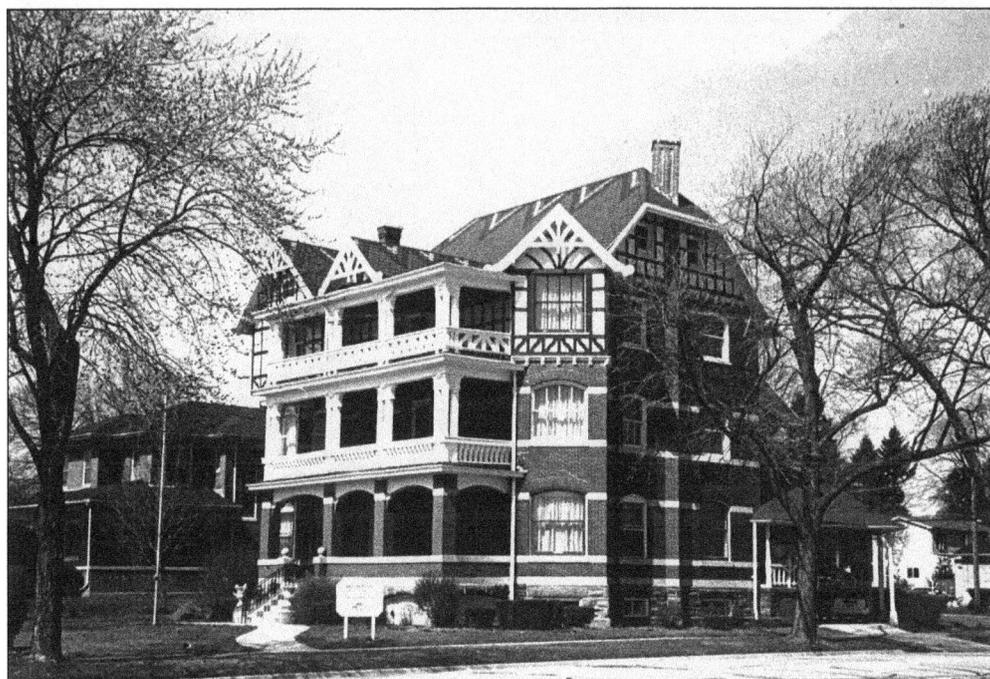

Two upper porches were added to the Shiloh House by a later owner. The porches were painted white, as was much of the interior woodwork. The porches are still white today, but with the exception of the family parlor, the interior woodwork has been restored to its original beauty.

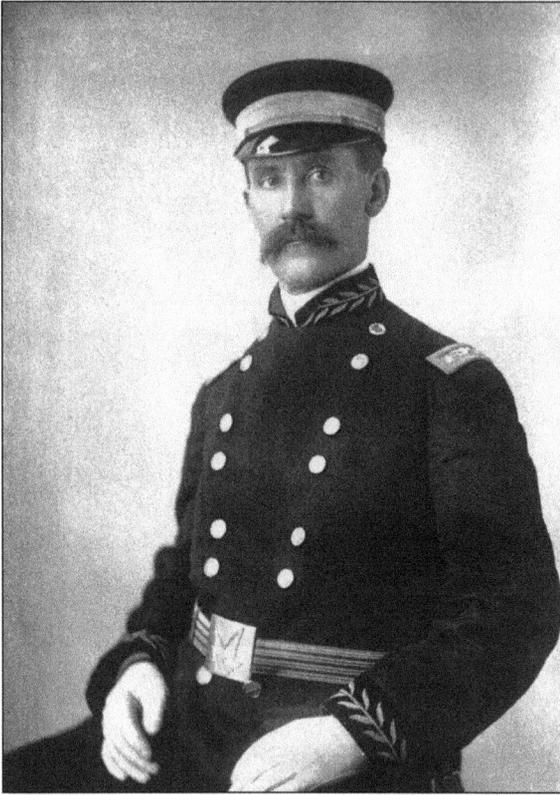

Carl Stern was Dr. John Alexander Dowie's personal attendant and colonel of the Zion Guard. He served as chief of both the Zion Police and Fire Departments. His wife, Ida, was Dowie's private secretary. The Sterns lived on the second floor of the Dowie's residence at 1300 Shiloh Boulevard. Colonel Stern died in 1904 of pneumonia.

Pictured in 1898, Col. Carl Stern and his wife, Ida, prepare for an outing in their Twelfth Street home in Chicago. Prior to his service as Dowie's bodyguard, Carl was a Chicago policeman and saloon keeper.

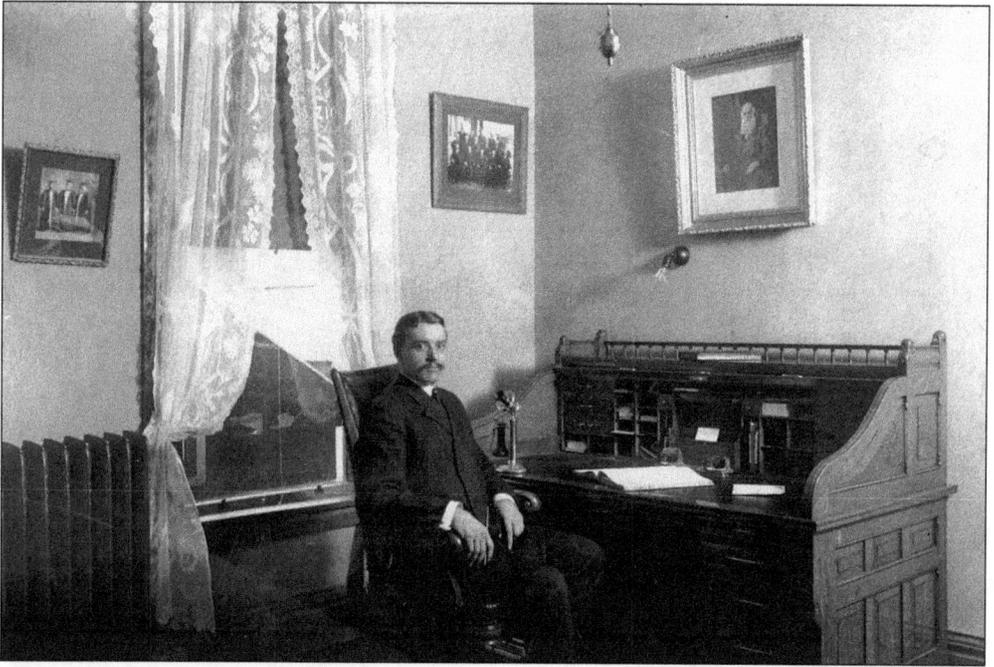

Jasper Herman Depew was personal attendant to Dowie, general overseer of the Christian Catholic Apostolic Church. This photograph was taken in August 1905. The desk and chair were used by Dowie in the early days of his work in Chicago.

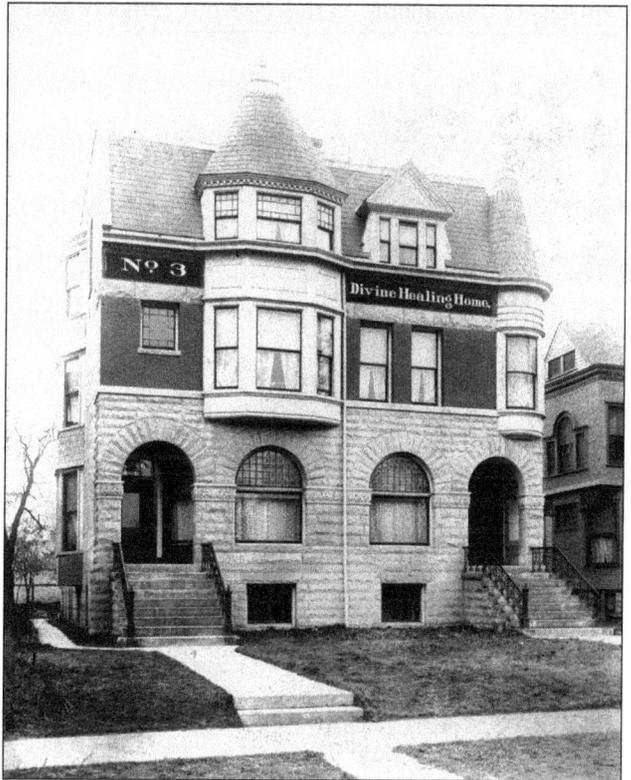

Dowie was a servant of God who had been instrumental through prayer and Biblical teaching in the divine healing of many. He leased and furnished several large rooming houses to be used as healing homes where people got their meals and lodging at a nominal charge and received spiritual guidance. His "Divine Healing Home No. 3" was operating in Chicago between 1895 and 1900.

Dr. John Alexander Dowie published a periodical, *Leaves of Healing*. Publication began in the spring of 1886, while he was doing mission work in New Zealand. In this periodical, he included recounts of healings and biblical teachings. A good portion of Zion's successful beginnings was attributed to *Leaves of Healing* being circulated all over the world. Literature was distributed in Zion City in this building on the southwest corner of Twenty-fifth Street and Sheridan Road.

The cover story of the Saturday, January 2, 1904, *Leaves of Healing* informs readers about Christian Catholic Church general overseer Dowie's departure for his around-the-world visitation.

Charles Champe, Zion's cartoonist, was employed by the *Zion Banner*. His illustrations also appeared in Dowie's *Leaves of Healing*. The subject matter of Champe's drawings covered everything from choosing a profession for your children to the Christian influence in the cooperative industries. Three of his cartoons are displayed on the wall while one remains "on the drawing board."

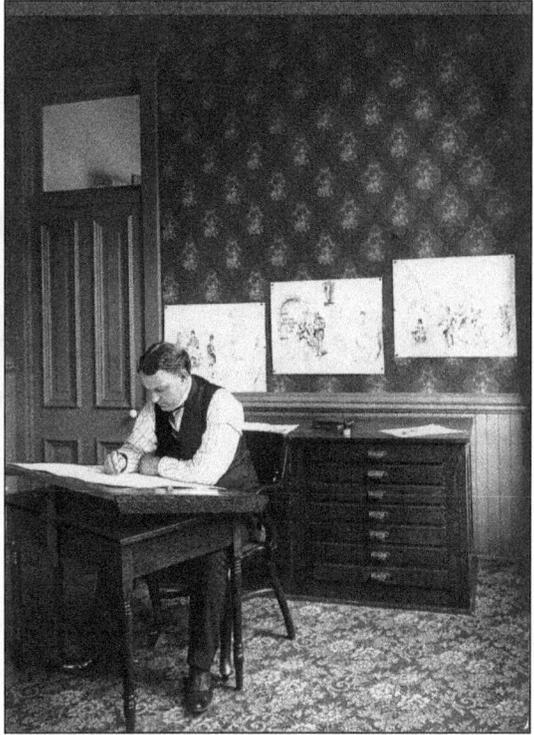

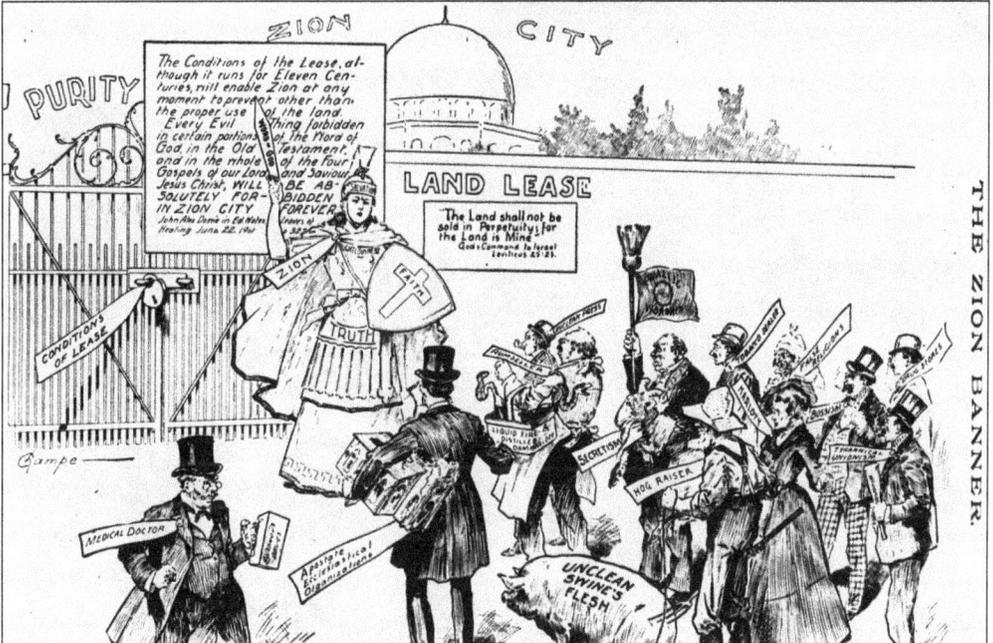

This Champe "cartoon," entitled "Barred Out," was published in the *Zion Banner*. It depicts the soldier of faith, truth, and salvation guarding the gates of Zion City against those who wished to enter to participate in evil practices, therefore violating the conditions of the land leases. Some approaching the gate include unclean swine's flesh, a distiller, a rum seller, a tobacco dealer, and drug stores.

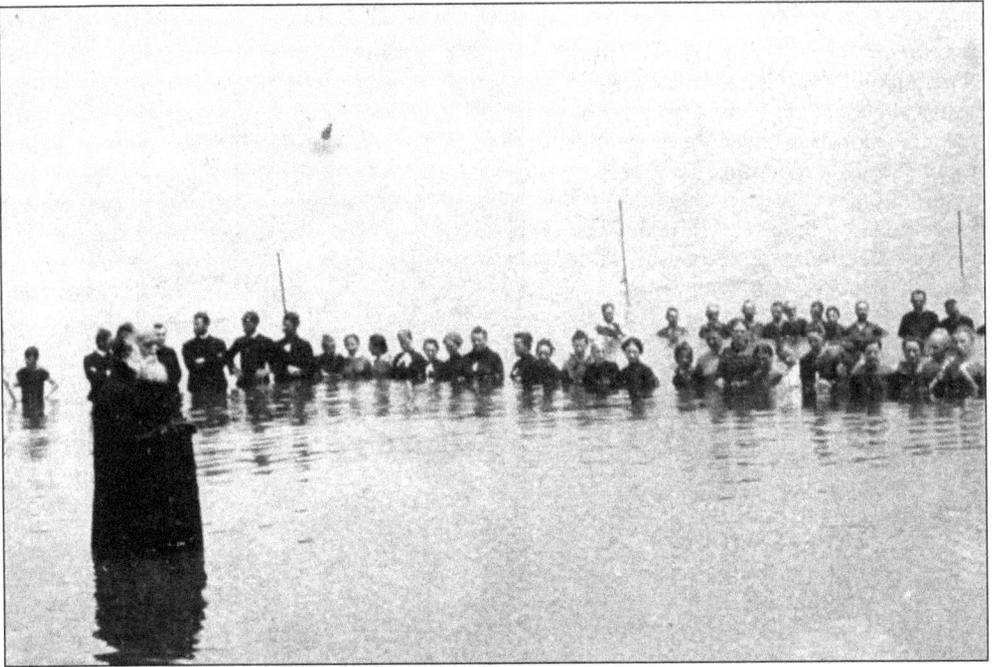

Christian Catholic Church general overseer Dr. John Alexander Dowie (left front) performs a group baptism in Lake Michigan.

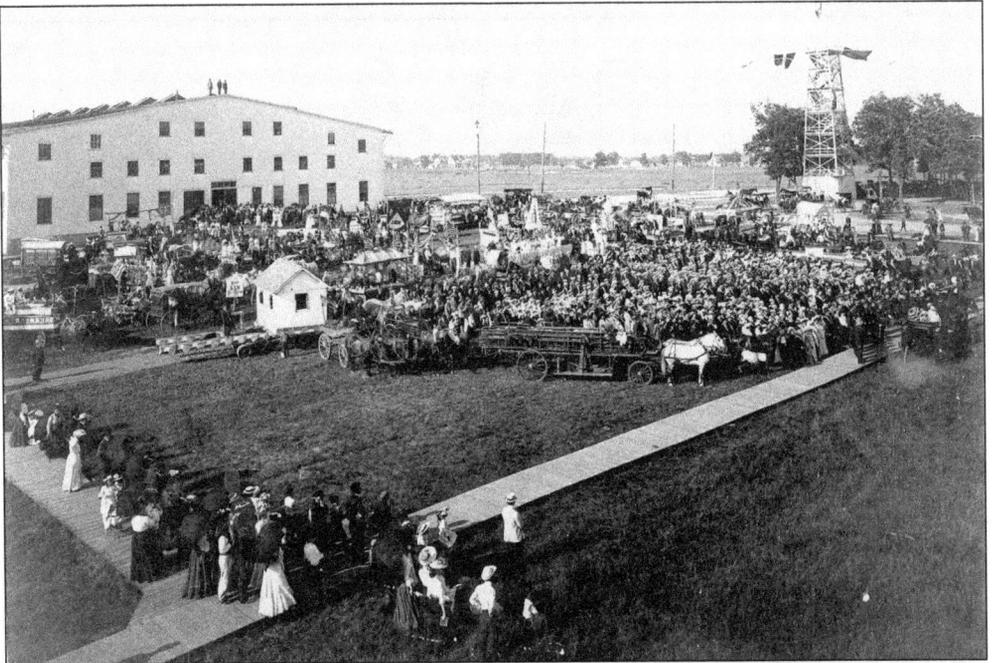

Dr. John and Jane Dowie traveled extensively, holding meetings in England, Switzerland, France, Germany, Australia, and New Zealand, encouraging people to come to Zion where salvation, healing, and holy living were foremost in the hearts of the people. Dowie's homecoming following his world tour led to a well-attended parade in his honor that culminated on the grounds of Shiloh Tabernacle on June 30, 1904.

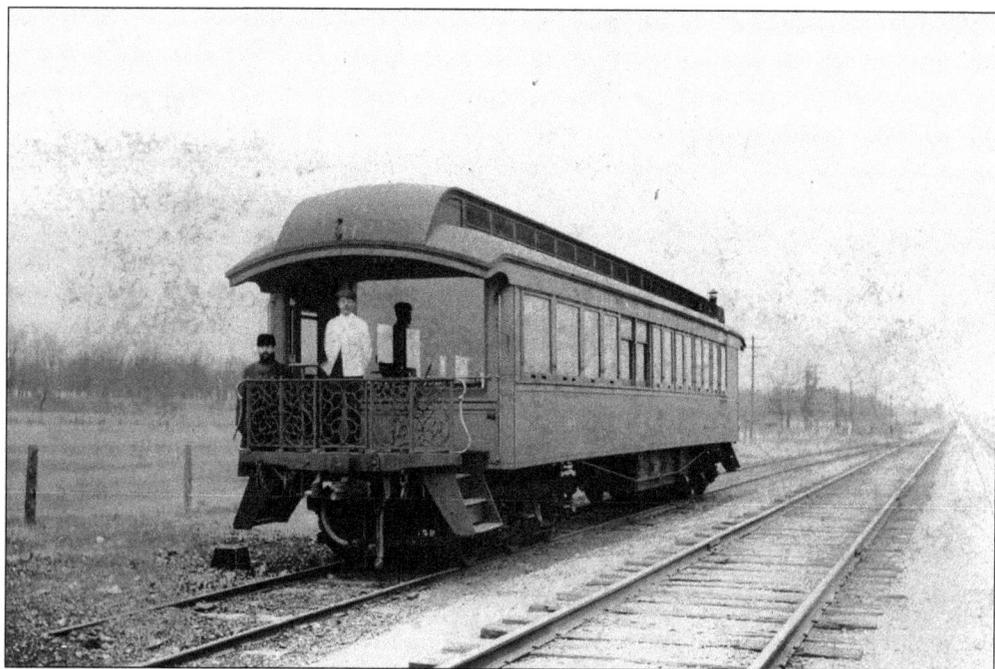

Dowie had his own private railcar at his disposal. It stands ready on the Chicago and Northwestern Railroad tracks in 1901.

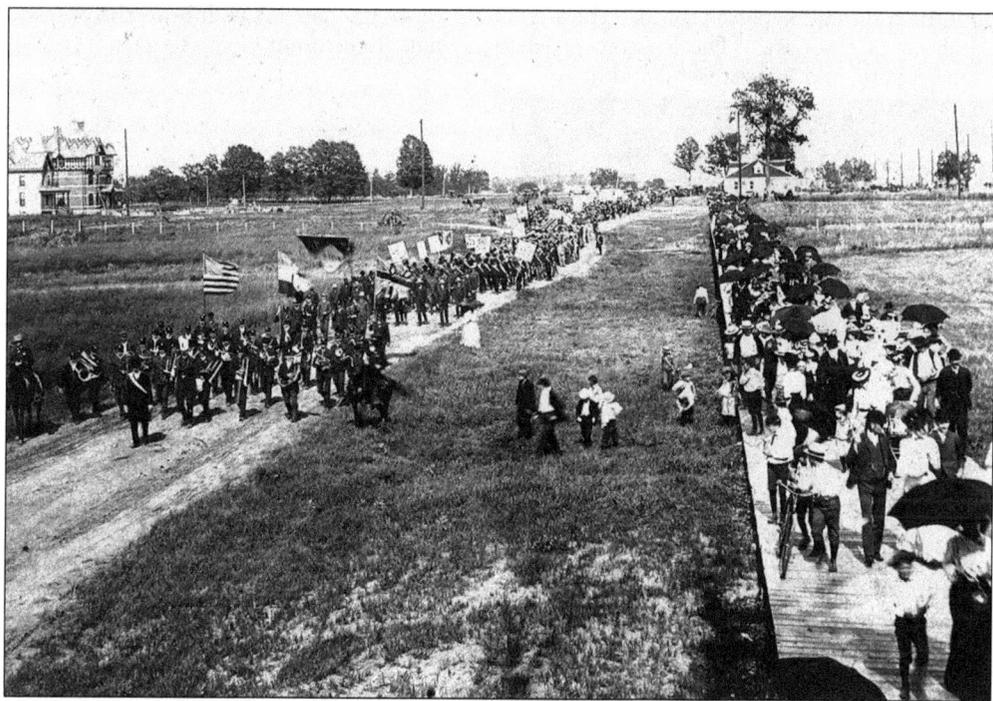

A crowd of thousands joined Dowie and his entourage as they made their way from the train station to the Tabernacle upon his return from his world tour in 1904. Some walked on the road, Shiloh Boulevard (center), and some took advantage of the boardwalk (right) that was built to accommodate foot traffic from the Zion station to the temple site.

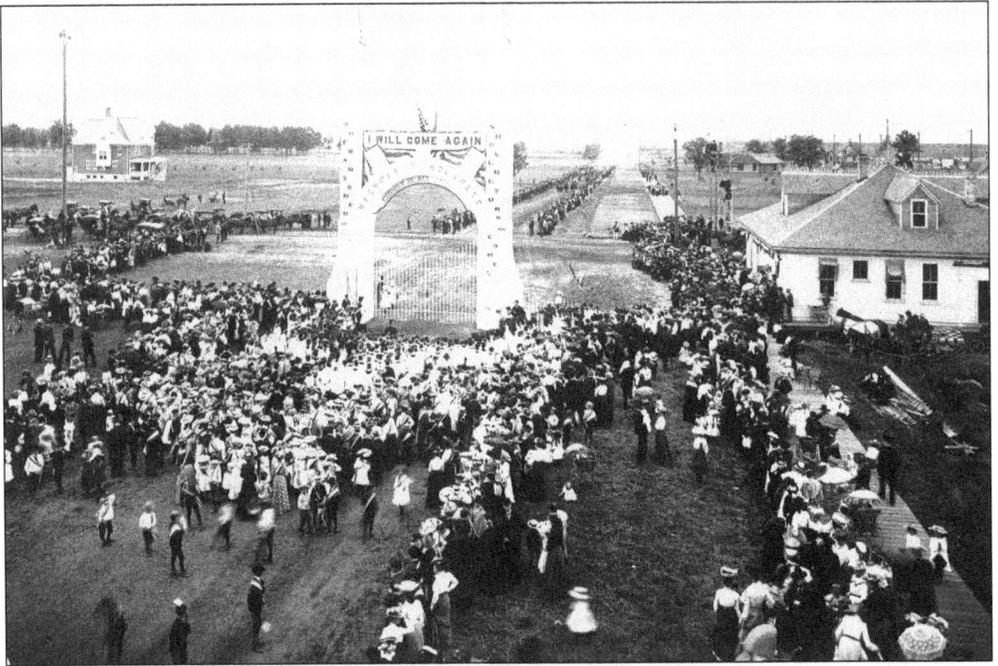

A large wooden white arch was erected at Twenty-fifth Street and Sheridan Road in honor of the return of General Overseer Dr. John Alexander Dowie from his world visitation. The procession from the train station passed through the arch on its way to the temple site. It bears the phrases, "Highway of Holiness," "The Ransom of Jehovah Shall Return and Come to Zion," "I Will Come Again," and "Christ is All and In All".

Jane Dowie poses for the last known photograph of her. Jane left Zion when the estate fell into receivership but returned to live out the remainder of her life. She died in 1936 and was buried in the Dowie family plot in Lake Mound Cemetery at the corner of Twenty-ninth Street and Sheridan Road in Zion.

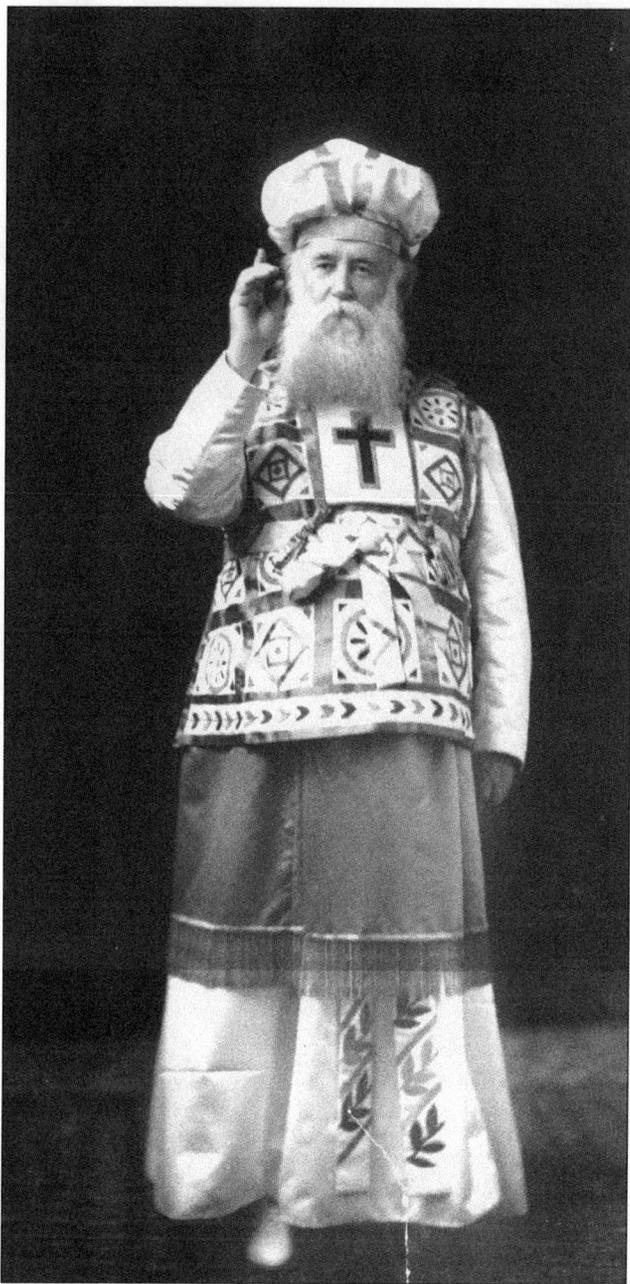

Since the Zion Church was the "True" church, it was determined that the Apostolic Order would be used. The general overseer, Dr. John Alexander Dowie, had proven by his works, he would be the "First Apostle." In time, he would call the other 11. On September 18, 1904, the prophet appeared on the platform of Shiloh Tabernacle dressed in a robe of several pieces. White was combined with gold, scarlet, and purple to make this spectacular garment. His liturgical headdress was of white, gold, and purple. His new title now was "John Alexander, First Apostle of the Lord Jesus, the Christ, in the Christian Catholic Apostolic Church in Zion, who is also Elijah, the prophet of the Restoration of All Things." Over 7,000 people gathered in the sanctuary to witness the transition.

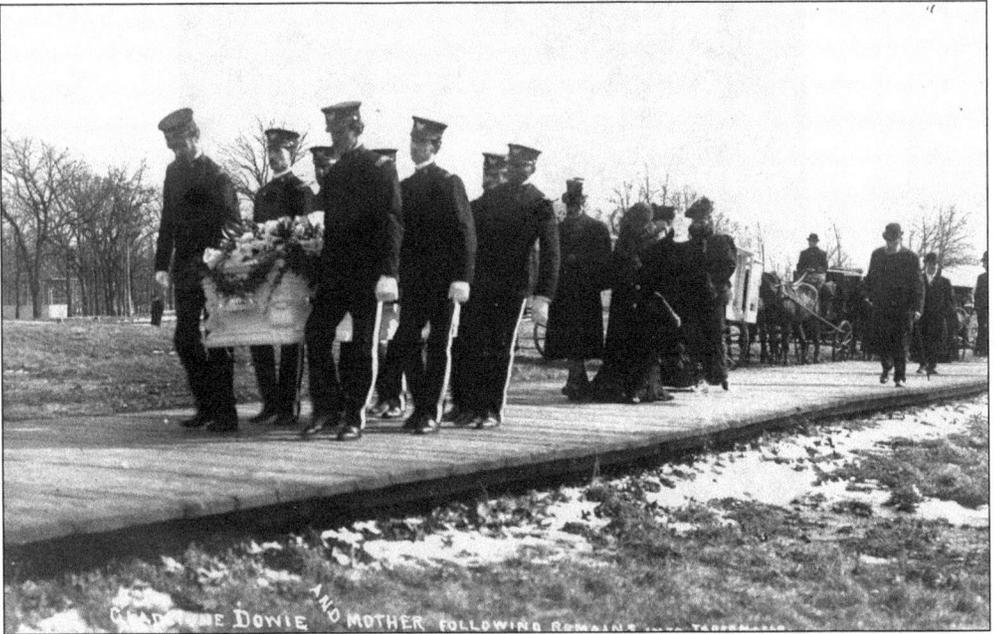

Dr. John Alexander Dowie died at Shiloh House on May 9, 1907. According to Judge V. V. Barnes's memorial message, Dr. Dowie's last words were, "The millennium has come; I will be back for a thousand years." On March 12, 1907, members of the Zion Guard carried his casket to and from Shiloh Tabernacle, with Gladstone Dowie (center in top hat) and Jane Dowie (on Gladstone's arm) following.

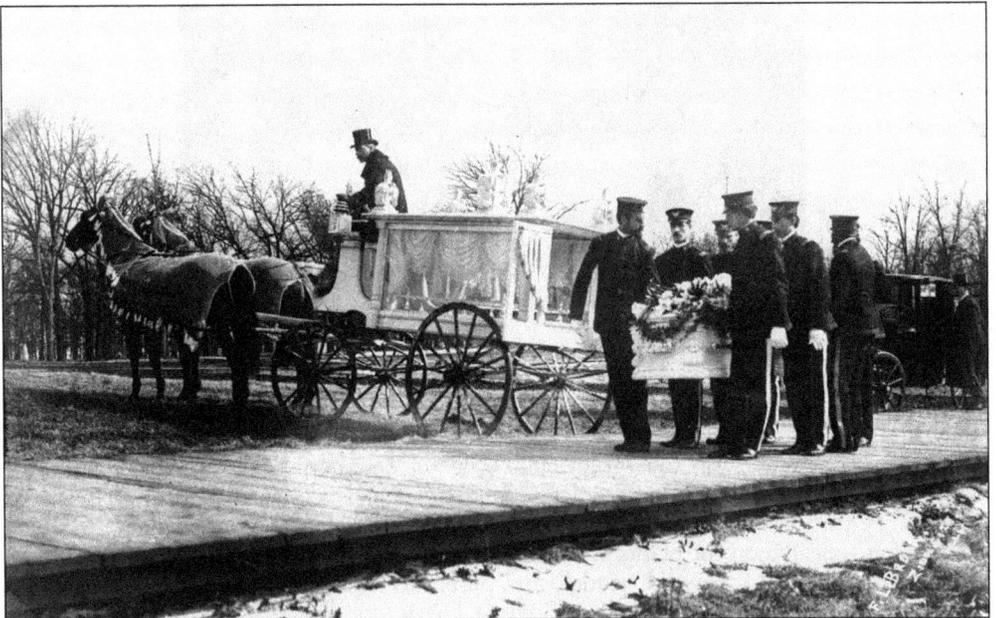

The hearse that carried Dr. John Alexander Dowie's casket to Shiloh Tabernacle for the services and then to Lake Mound Cemetery for interment stands ready along the boardwalk outside the tabernacle.

Two

CHRISTIAN CATHOLIC CHURCH

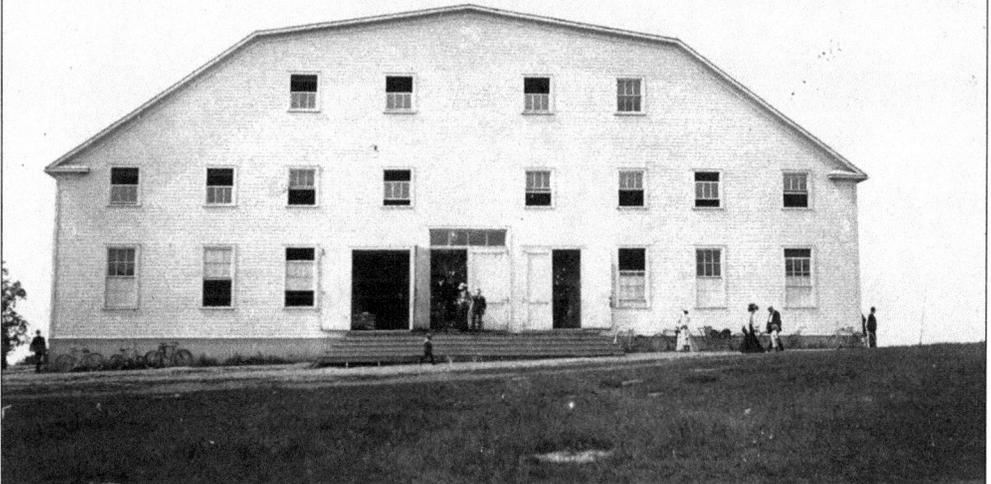

Shiloh Tabernacle was built in 1902 on what is known as the temple site. Built in just 46 days, it was meant to be a temporary church. Plans were being drawn for a much larger, more ornate temple, which were never realized. Dr. John Alexander Dowie held meetings here on Wednesdays and Sundays, often filling the room to capacity.

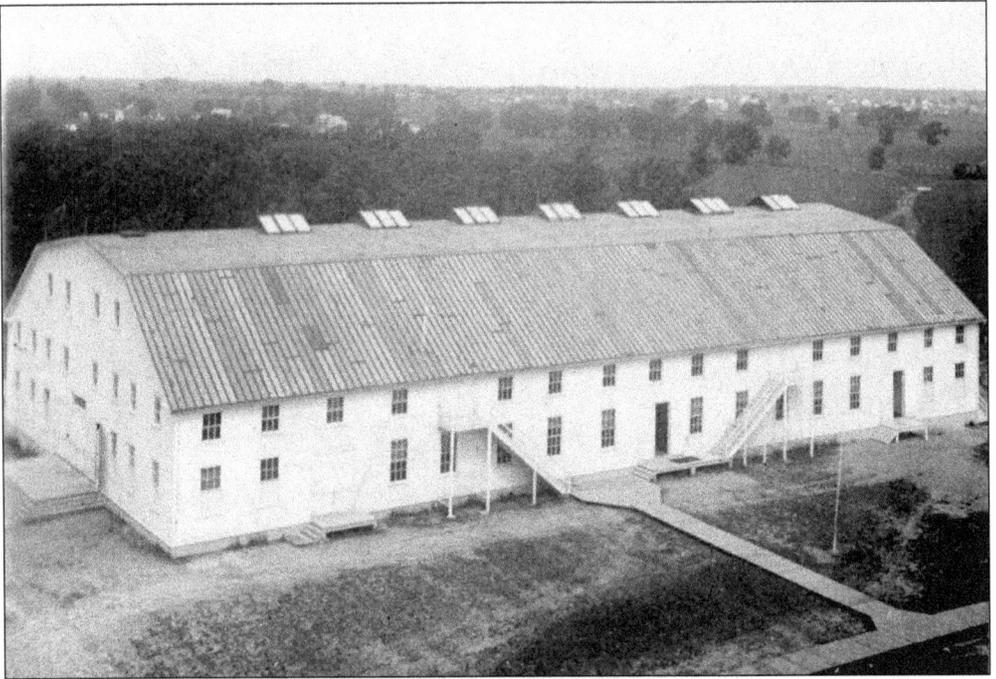

Shiloh Tabernacle was the heart of the Christian Catholic Church, and Zion City was its headquarters. On Easter Monday, March 31, 1902, the tabernacle was dedicated, and Zion City was incorporated under the law of the State of Illinois.

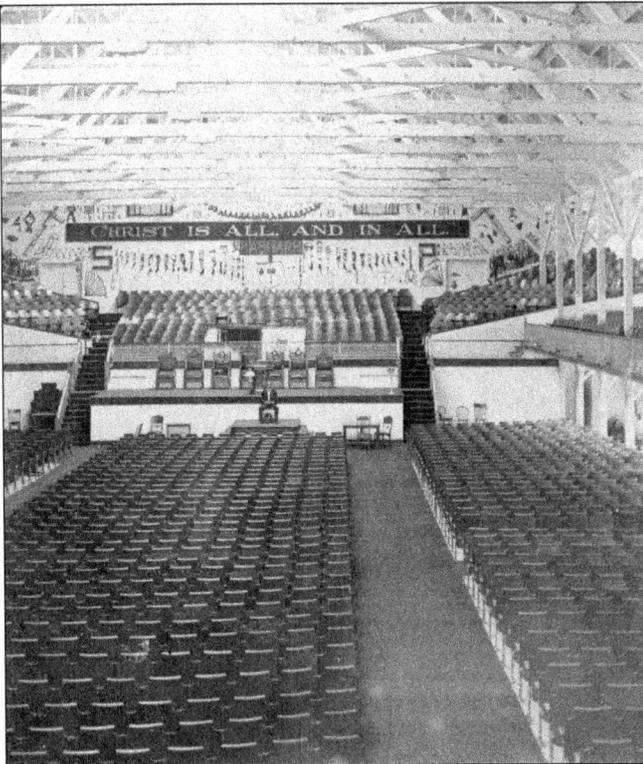

The interior of Shiloh Tabernacle had a capacity of 8,000. There was no public address system at that time, but the acoustics were quite good. Dr. John Alexander Dowie had a strong voice, as did most officers who spoke from the platform. The large one-room sanctuary included a band and choir loft behind the pulpit.

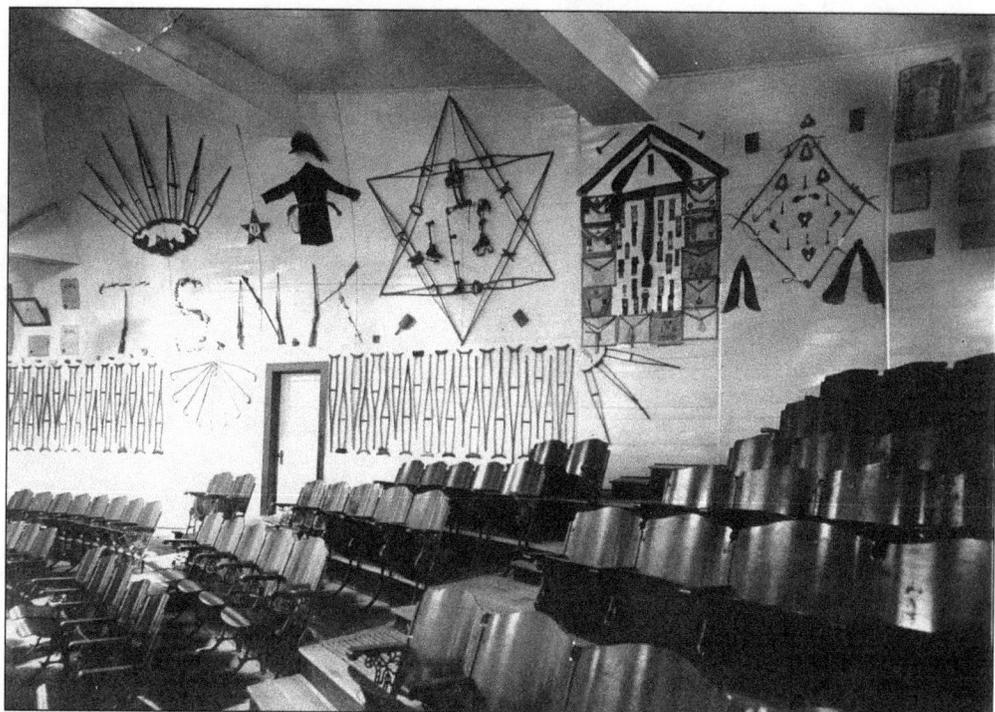

Displays of crutches, canes, casts, braces, flasks, pistols, tobacco pouches, medicine bottles, brass knuckles, and other reminders of the ill effects of the outside world covered the interior walls of the Shiloh Tabernacle. People who received their divine healing from Dowie were all too happy to leave these "trophies" behind.

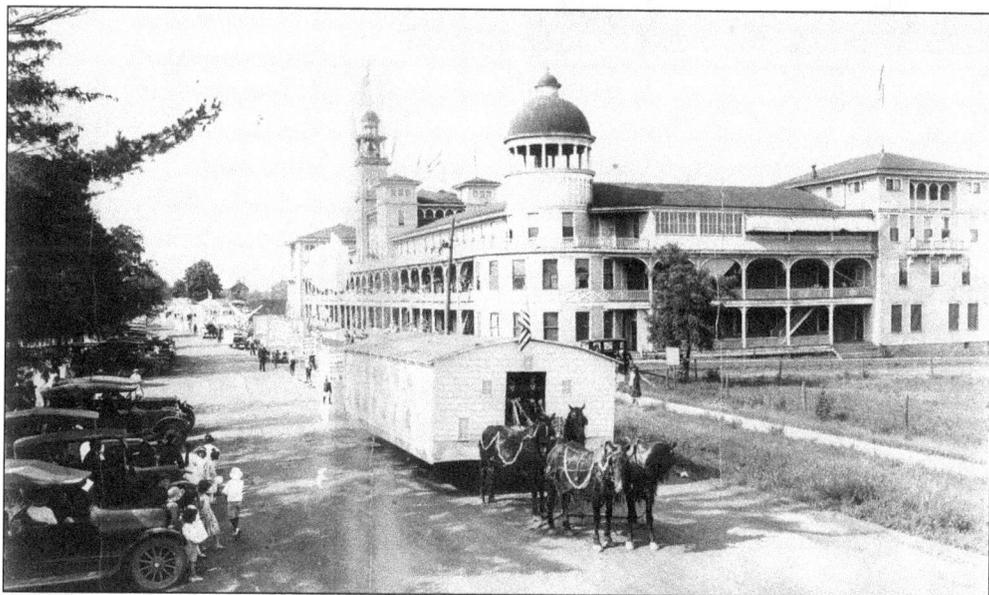

There were branch tabernacles located throughout Zion City. During the inclement winter months, when parishioners could not get to Shiloh Tabernacle due to the weather, they could still attend services. As part of a "Building Industry" project, in July 1916, this branch tabernacle was moved to its location.

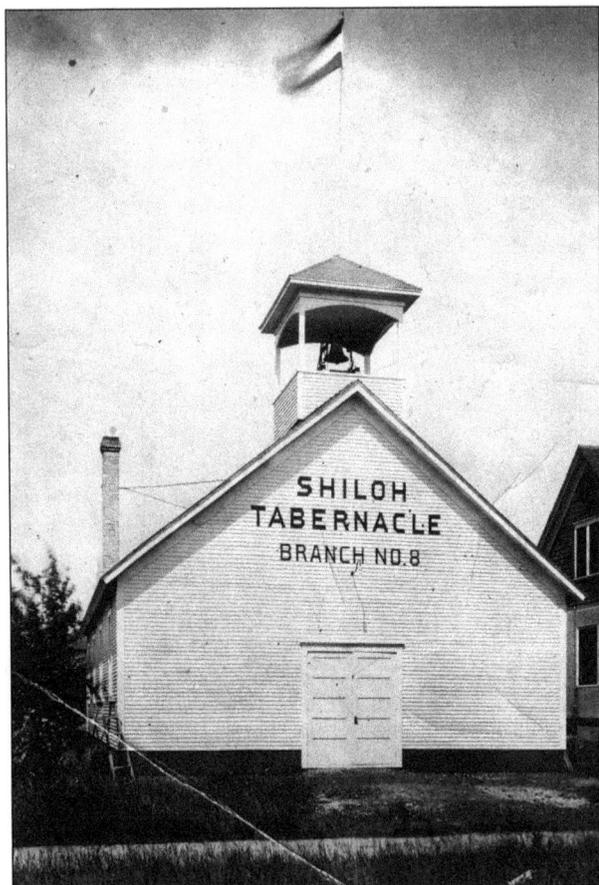

Shiloh Tabernacle, branch No. 8, served the parishioners in Zion City from 1916 to 1928.

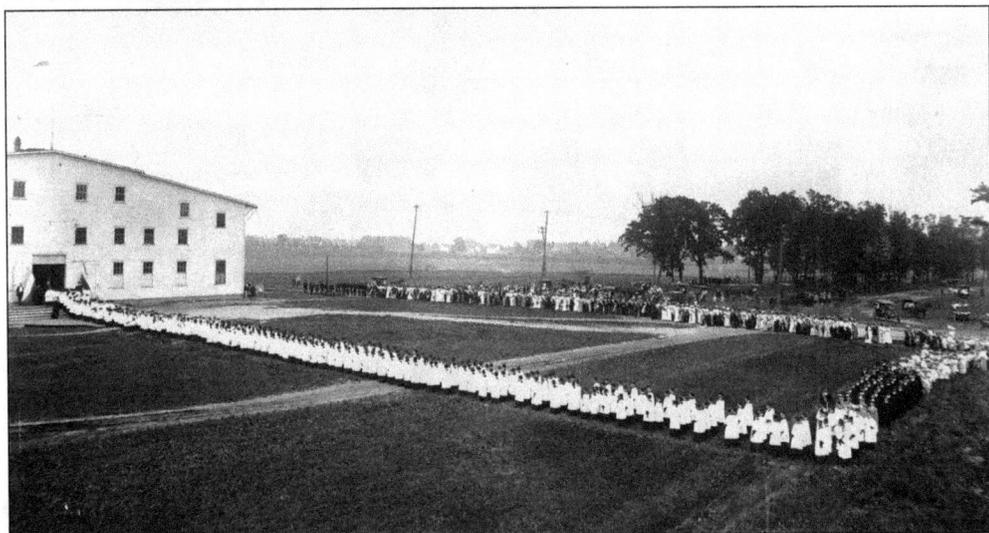

During Dr. John Alexander Dowie's tenure as church leader, the White-robed Choir was formed under the baton of conductor John D. Thomas. The choirs, including both a junior and adult choir, which at various times consisted of 300 to 1,000 voices, lined up on the Shiloh Tabernacle grounds (shown here in 1903) prior to procession into the building.

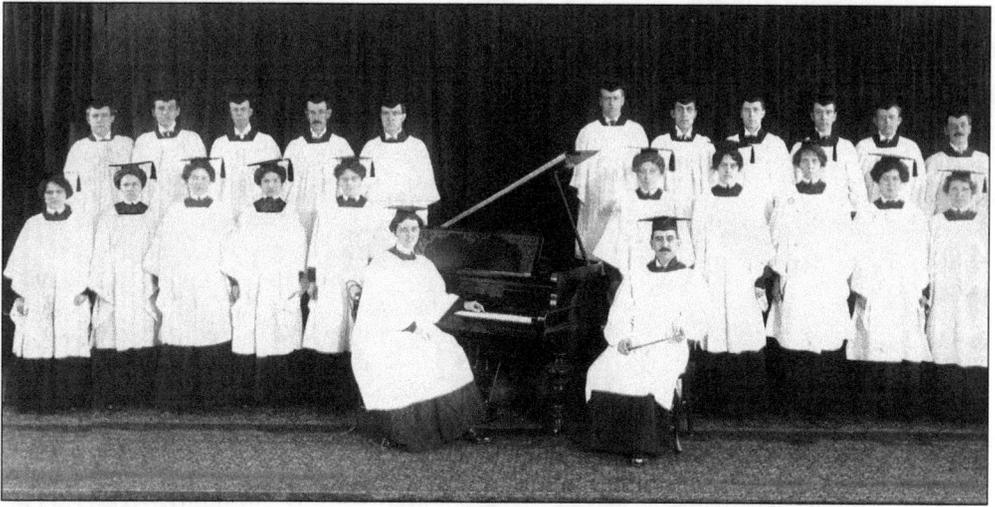

The Zion Senior Chorus was a faction of the White-robed Choir. Edith Hire, pianist, is seated at the piano and the chorus director, John D. Thomas, with baton in hand, is seated on the right.

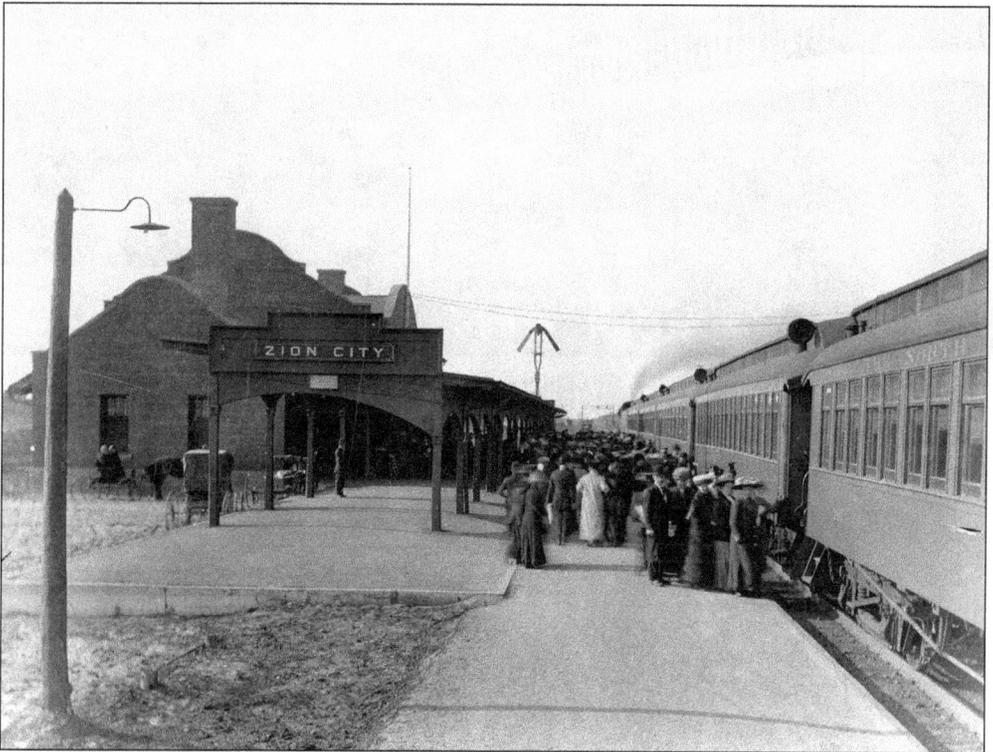

A group of "Seventies" workers prepare to board the train at the Zion Chicago Northwestern Station in 1913. The Seventies, a missionary division of the Christian Catholic Church, were organized in 1897. They traveled in pairs visiting the needy to scrub floors, cook meals, tend the sick, and distribute food and clothing.

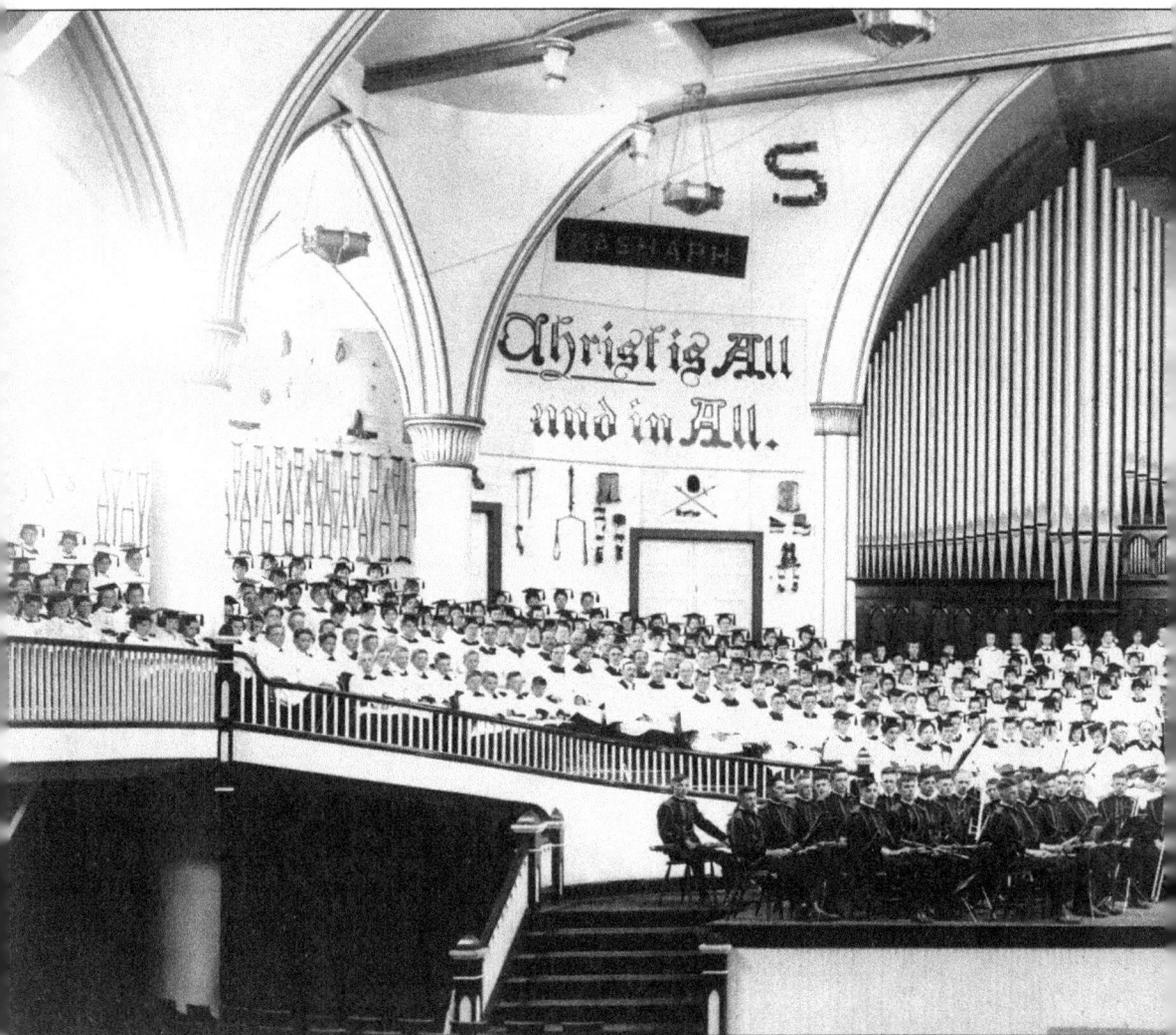

As soon as the Shiloh Tabernacle was purchased from the receiver in 1910, plans were made to beautify its interior. In conjunction with the remodeling, the Christian Catholic Church installed an organ, a combination of seven organs with over 5,000 pipes, which was built by the Felgemaker Organ Company of Erie, Pennsylvania. It was installed in the newly remodeled

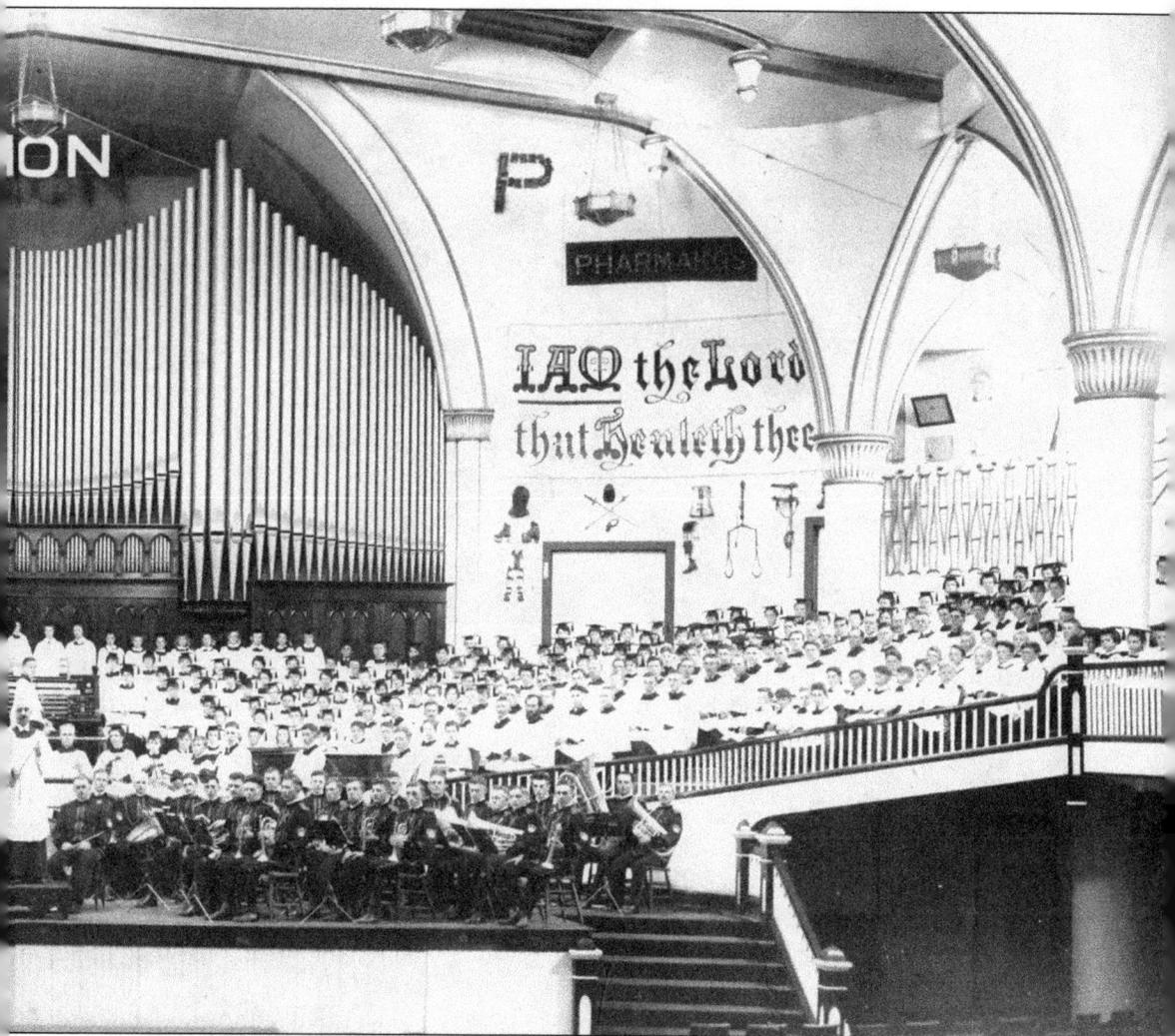

choir gallery boasting 305 seats. It was one of the first electronically controlled organs made by Prof. William Middleshulte of Chicago. Because of electrical difficulties encountered during later remodeling, an Austin Console was installed.

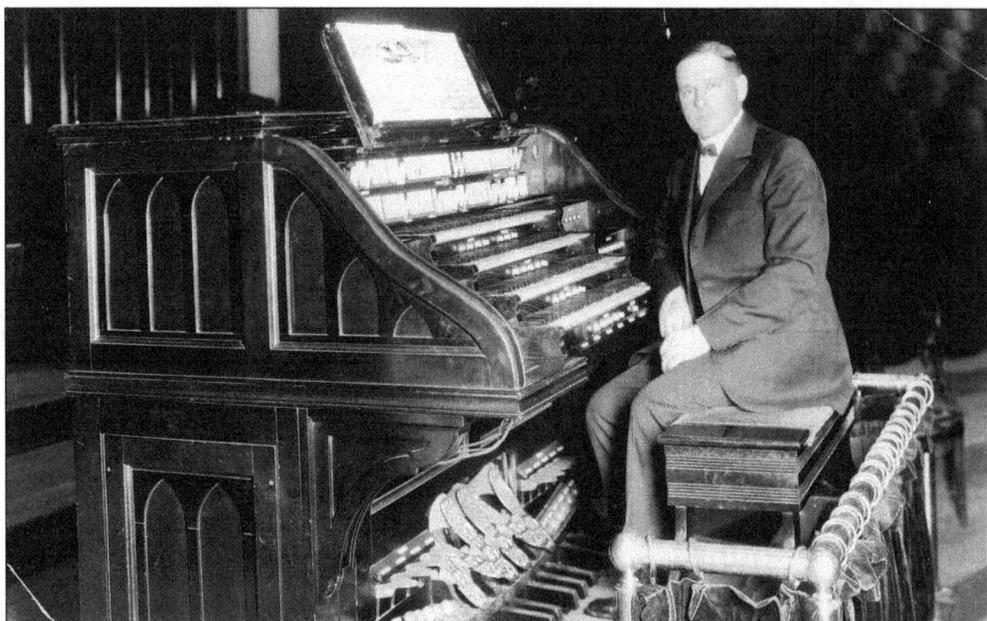

In 1912, the Christian Catholic Church purchased one of the largest pipe organs in the world. The church organist at the time was Dr. Hyland Em Wilson. In 1917, Fred Faassen (pictured here at the console), who had been at Great Lakes Naval Training Station, became the church organist.

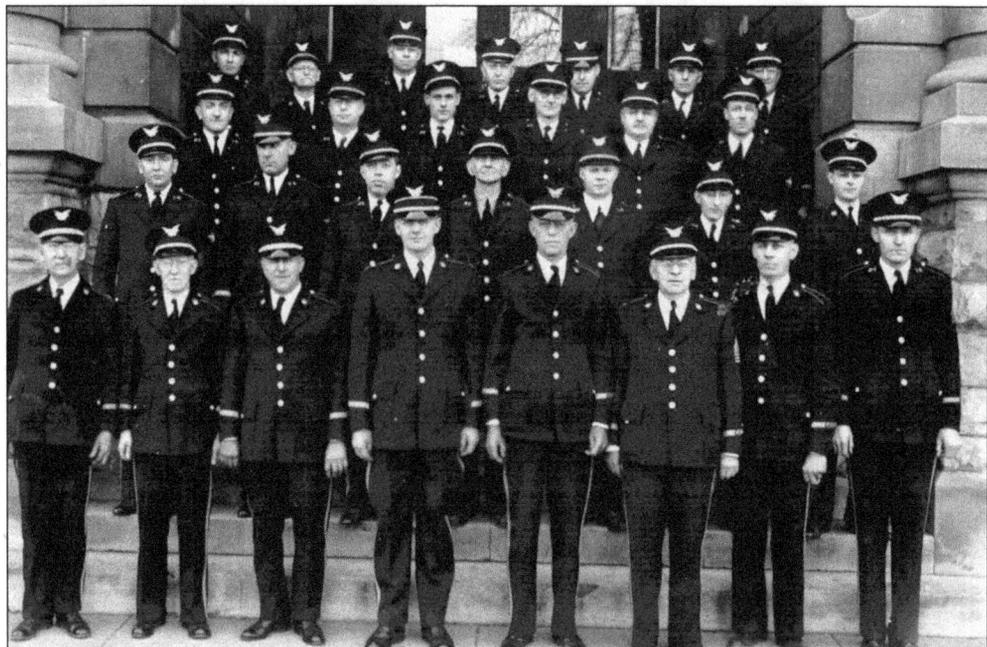

The Zion Guard (shown here in 1950) was a group of men originally organized to patrol the healing home neighborhoods during Dr. John Alexander Dowie's Chicago ministry. They wore uniforms including a visored cap that sported a bronze dove with an olive branch in its beak and the word "patience" in gold letters. They carried Bibles in their holsters. In Zion, they were used to direct traffic, usher, and check attendance at church services.

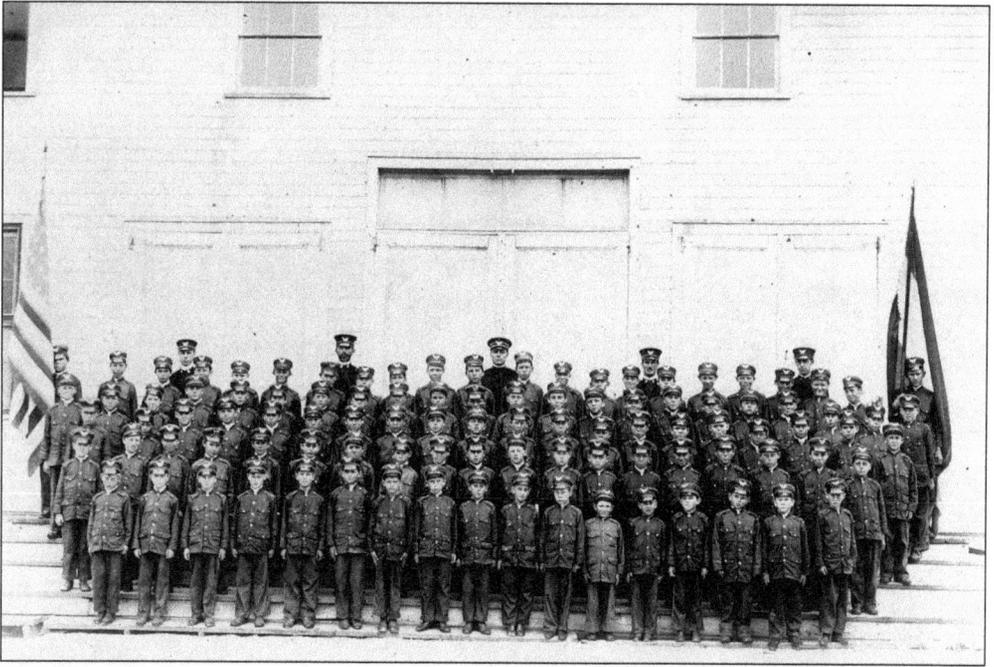

The Zion Guard brought young boys up to learn the ways of the guard. When these young men lined up on the steps of the Shiloh Tabernacle came of age, they would serve as trained replacements for the adult Zion Guard.

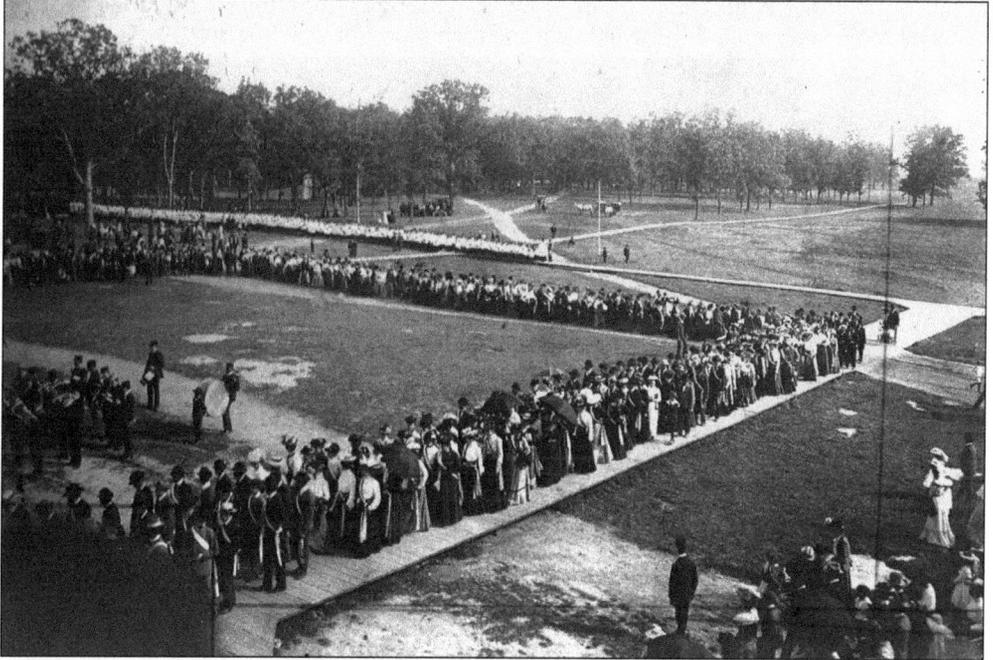

Taken in 1903, looking south from the Shiloh Tabernacle roof, this photograph features an assemblage of church members waiting to the enter the tabernacle following the annual march around the temple site as part of the "Feast of Tabernacles." The White-robed Choir approaches along the boardwalk in the background.

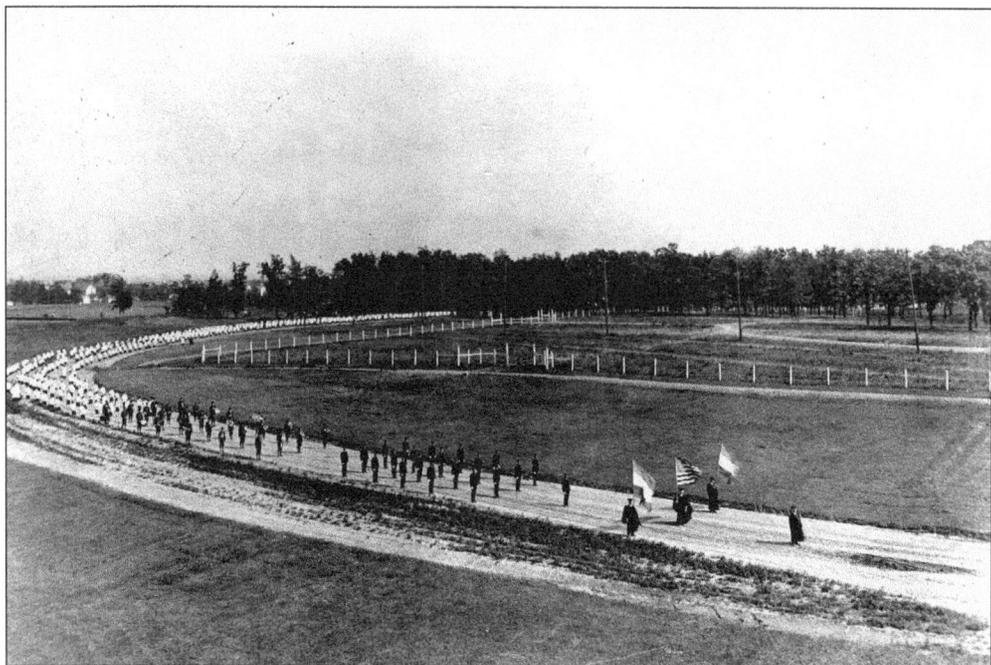

The first march around the temple site was conducted in July 1914 as part of the "Feast of Tabernacles," an event in celebration of Zion City's progress. This line-up consisted primarily of the Zion Guards, church officers, the band, and the White-robed Choir, followed by church members. The march became an annual event, sometimes 2,000 marchers strong, as they marched three times around the temple site and then posed for a photograph.

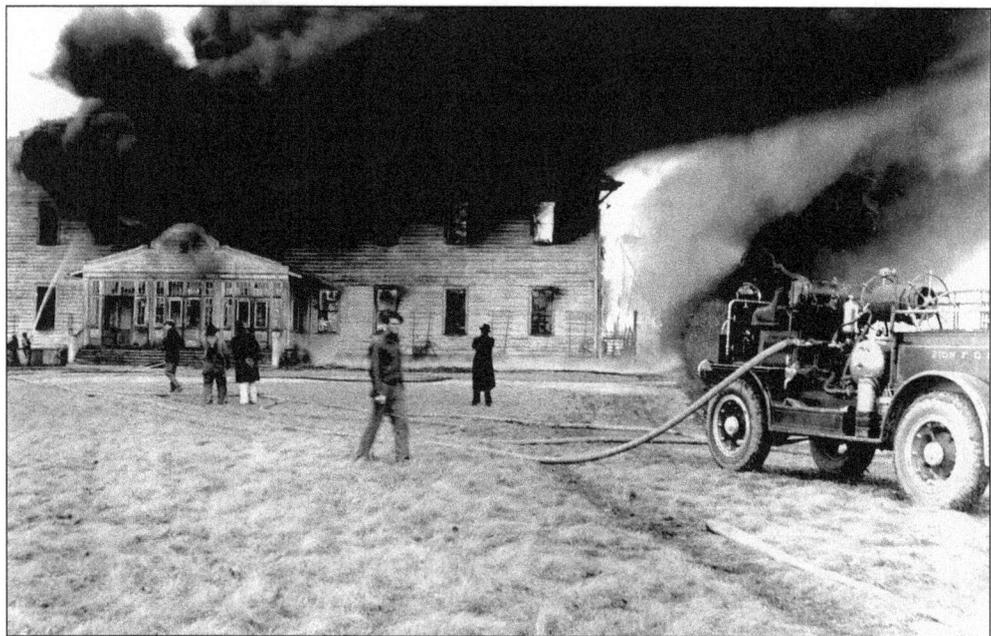

On April 2, 1937, Shiloh Tabernacle, that once seated 7,200, along with the WCBD radio station adjoining it, fell victim to arson. Within 90 minutes, the structure was reduced to a pile of smoldering ash.

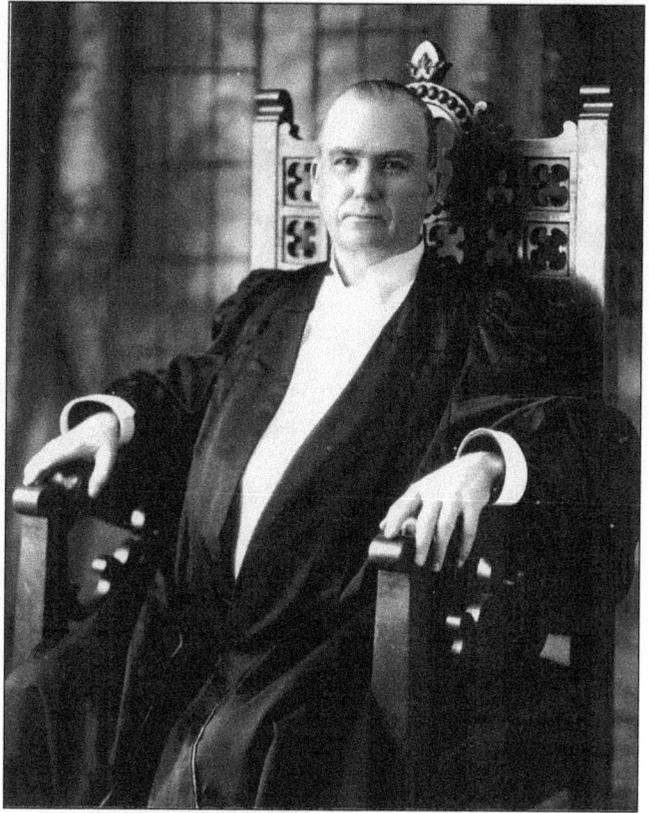

Wilbur Glenn Voliva served as general overseer of the Christian Catholic Church in Zion from 1906 to his death in 1942.

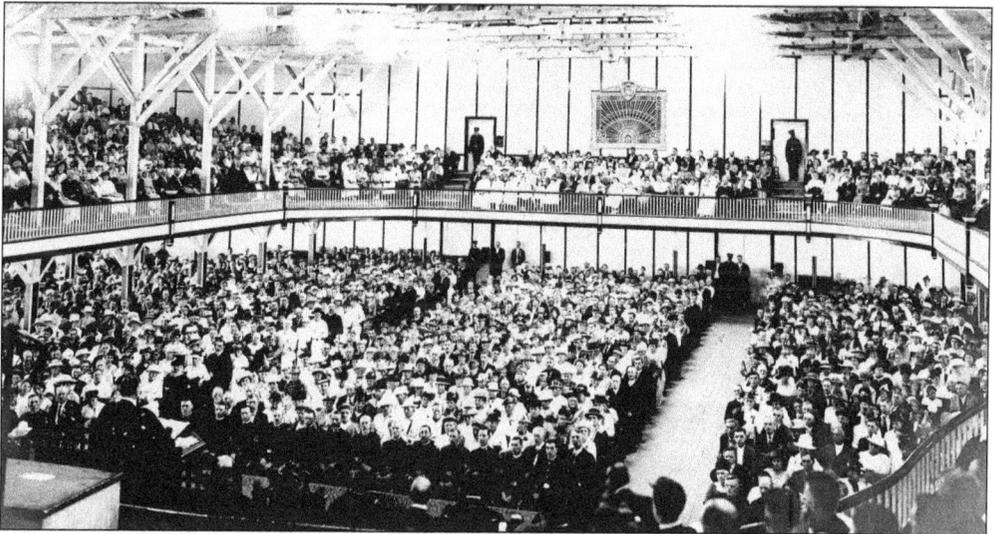

Christian Catholic Church general overseer Wilbur Glenn Voliva (front left) addresses the congregation at a Sunday afternoon service in Shiloh Tabernacle in 1923.

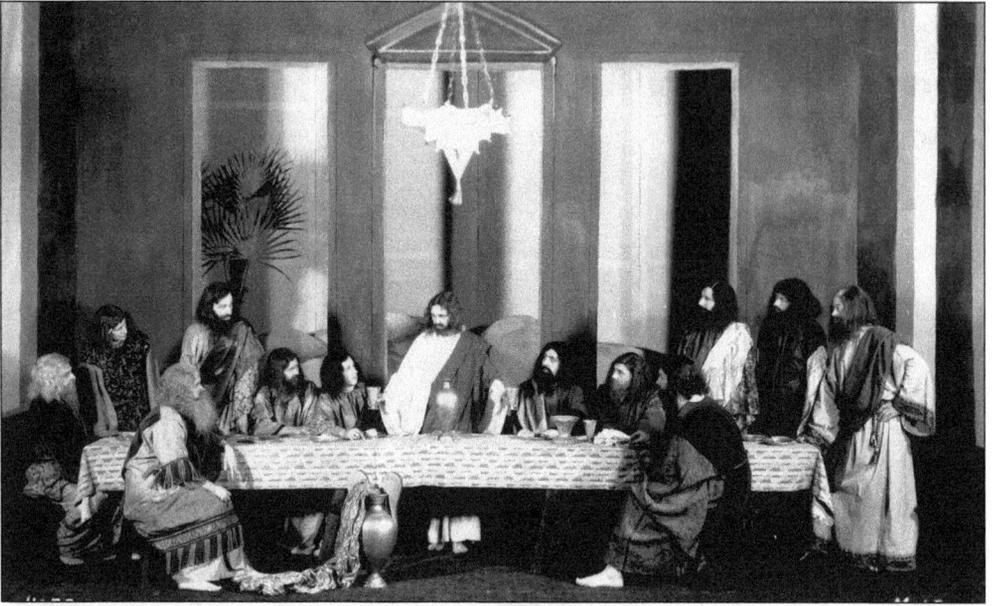

The Last Supper provided subject matter for a scene in the Zion Passion Play. The play was written and directed by Rev. Jabez Taylor and was performed in Shiloh Tabernacle for the first time in 1935. It grew from a three-performance schedule to a 29-performance season. Reverend Taylor traveled to the Holy Land to make sketches, take photographs, and buy artifacts in an effort to make the scenery, costumes, and props as realistic as possible. (Courtesy of Christ Community Church.)

Carl Q. Lee joined the staff of the Christian Catholic Church in 1930, having answered General Overseer Wilbur Voliva's request for young men to join the ministry. He worked in the literature department, at the radio station, and assumed pastoral duties while he finished college. He became active in preaching and church administration. Carl Lee (pictured here in 1943) was appointed general overseer in 1959.

Three

BUILDING A UTOPIA

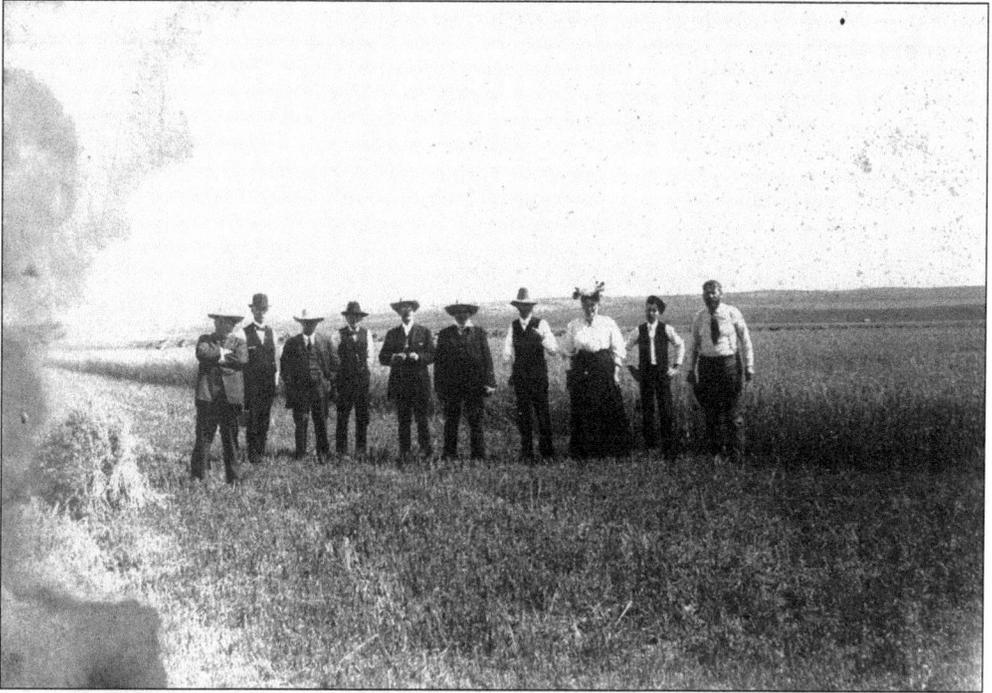

In early June 1899, a group of land scouts, including Dr. John Alexander Dowie, traveled from Chicago to Zion to inspect the land that had been recommended to them for purchase six months prior. They settled on the land that would soon become Zion City, and Dowie's real estate agents began negotiating the purchase of the land.

In 1900, the shore of Lake Michigan in Zion City was sand dunes and open space.

Passengers on a northbound Chicago Northwestern train in 1900 enjoyed a westerly view of undeveloped farmland where the city of Zion stands today.

In 1900, the land upon which Zion City was built was open farmland. Looking west toward the temple site, the Chicago Northwestern Railroad tracks and a lone train car are visible.

The Bennett Farm was located on the far west side of Zion City on Kenosha Road.

Dr. John Alexander Dowie hired Burton J. Ashley as chief engineer and planner. He had served as a county surveyor and gained respect as a drainage specialist in Ohio. He worked on construction of the Chicago Art Institute, the World's Columbian Exposition great pier, and the Merchandise Mart. In 1899, he left a lucrative private practice to join Dowie in the development of Zion City.

In 1900–1901, architects work steadily planning the City of Zion. Questionnaires were sent to various boards of public works, gathering concepts on specifications for streets, alleys, lot sizes, sewer and water mains, landscaping, and sidewalks. All aspects of the city's development were considered as ideas were compiled and applied to paper.

Areas were set aside for parks in Dr. Dowie's city plan. This tract of land on Zion's far north side was vacant in 1900. It was identified as "Beulah Park" on the original plat of Zion City subdivisions.

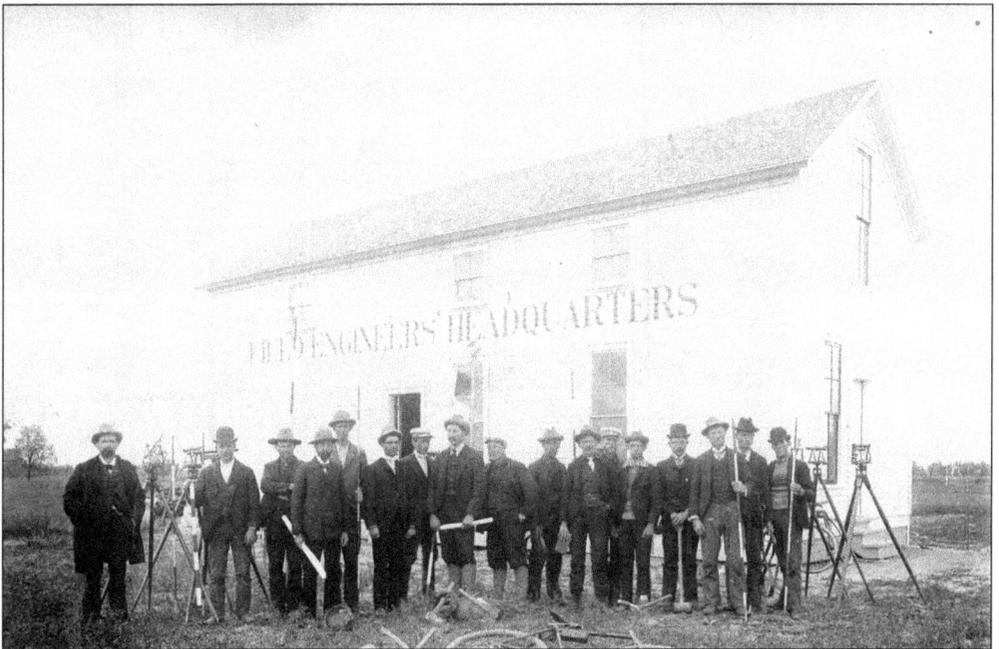

Field engineers take time for a photograph in 1900. They accepted the challenge of drawing up the plan and surveying for the development of 6,500 acres, approximately 10 square miles and some 800 blocks. They laid out the city streets, all of which would receive the name of a biblical person or place.

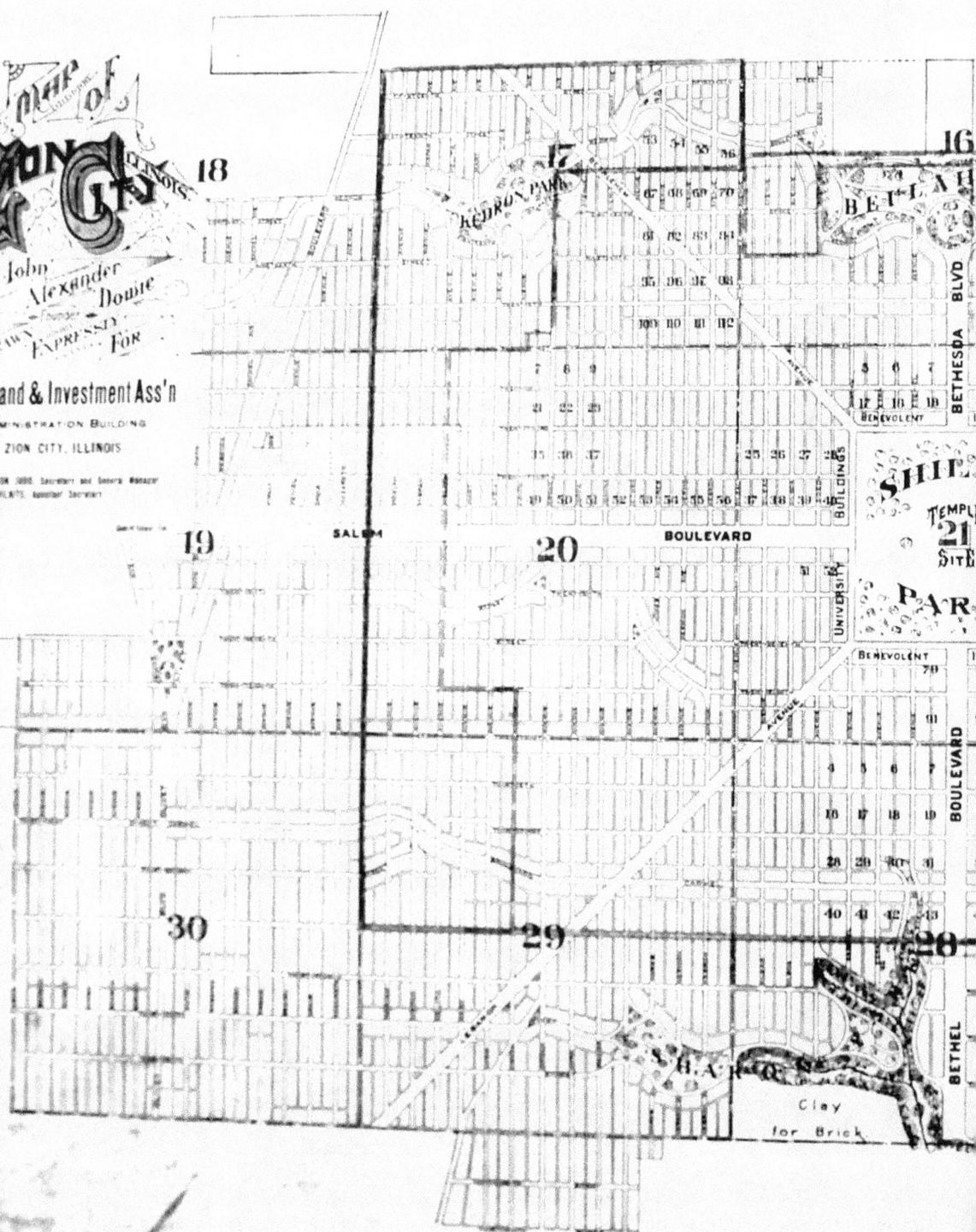

18

17

16

KEDRON PARK

BETHESDA BLVD

BEULAH

BENEVOLENT

19

SALEM

20

BOULEVARD

SHILOH
TEMPLE
SITE
21
PARK

UNIVERSITY

BENEVOLENT

BUILDINGS

BOULEVARD

30

29

28

SHARON

BETHEL

Clay
for Brick

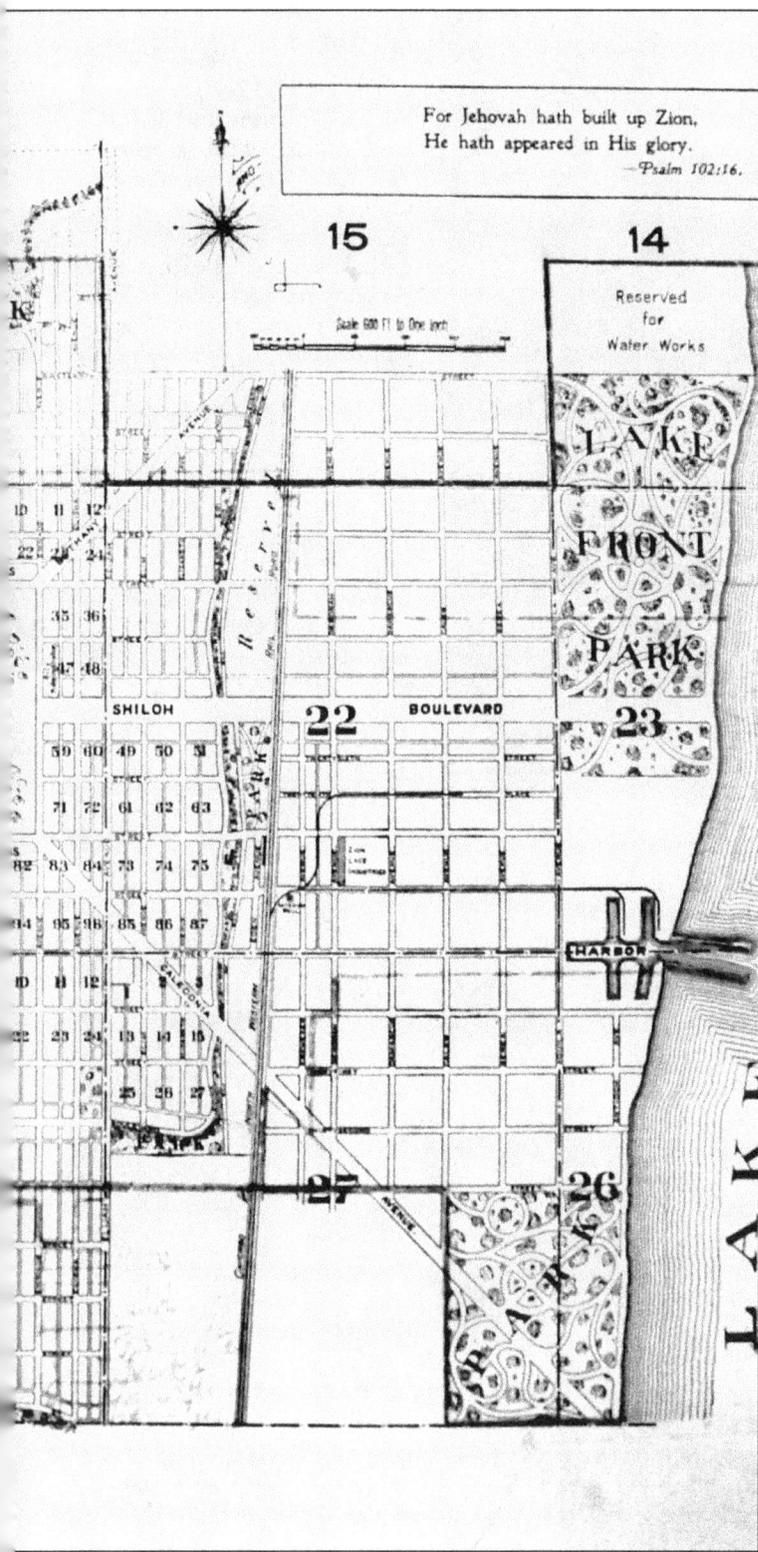

For Jehovah hath built up Zion,
He hath appeared in His glory.
—*Psalm 102:16.*

One of the earliest maps of Zion City reveals Dr. John Alexander Dowie's land plan. Shiloh Park and the temple site occupied the center square of 200 acres and four boulevards radiated north, south, east and west from the park. Broad diagonals joined the park at the corners. In following the design of the British flag, this skeletal plan would be in-filled with avenues running north and south. East and west streets were numbered. Dowie chose the name of each avenue from someone or something in the Bible. They were assigned in alphabetical order from east to west. Only two streets were non-biblically named. Caledonia Avenue, one of the diagonal streets, is the Roman word for Scotland, Dowie's homeland. Edina Boulevard is an old Roman abbreviation for the city of Edinburgh, Dowie's birthplace.

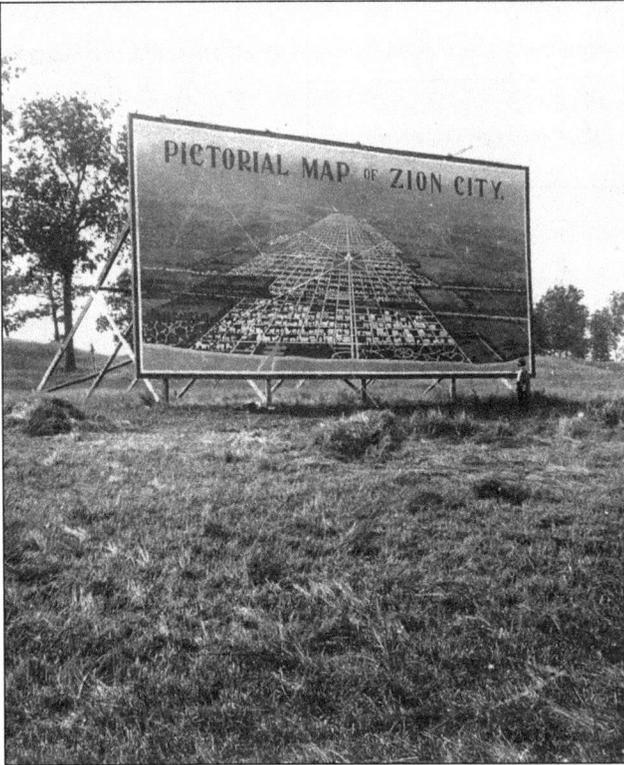

At the Watchnight Service in Chicago on New Year's Eve, December 31, 1899, Dr. John Alexander Dowie unveiled a large drawing of the proposed Zion City. This pictorial map of Zion City was erected at the Zion railroad station. Much enthusiasm developed and huge interest was generated due to the rendering of Dowie's planned city.

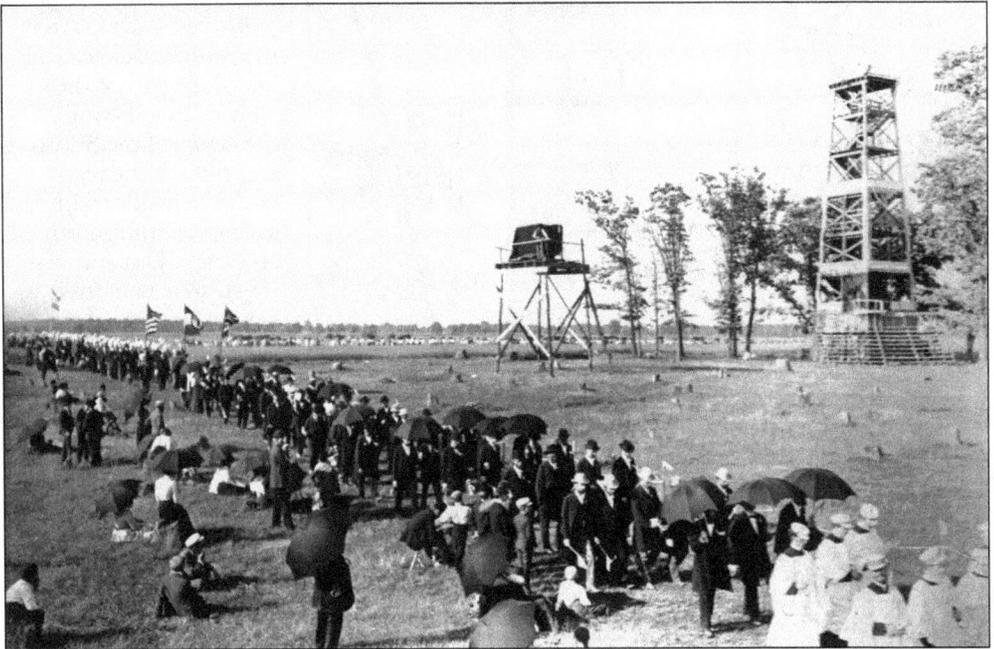

On July 14, 1900, hundreds of people traveled north from Chicago for the dedication of the grounds on which Shiloh Tabernacle would be built. The platform (center) was built to support a huge camera used by George Lawrence who took magnificent panoramic photographs. The land survey tower is on the right.

George H. Lawrence was a world famous commercial photographer of northern Illinois who took promotional photographs of Zion and Chicago Tabernacle. In 1900, Lawrence built the world's largest camera. The camera weighed 1,400 pounds and used a 4.5-by-8-foot glass-plate negative. It took a 15-man crew to operate it. Even though he had years of experience in building kites and balloons for aerial panoramic photography, he often used a 75-foot tower in Zion for his local panoramic and promotional shots. In 1901, Lawrence used the camera for what was termed the "largest half-tone in the world," a 24-by-96-inch picture of Dowie consecrating land in Zion (shown on page 46). Seen below, Lawrence (right) is perched on the camera support, assisting in setting up his famous camera.

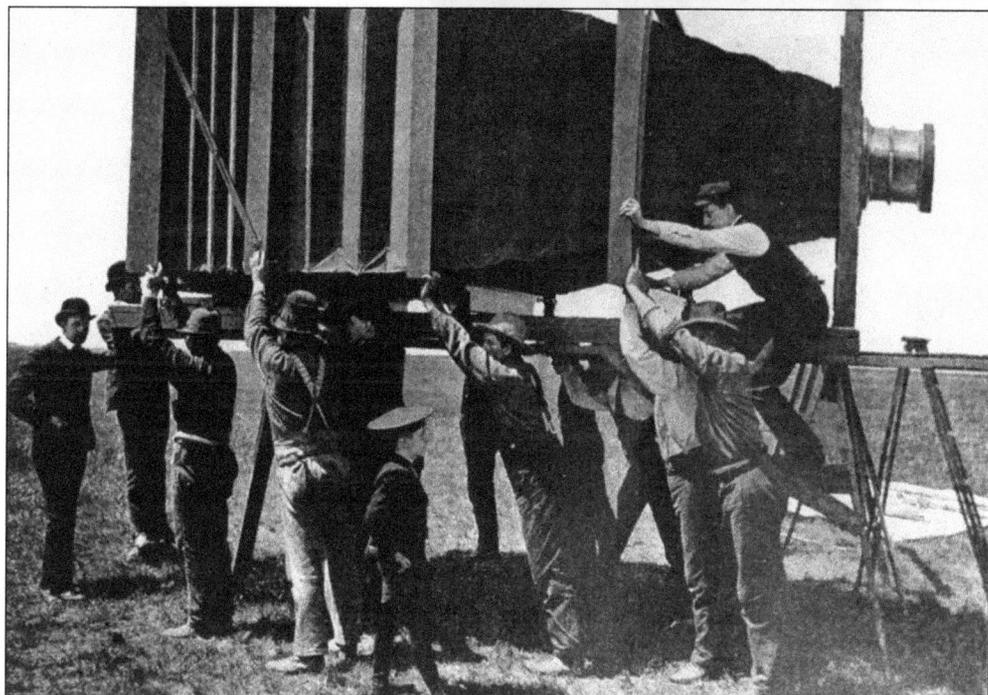

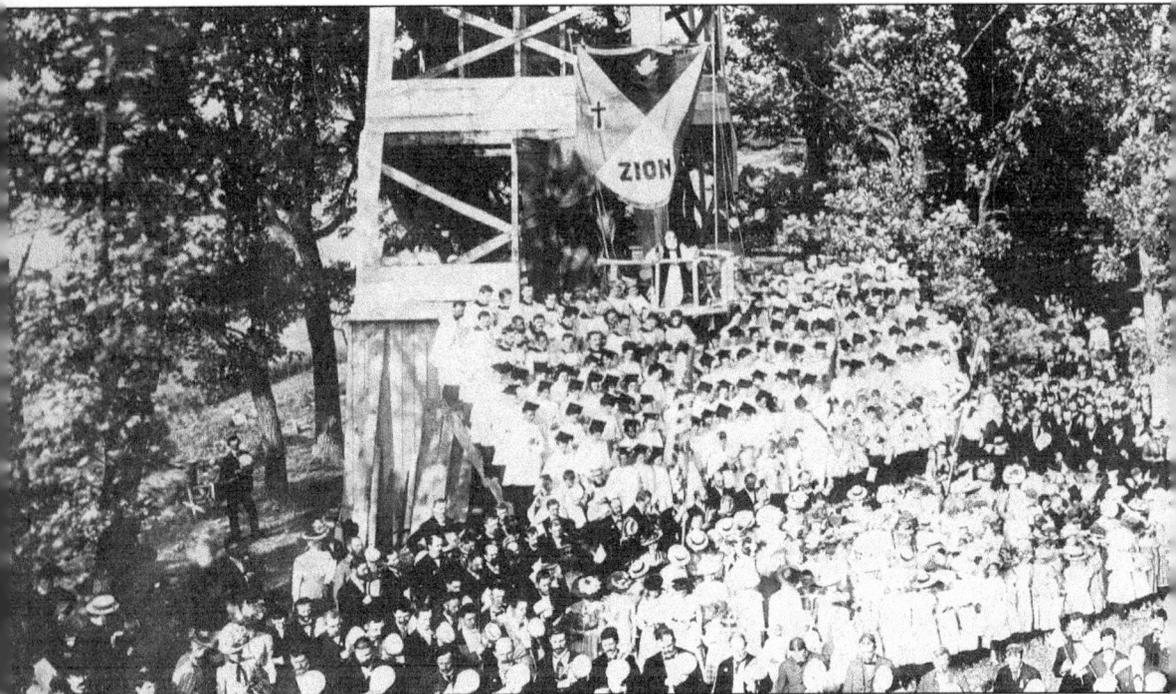

On July 14, 1900, 11 trains brought nearly 10,000 people from Chicago to witness the consecration of the temple site. A 75-foot tower was built in the center of the gathering place. A Zion flag of blue, white, and gold with a red cross on a shield in the center was displayed at each corner. A "Christ is All" banner waved from the top of the tower, along with United States, Great Britain, and Zion City flags. At midday, a bugle sounded and everyone gathered for prayers and

hymns, and Dr. John Alexander Dowie described how wonderful it would be to live in Zion City. (The original photograph, taken by George R. Lawrence, measures 24 inches by 96 inches. This halftone was printed by Zion Printing Company in Chicago in two sections as no press was available large enough to print it in one piece.)

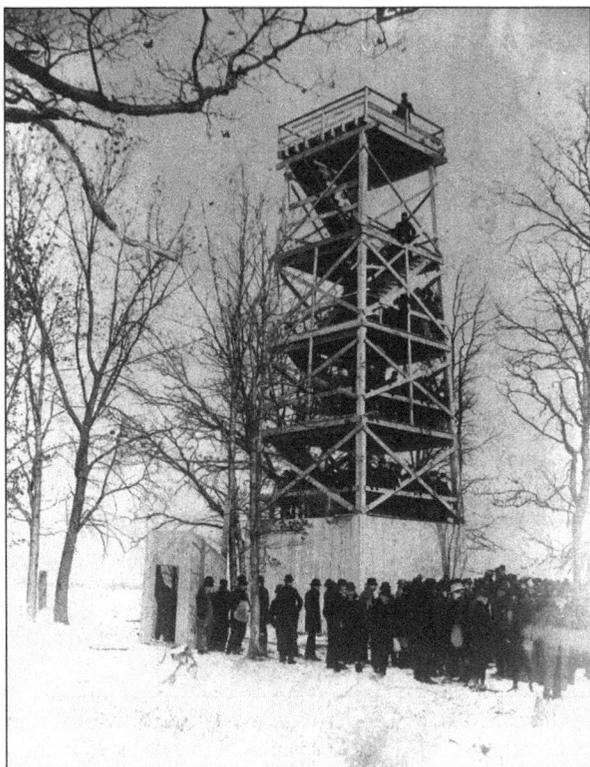

Two 75-foot land survey towers were built for the convenience of prospective land buyers. They could climb the towers and survey the land for miles around. One tower was built at Twenty-fifth Street and Edina Boulevard and the other near the center of the area known as the temple site.

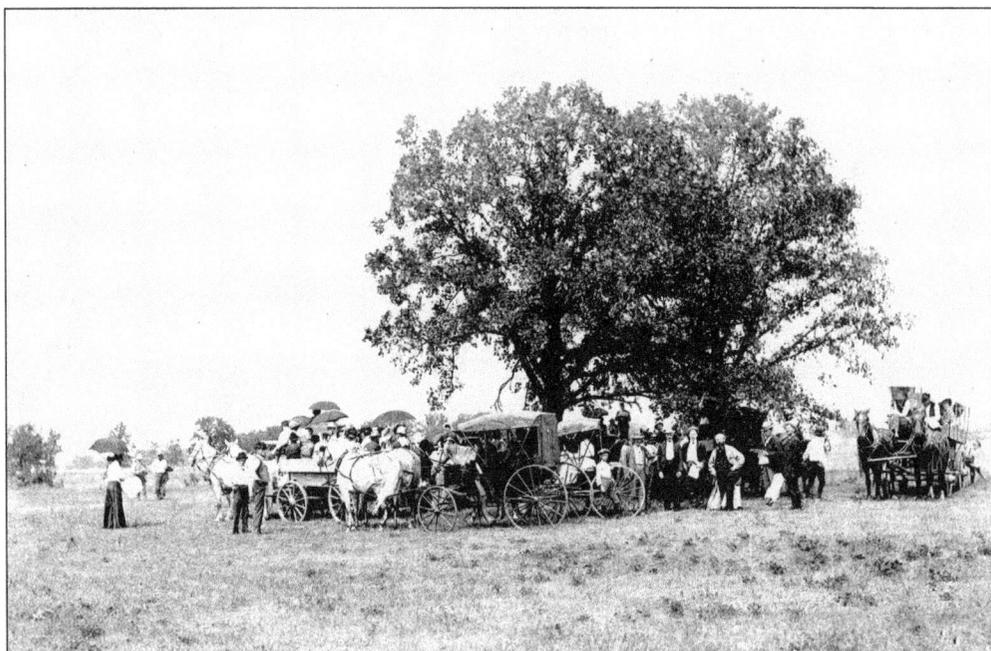

City lots were made available for public sale in 1901. Some 6,000 lots were opened for purchase. After surveying the land from one of two 75-foot towers, the purchasers selected a parcel and then lined up under an oak tree. At the firing of a gun, they dashed off to their chosen spot for the squatter's right.

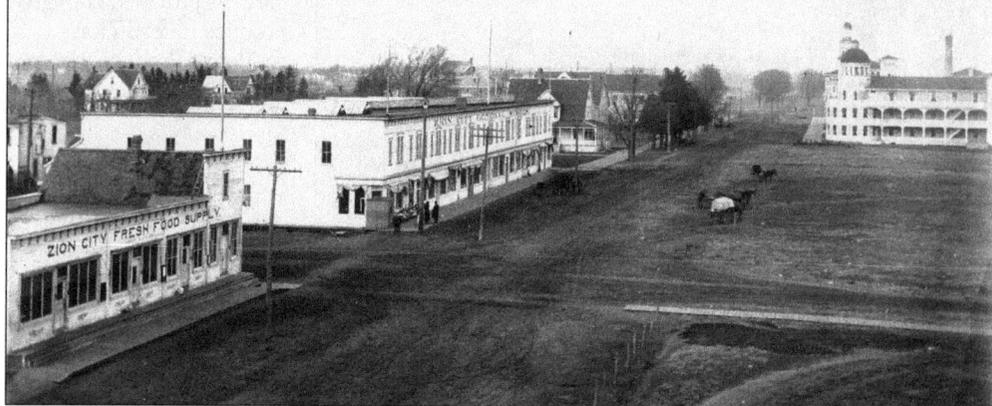

Zion down town 1903

Sheridan Road (Elijah Avenue) was Zion City's major thoroughfare. In this 1903 view of downtown Zion (south to north), Zion City Fresh Food Supply and Zion City General Store stand on the corner of Twenty-seventh Street and Sheridan Road. Elijah Hospice (Zion Hotel) stands on the right. A board sidewalk runs east-west along Twenty-seventh Street.

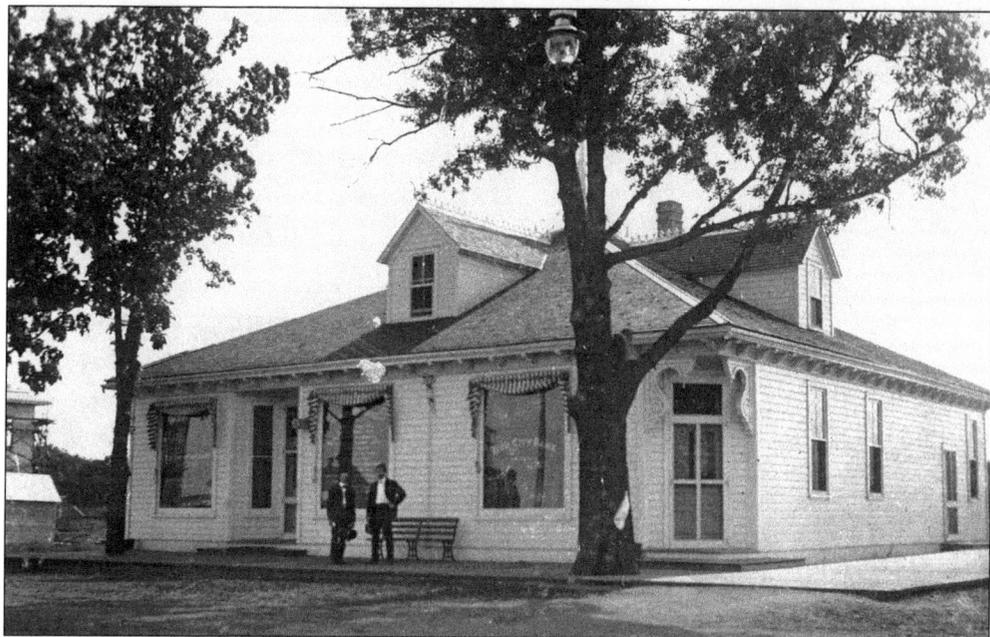

The Zion City Land Office, built in 1901 on the southwest corner of Twenty-fifth Street and Sheridan Road, was one of the first administrative buildings built in Zion. The original plats of city property were finalized in this office establishing the farm, industrial, business and residential sections and boundaries of the city. The building later served as the city bank, post office, and express office. It was eventually moved, intact, to 2900 Elim Avenue.

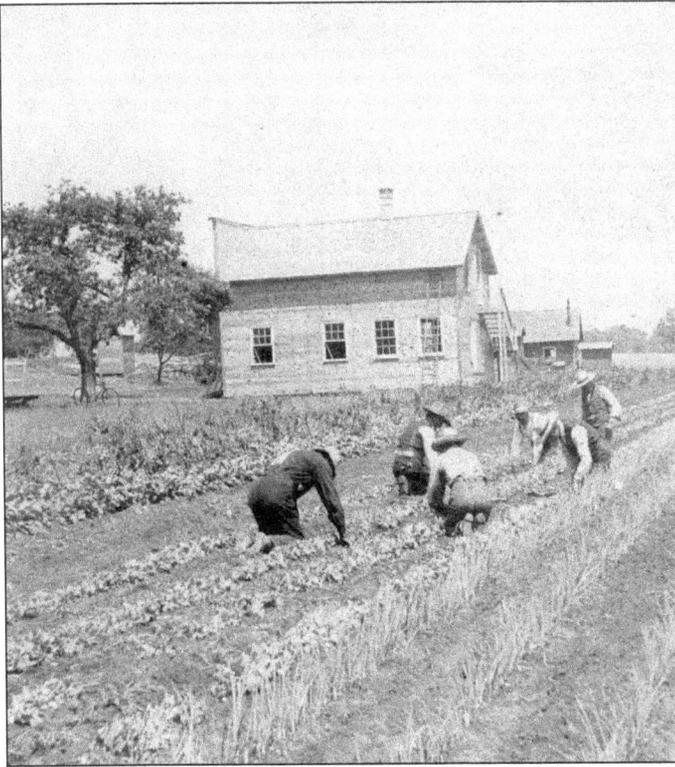

Community agricultural enterprises began in 1901 in Zion City. A variety of vegetables was planted and harvested. By 1903, 180 acres of rich farmland was planted in garden. The gardens provided enough produce to feed Zion residents. Produce was sold through the Zion stores.

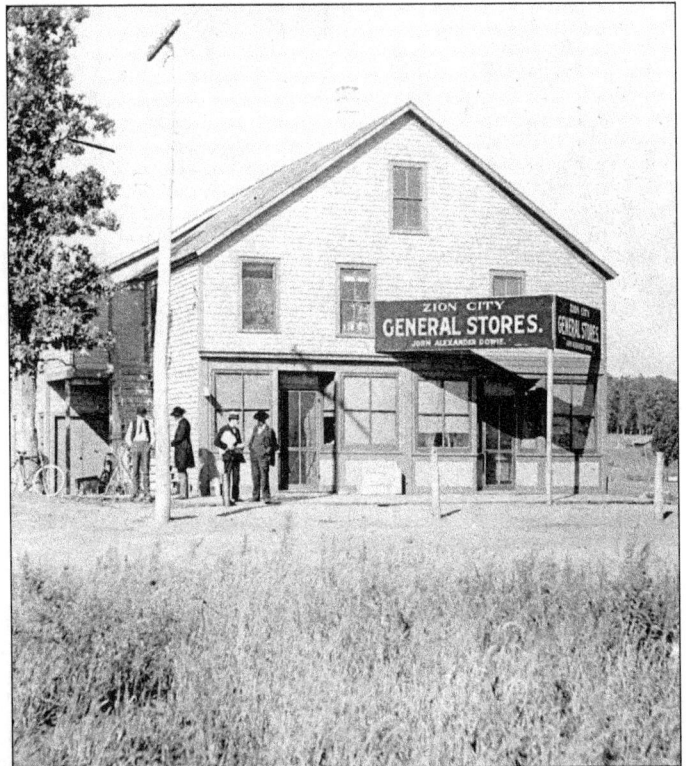

Already established in 1900, Zion's first store was carrying on a thriving business, including mail order, with such items as bicycles and sewing machines being available for customers.

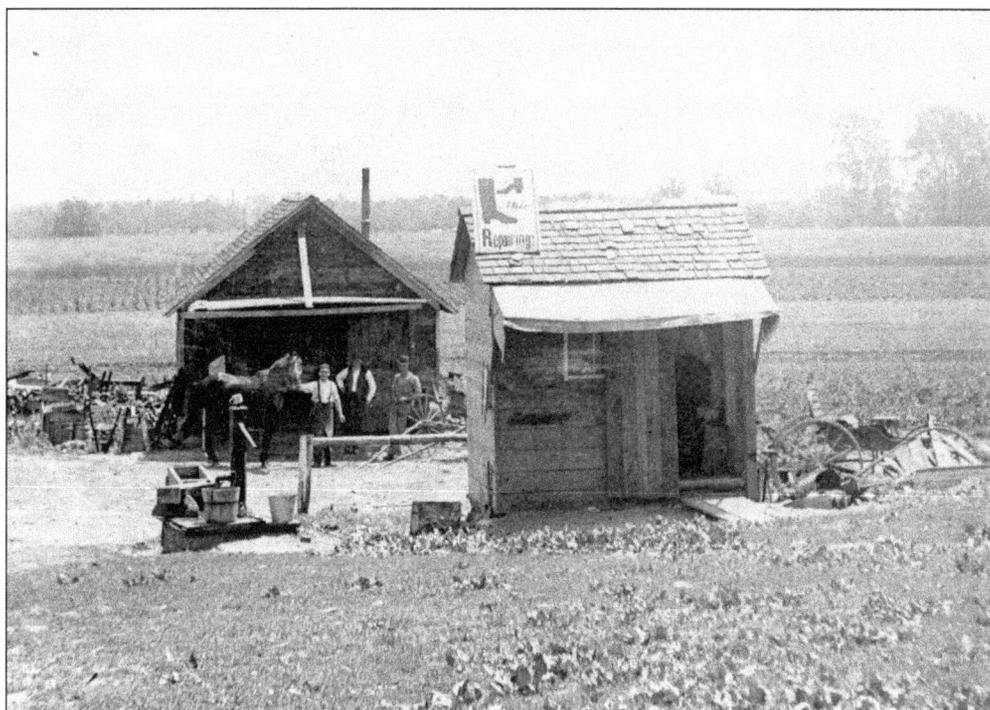

In 1900, a blacksmith shop (left) and a cobbler shop (right) were satisfying the need for well-maintained shoes for residents and horses alike.

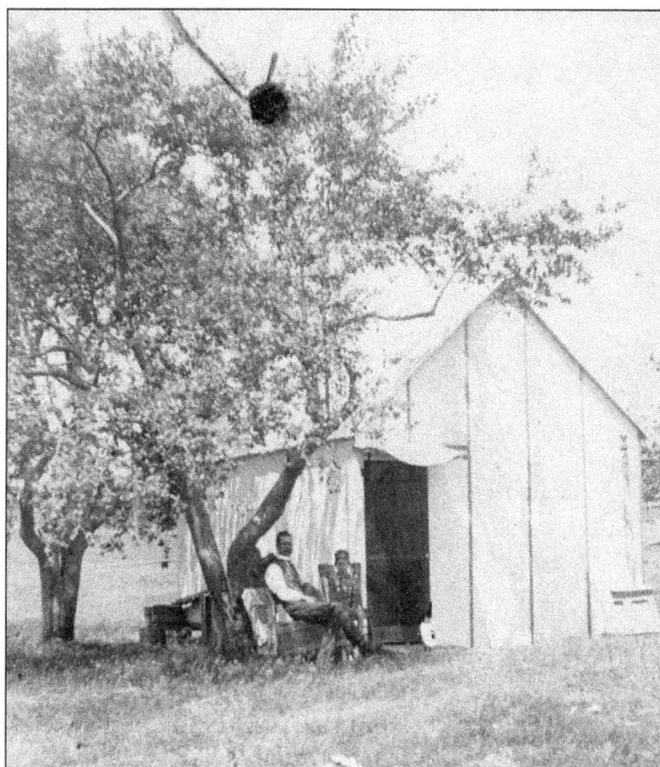

Zion City's first barbershop was established by 1900. A barber pole stood out front (right) identifying this modest structure as a likely place to get a shave and a haircut.

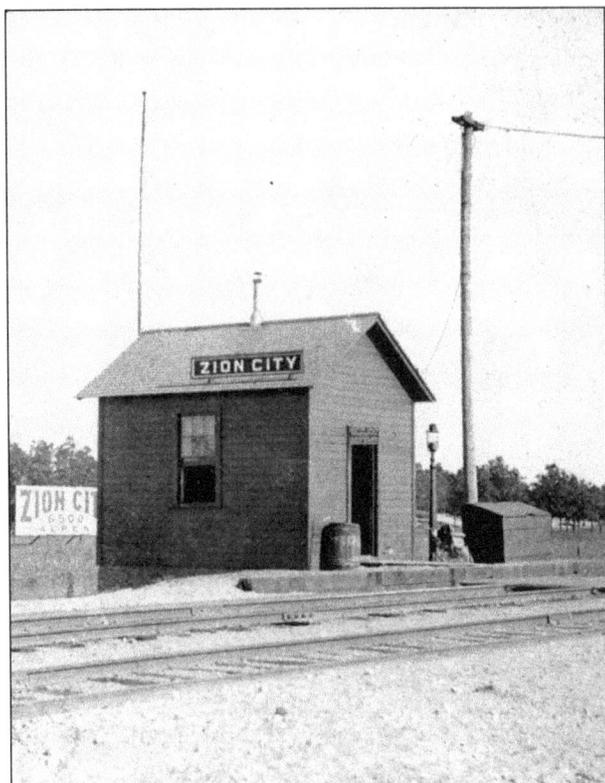

In 1900, a small wooden depot was built on the Chicago Northwestern Railroad. It soon became evident that much larger facilities were needed to accommodate the thousands of people coming to Zion City for Dr. John Alexander Dowie's meetings and to see his growing city firsthand.

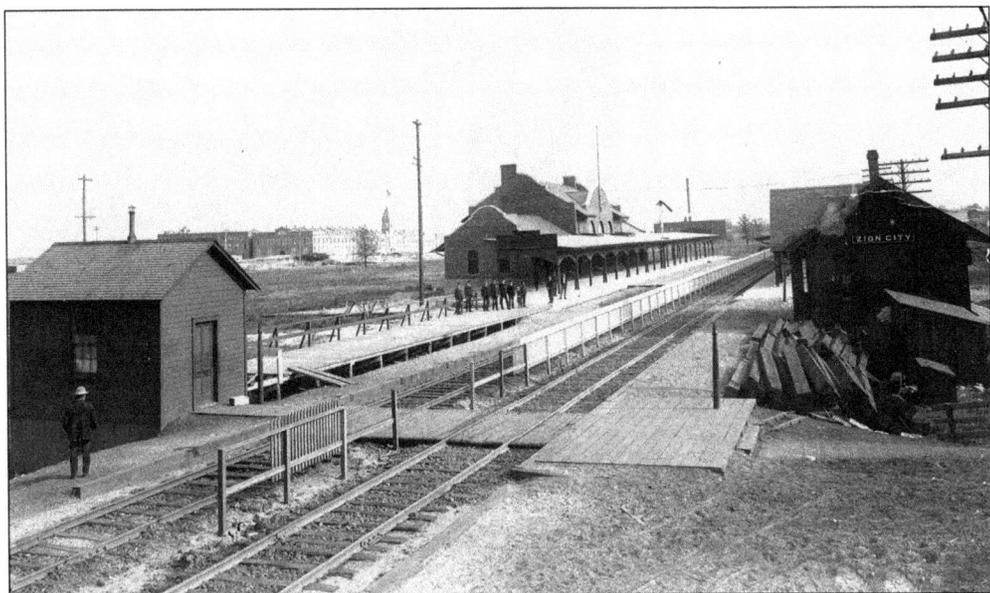

The Chicago Northwestern depot in Zion was built in 1903 at Twenty-fifth Street including a freight depot more than a block long, stretching from Twenty-seventh Street south. The passenger depot featured a large covered waiting area, decorated lounge rooms with two fireplaces, restrooms, and pew-like wooden benches with seating for 200 passengers.

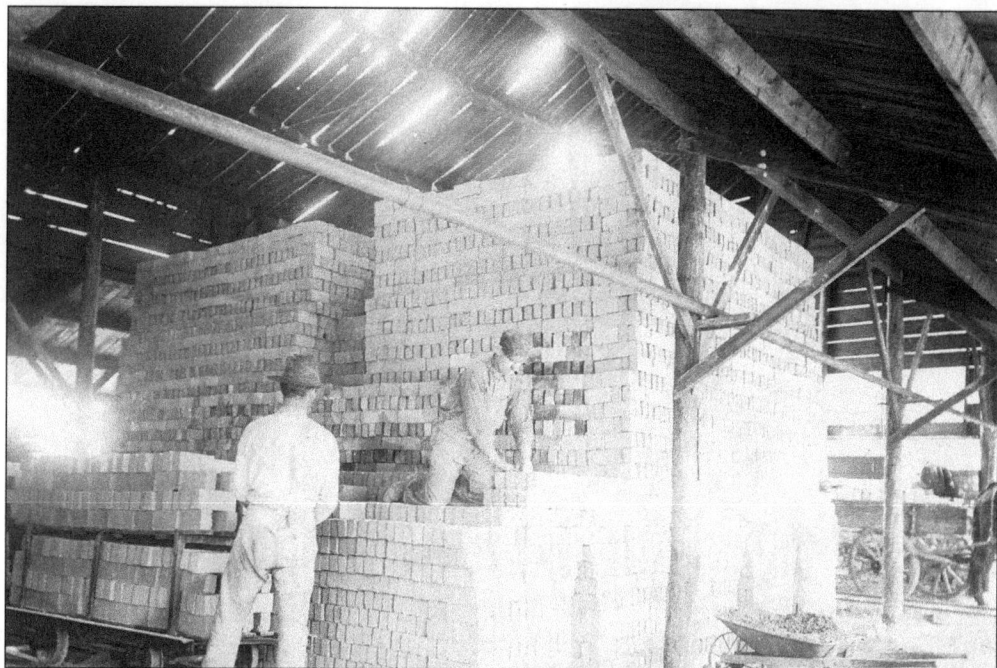

The city engineer designed buildings primarily constructed of brick or masonry. South of the lumberyard, at Thirty-first Street and Edina Boulevard, a brick manufactory was built. These men stack bricks in the drying shed in 1901. It was hoped all of the bricks needed to build Zion City could be made here.

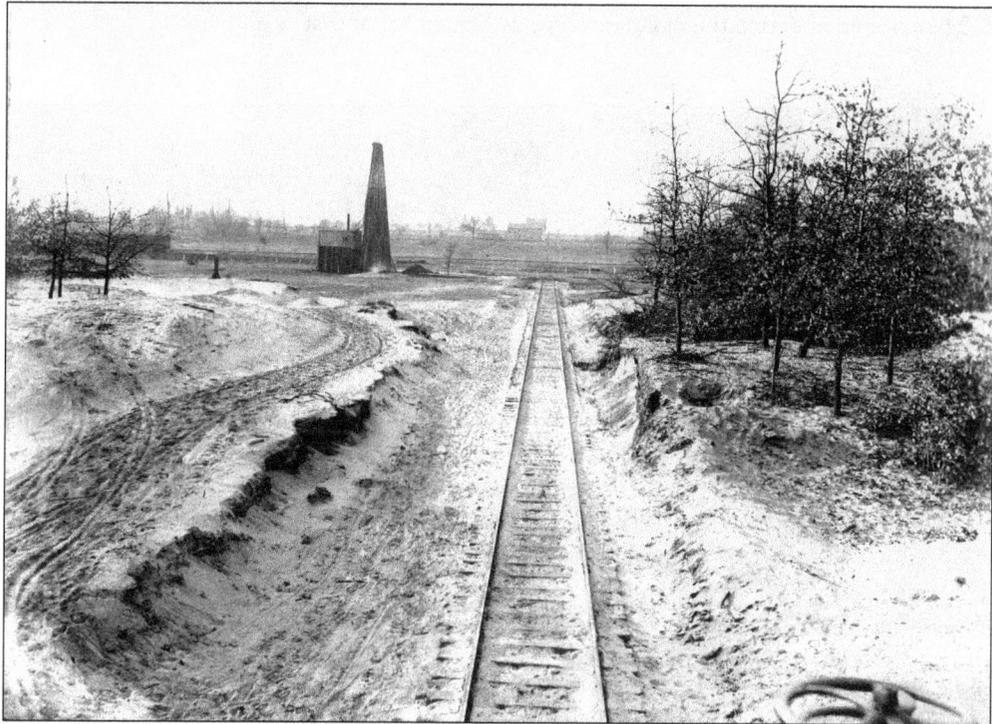

A railroad spur was built to service the brick factory at Thirty-first Street and Edina Boulevard.

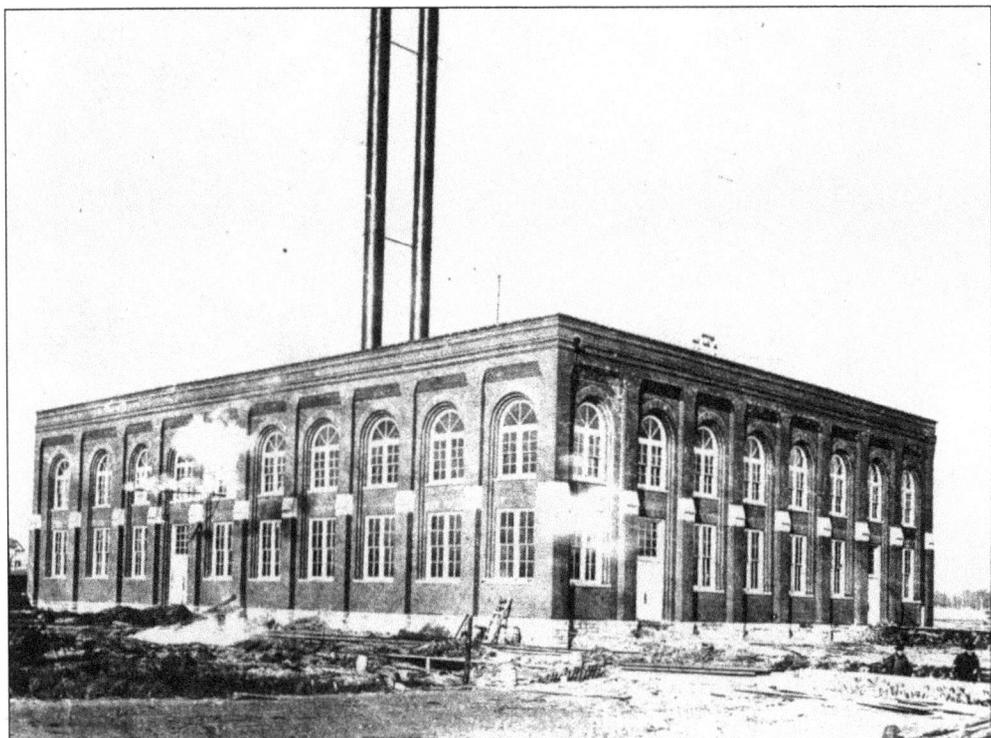

In 1901, Zion City operated its own electric power plant located at Twenty-eighth Street and Deborah Avenue. The plant supplied electricity to the growing industries and the more than 200 buildings that dotted the Zion landscape by September of that year.

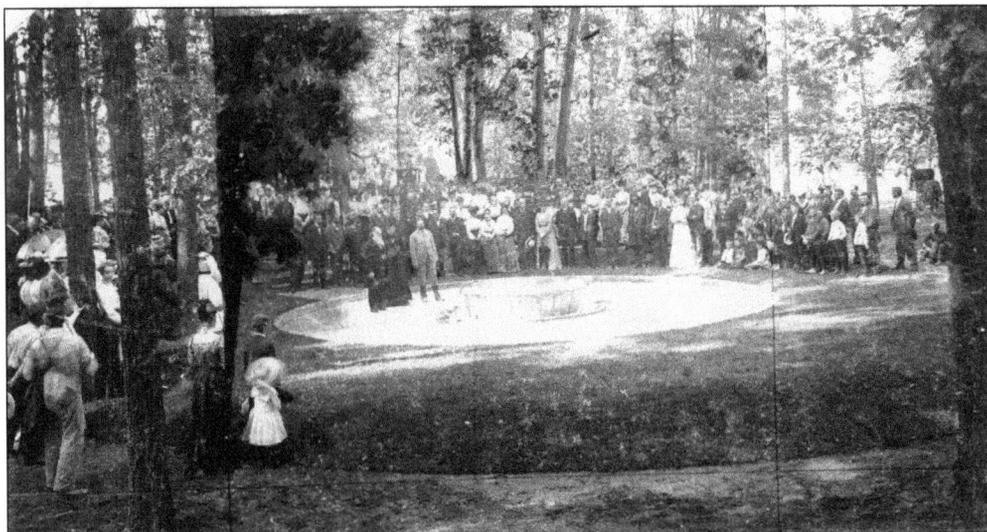

Dr. John Alexander Dowie, his wife Jane, and son Gladstone, along with a host of residents, dedicate a memorial fountain built over an artesian well in memory of his daughter, Esther, in Shiloh Park in 1902. This well was later known as Esther's Well. It is located near Shiloh Boulevard and Dowie Memorial Drive.

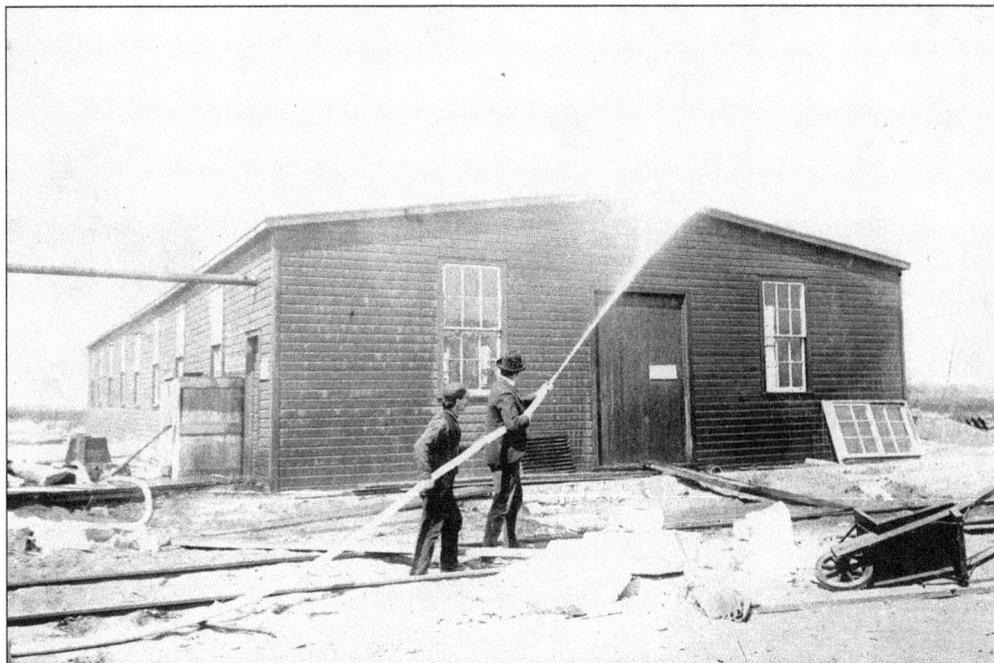

City planners fully expected to see the population of Zion City to expand to 10,000 by the end of 1902. Plans were drawn for a water works system with Lake Michigan serving as the reservoir. In the meantime, some homeowners had private wells and some shared common wells dug in various parts of the city. This early 1900s photograph depicts a waterpower demonstration.

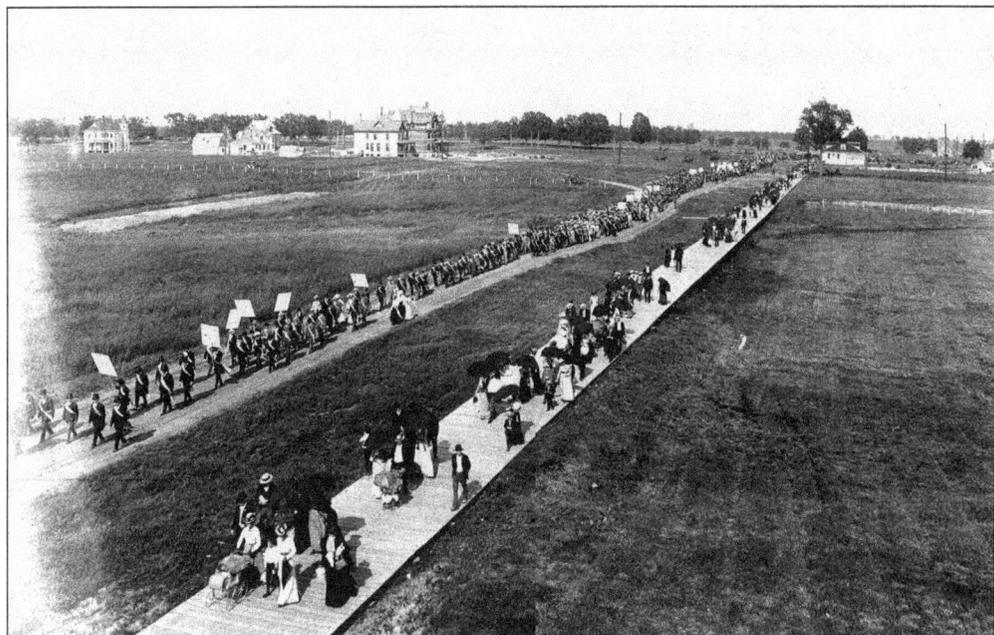

Board sidewalks, 12 feet wide, were built where traffic would be heavy, such as from the railway station at Twenty-fifth Street to the Shiloh Tabernacle (pictured in 1902) and in the Sheridan Road business district. The sashes worn by the pedestrians indicate that this procession took place during the Feast of Tabernacles.

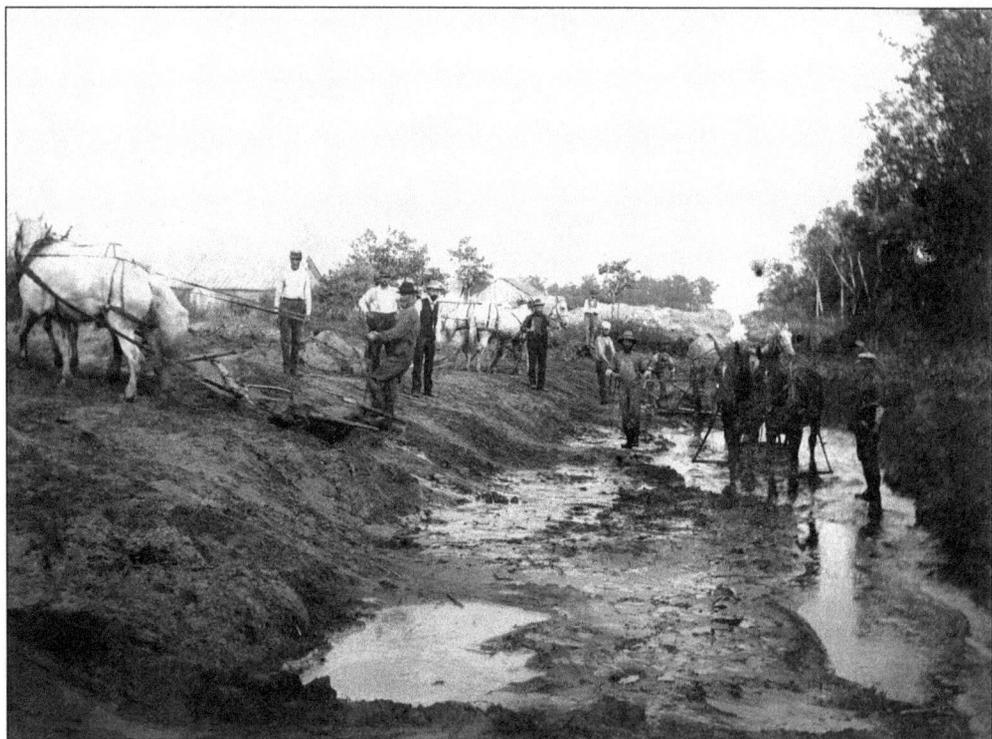

Being engineer Burton Ashley's area of expertise, drainage throughout the city was well considered. The city plan called for a drainage ditch along Twenty-ninth Street. In 1901, teams of horses and men worked in unison to complete the ditch.

The Twenty-ninth Street drainage ditch project required the persistence of many laborers. Sheds were built at the work site to accommodate men, equipment, and horses.

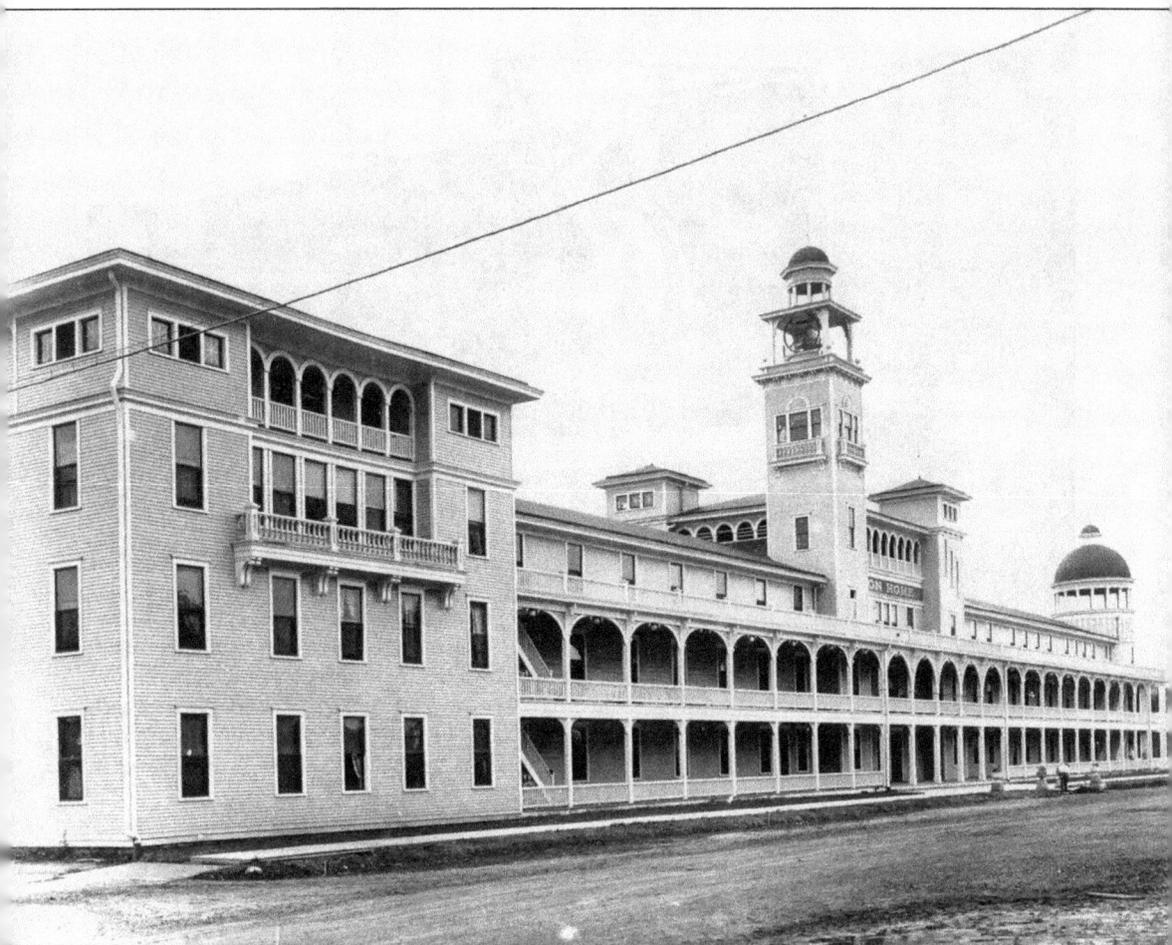

Elijah Hospice (Zion Hotel), a four-story frame hotel, was completed in 1902, in only 10 weeks. It was built on the east side of Sheridan Road between Twenty-sixth Street and Shiloh Boulevard to house workers who came to build the city, prospective residents, and second Feast of Tabernacle visitors. The building was 340 feet long, 130 feet wide and had 350 rooms. Three million feet of lumber were used in its construction. The dining capacity was 1,000 guests. From the bell tower, the bell tolled daily at 9:00 a.m. and 9:00 p.m. as a signal for all to stop and pray. The building served as a residential hotel and then as a nursing home. In 1976, it was listed on the National Register of Historic Places. Maintenance costs and declining profits forced the nursing home management to abandon the building. The Zion Park District purchased it and made plans to preserve it. In 1979, the Division of Historic Sites approved a $70,000 grant, but it was rescinded due to problems with bid procedures in the re-use plans. It was torn down in the fall of 1979.

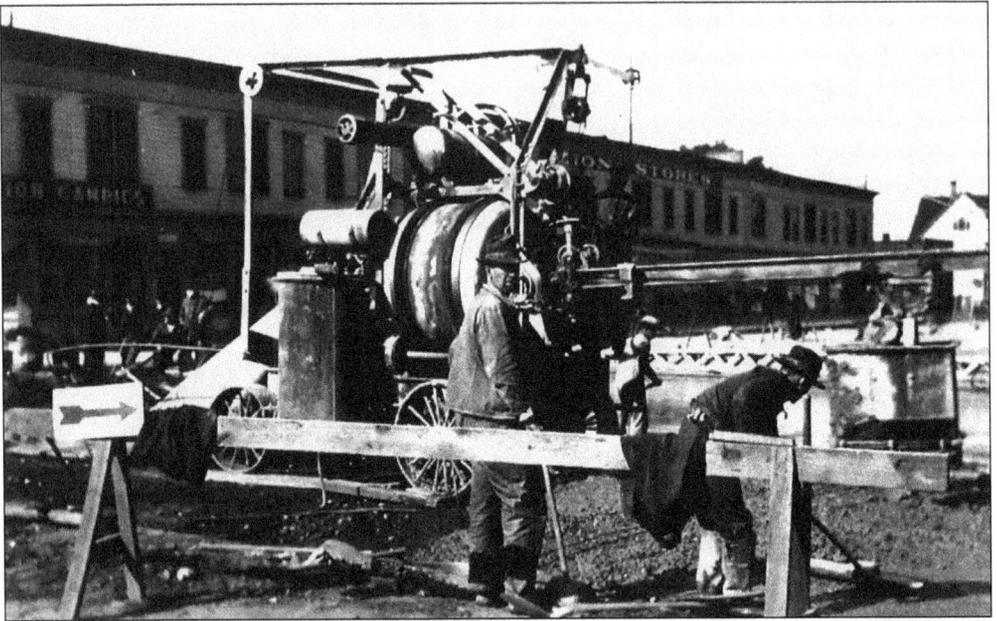

On January 27, 1922, the Zion City Council, under the leadership of Mayor W. Hurd Clendinen, passed an ordinance "providing for the improvement, constructing manholes and catch basins, inlets, drains, curbs, grading, draining, adjusting existing cement walks and paving with reinforced concrete, and otherwise improving the roadway of Elijah Avenue, commonly referred to as Sheridan Road." The road crew is using a skip mixer at the intersection of Twenty-seventh Street and Sheridan Road.

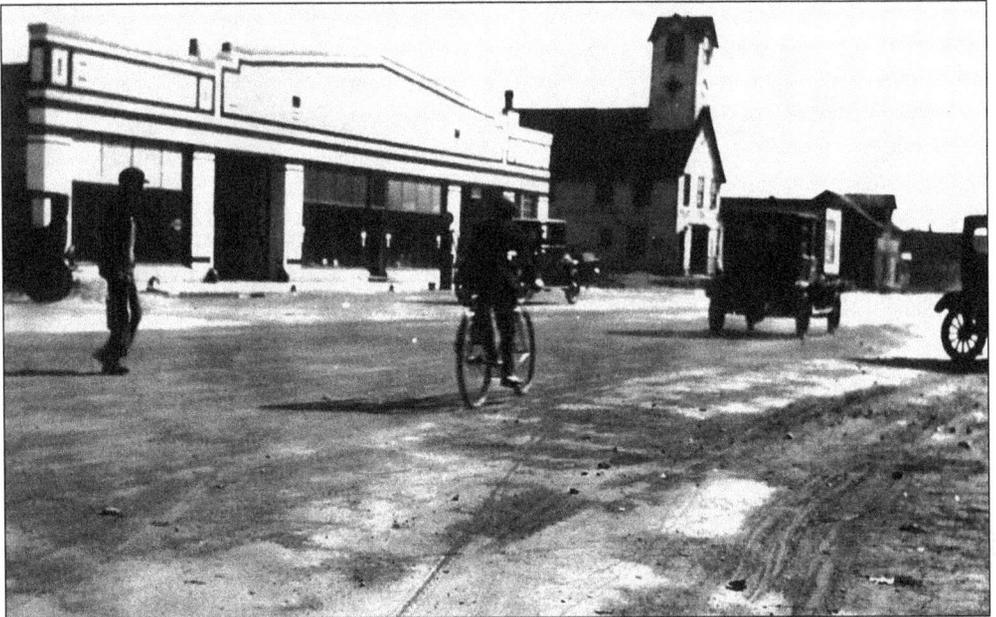

A man rides a bicycle south on Sheridan Road (Elijah Avenue) in the spring of 1922, just prior to paving. The White Front Garage (left) and the original Zion City Fire and Police Station (with the tower) occupy the east side of the road between Twenty-seventh and Twenty-eighth Streets.

Four

A THEOCRATIC GOVERNMENT

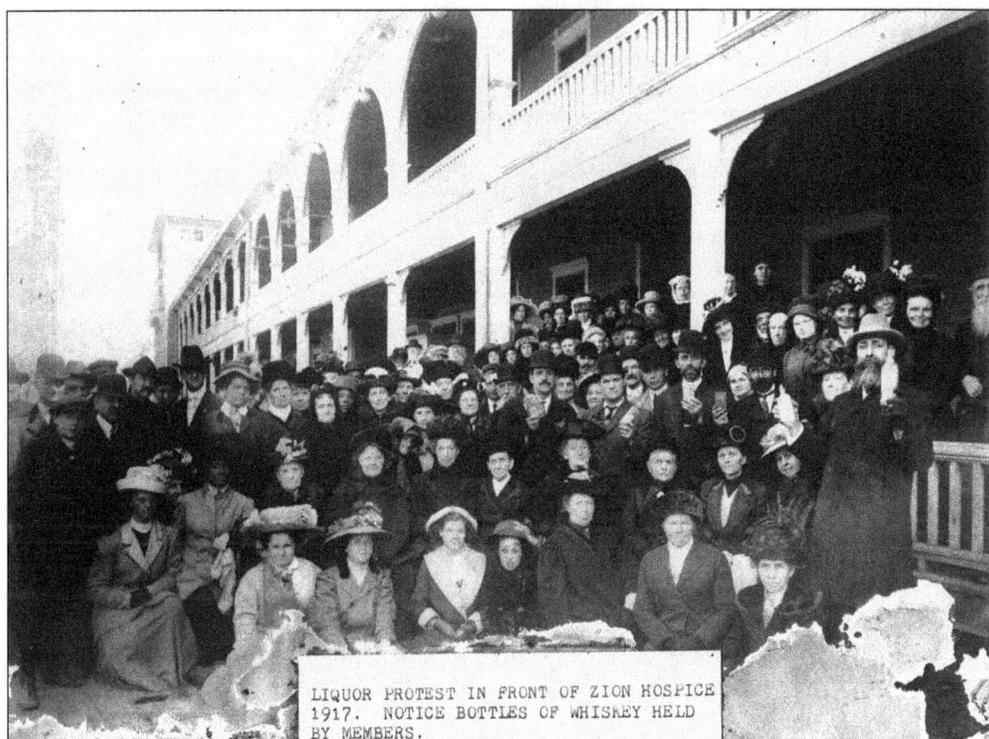

LIQUOR PROTEST IN FRONT OF ZION HOSPICE 1917. NOTICE BOTTLES OF WHISKEY HELD BY MEMBERS.

The Zion City theocracy's mission was to reform society. The use of alcohol in any form was strictly prohibited. A liquor protest was held in front of Elijah Hospice (Zion Hotel) in 1917. Protesters in this photograph held whiskey bottles. Liquor had no place in a city of clean living.

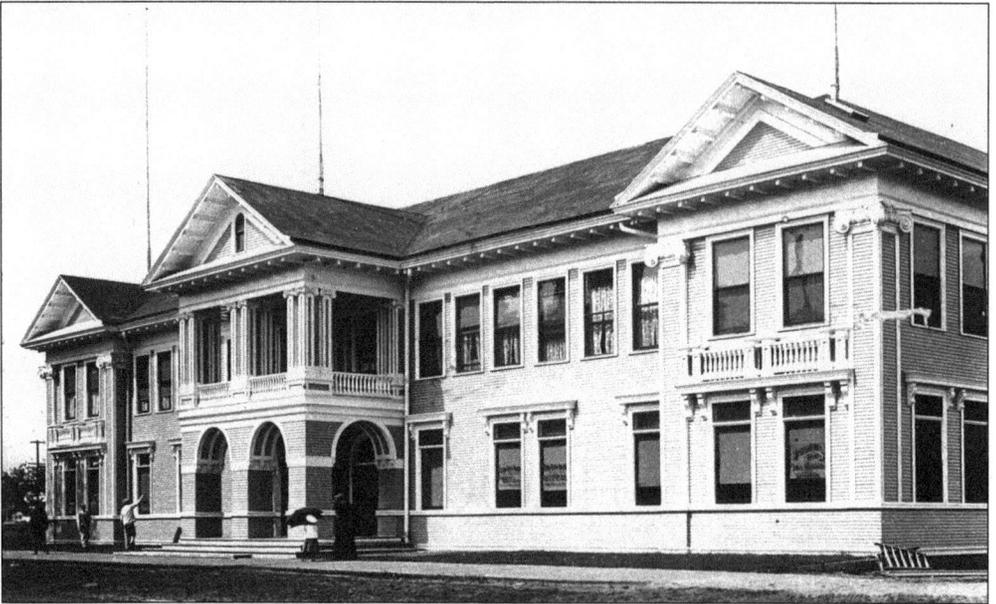

The administration building, built in 1902, was located on the west side of Sheridan Road between Twenty-sixth Street and Shiloh Boulevard. The general manager and his staff, a bank and a real estate office, occupied the first floor. The second floor housed General Overseer John Alexander Dowie's suite and offices for the church officers, lawyers, and the city architect. All Zion Industries bookkeeping was done here. Church membership and tithe records were kept here. The post office used the north wing in later years. The building was torn down in 1962.

The general offices of the Christian Catholic Apostolic Church, including Dowie's personal library, were located in the administration building.

Dowie's office was located on the second floor of the administration building in the 2600 block of Sheridan Road. Dowie accessed his safe through his outer office.

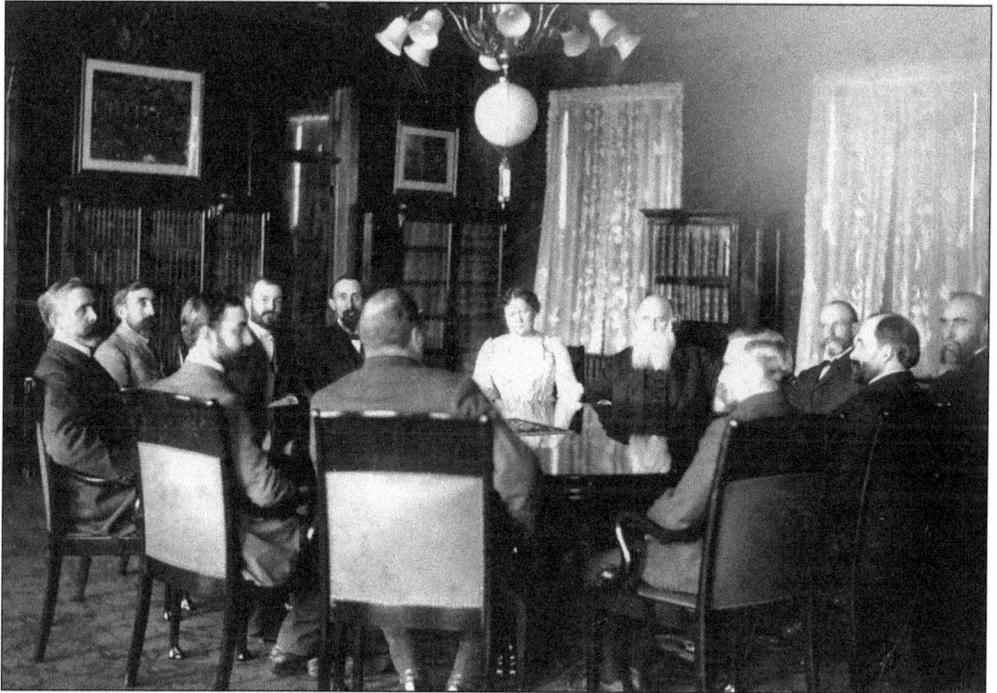

Dowie and his wife, Jane, join in a meeting of his top-ranking city and church officials. John is seated to the right of Jane.

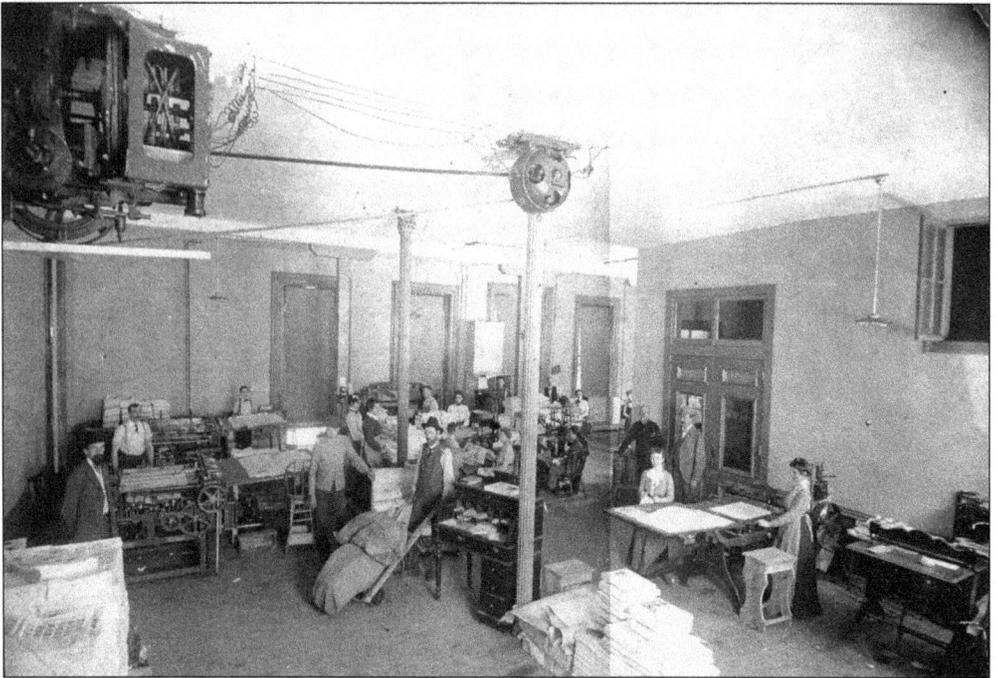

Much literature was sent from Zion to all parts of the world including the *Zion Banner, Leaves of Healing,* the *Theocrat,* and many individual tracts. All were printed at the Zion Publishing House by a large crew of skilled pressmen.

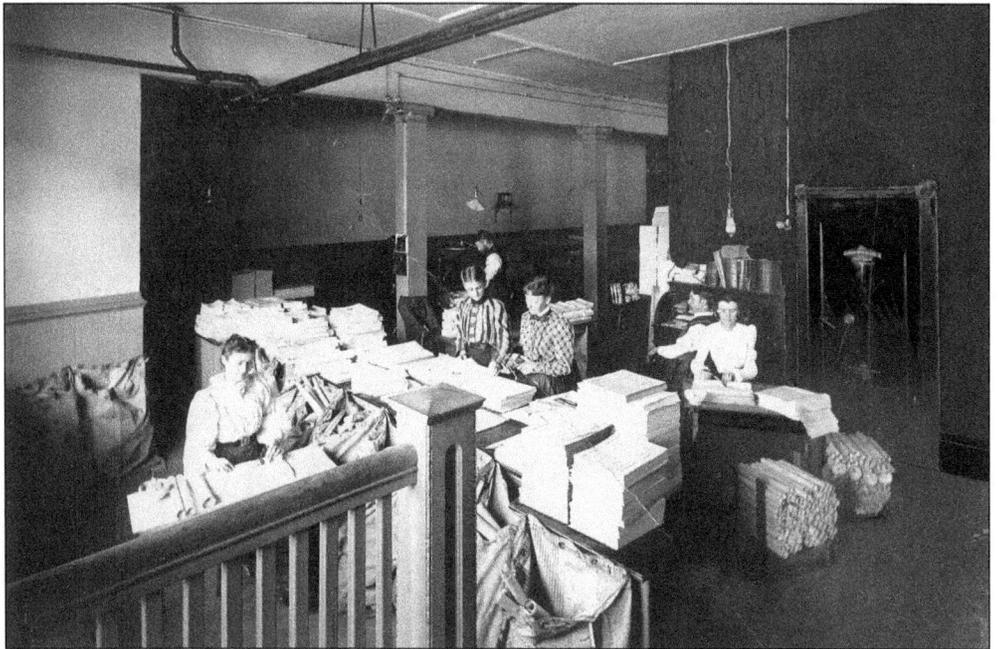

In the literature mailing room, located in the administration building, pamphlets, *Leaves of Healing* and other periodicals, literature, and small tracts were mailed to all parts of the world promoting the theocracy, a life of clean living, and Dr. John Alexander Dowie's healing ministry.

This original "Zion City" seal was adopted at the first city council meeting held on May 6, 1902. In 1987, after coaxing by the local chapter of the American Atheists, a lawsuit was filed demanding that the city discontinue use of the seal due to its unconstitutional endorsement of Christianity. The case progressed through the local courts and a series of appeals, and in 1992, the city was forced to adopt a new city seal.

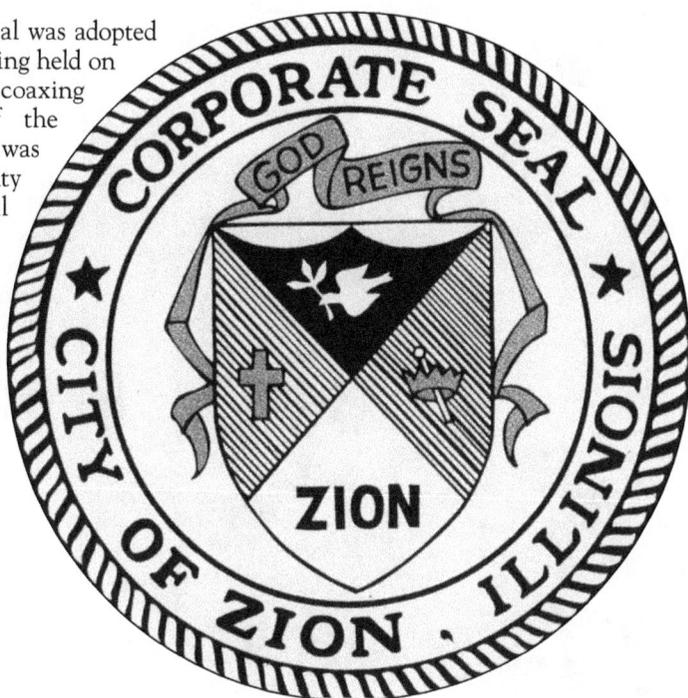

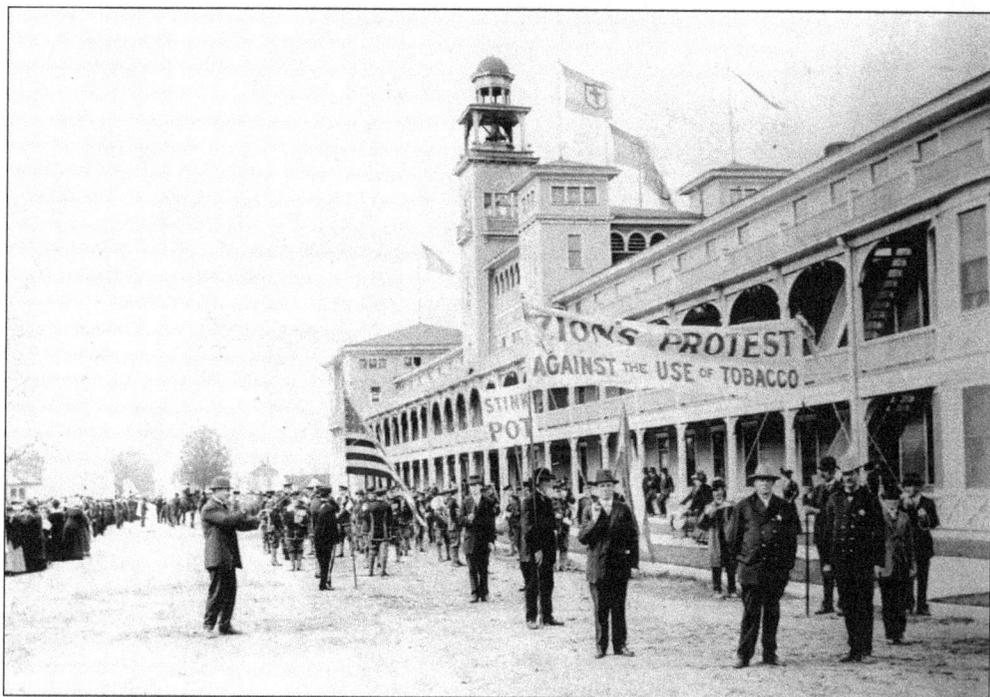

Zion was a city of blue laws. In 1902, laws were passed prohibiting drunkenness, profanity, spitting, gambling, and smoking. Violation of the no-smoking ordinance was the most common basis for arrest. Protests, like this one against the use of tobacco, were common.

In March 1899, Zion City Bank was launched in Chicago. The financial institution, as well as others, had to be established to serve those as they prepared for their new life in Dr. John Alexander Dowie's utopia. The Zion Bank in Zion City, pictured here in 1902, occupied the northeast corner of the administration building on the west side of Sheridan Road between Twenty-fifth and Twenty-sixth Streets.

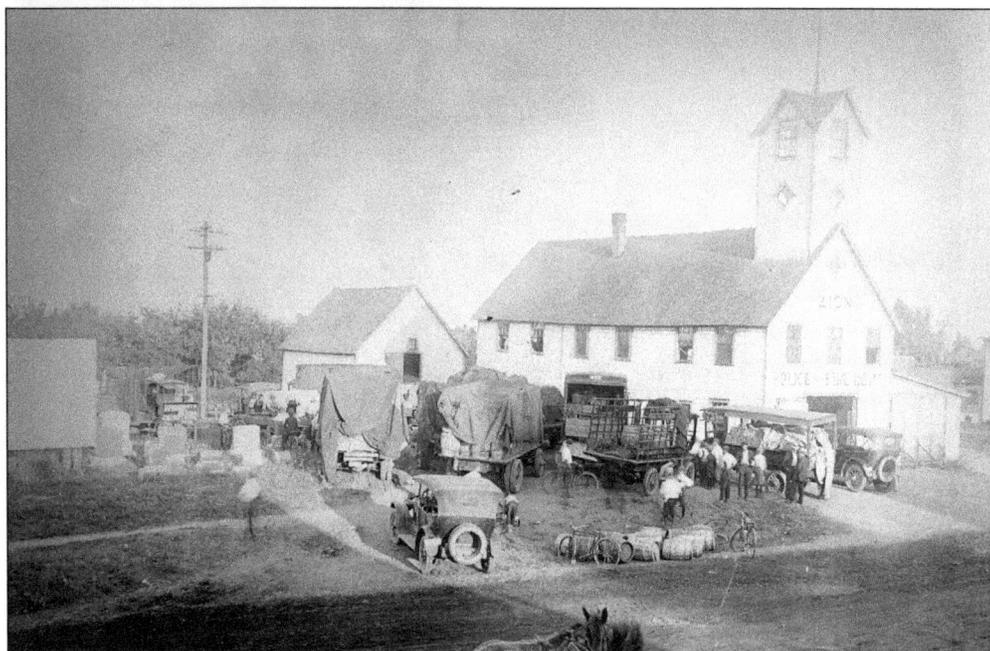

The first Zion City Fire and Police Departments were located on the east side of Sheridan Road between Twenty-seventh and Twenty-eighth Streets. The tower was used for draining hoses and as a fire watchtower. The structure housed two fire wagons equipped with ladders and water drum. City hall was located on the upper floor and a section in the rear served as the jail.

In 1918, Police Chief T. R. Becker (seated at the desk) met with a group of Independents at the Zion Police and Fire Station at Twenty-eighth Street and Sheridan Road. Anyone who rejected the Theocratic Party, under the leadership of Wilbur Glenn Voliva, was considered an Independent. The Independents still believed in the ideals and rules of the city but felt the days of a Theocracy were over.

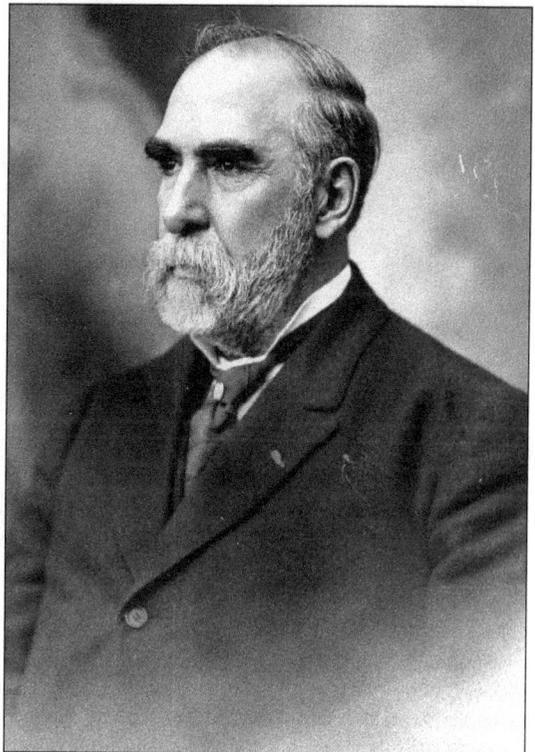

Judge Visscher V. Barnes came to Zion in 1902. He was an honor graduate of Yale University Law School and practiced and taught law in Chicago. He was appointed to the post of solicitor general in Zion upon his arrival. He was later named city attorney and then Judge of Zion's court of arbitration. Barnes was a staunch supporter of the theocracy, and it was his desire to be an integral part of building a utopia in Zion City.

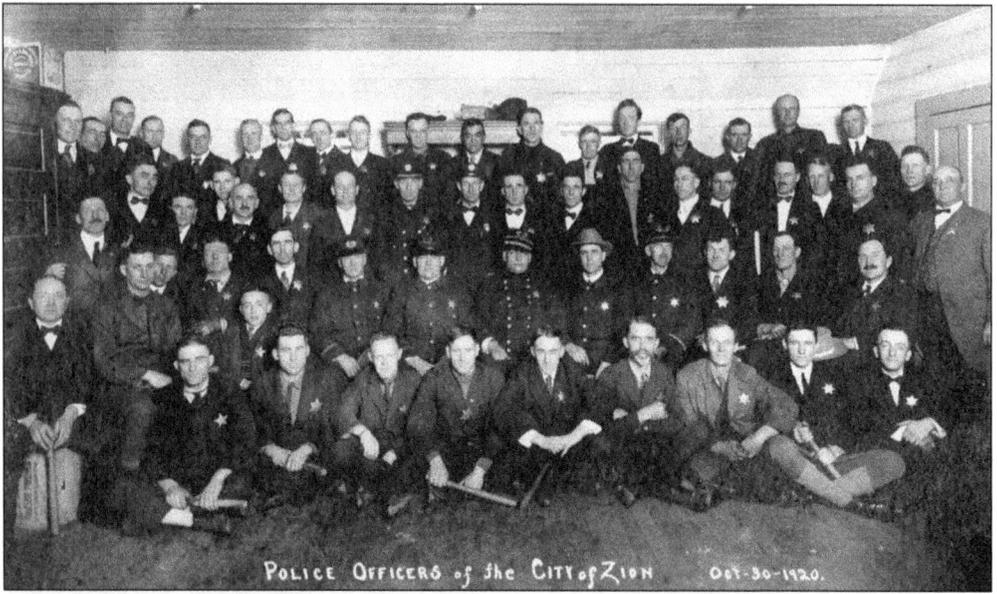

POLICE OFFICERS of the CITY of ZION Oct-30-1920.

These police officers represented the Zion police force on October 30, 1920. It took a large staff to keep the peace in Zion. They were always on the look out for anyone engaging in illegal activities—drunkenness, profanity, spitting, smoking, cockfighting, gambling, improper dress, or recreation or chores on Sunday.

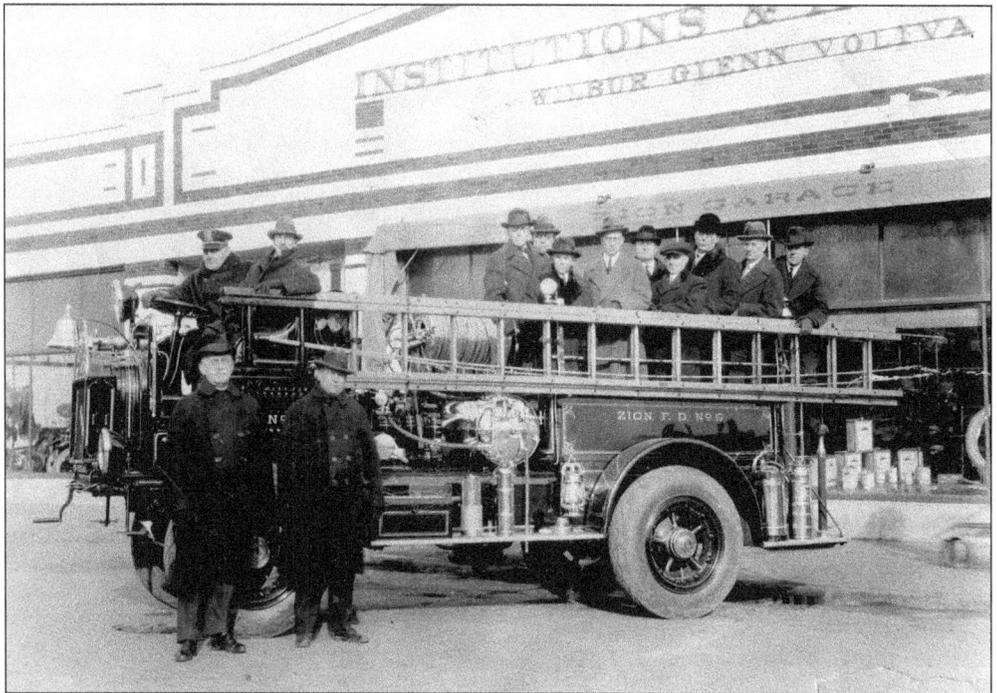

Zion City purchased a new fire engine in the early 1920s. Standing on the ground at the front of the truck are Mayor W. Hurd Clendinen (left) and Fire Marshal Theodore R. Becker (right). Becker served as a Zion City Alderman in 1908 and again from 1910 through May 1917 when he was appointed city marshal and fire marshal by Mayor Clendinen.

In order to secure federal permission to open a post office, Dr. John Alexander and Jane Dowie made a personal visit to Washington, D.C., and met with Pres. Theodore Roosevelt on March 8, 1902. In April 1902, authority was granted to Zion City to open a post office. A new post office was built at the southwest corner of Shiloh Boulevard and Elizabeth Avenue with 600 locks and call boxes. By December 1904, the city free delivery was established to serve the 3,000 residents. By 1907, larger quarters were needed and the post office moved to the north wing of the administration building.

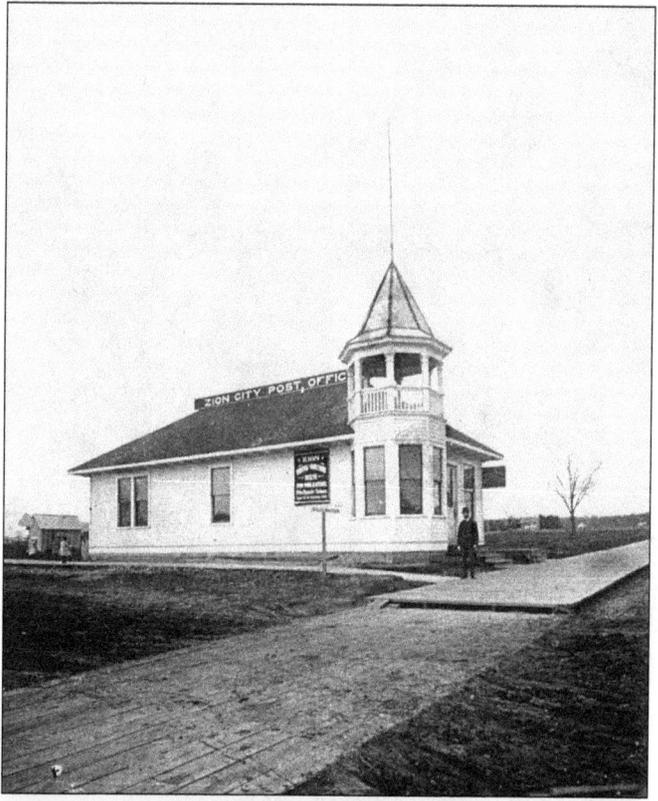

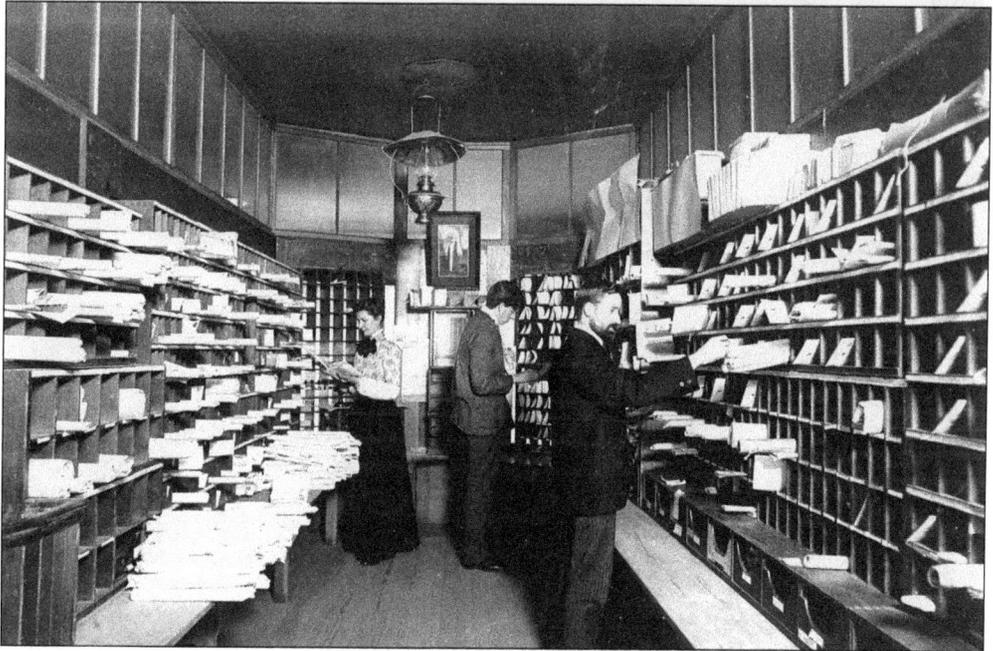

Deacon George Wiedman (front right) was the postmaster at the Zion City Post Office in 1903. E. Higley and Burt Bosworth assist with sorting the mail. All the mail had to be hand-stamped. A photograph of Dr. Dowie hangs on the wall (back center).

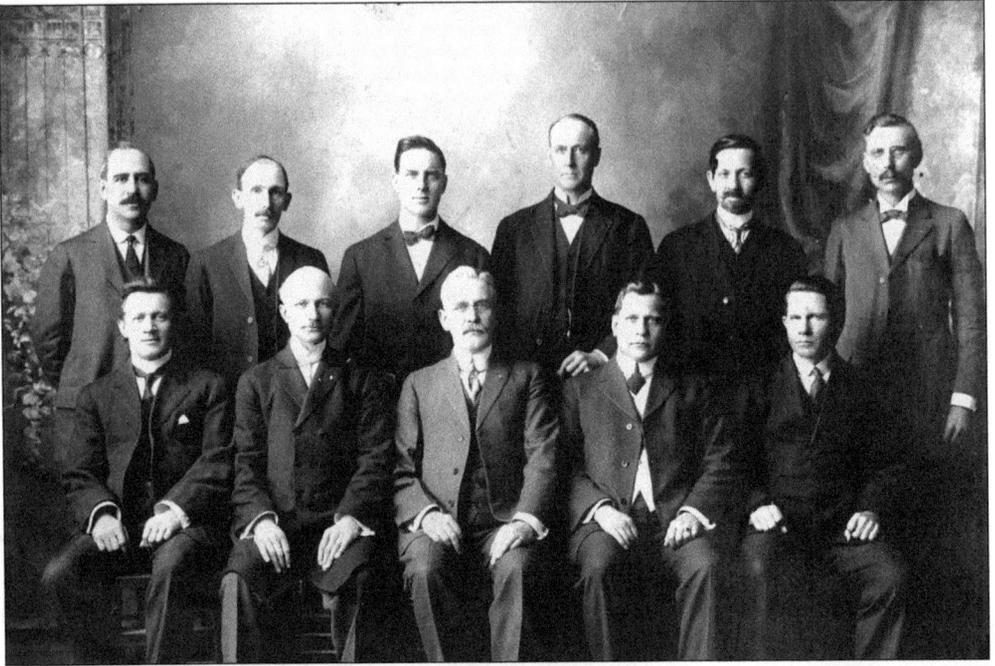

From 1912 to 1914, the following citizens served on the Zion City Council. Seen here are, from left to right, (first row) James D. Bird, Earnest E. Harwood, W. Hurd Clendinen (mayor), Theodore R. Becker, and George E. Robbins; (second row) John D. Thomas, William J. Bull, Conrad A. Brune, Alexander S. Burgess, J. M. Fiddes, and Theodore Forby. Harwood served as mayor of Zion City from 1925 to 1935.

Richard F. Hire (left) was a Zion musician who served as finance commissioner in Zion up to the death of Mayor William Edwards, who died in office in 1936. He was sworn in by Judge Forby to fill the unexpired term. Hire served as Zion's mayor from 1936 to 1951.

Five

COMMUNITY LIFE

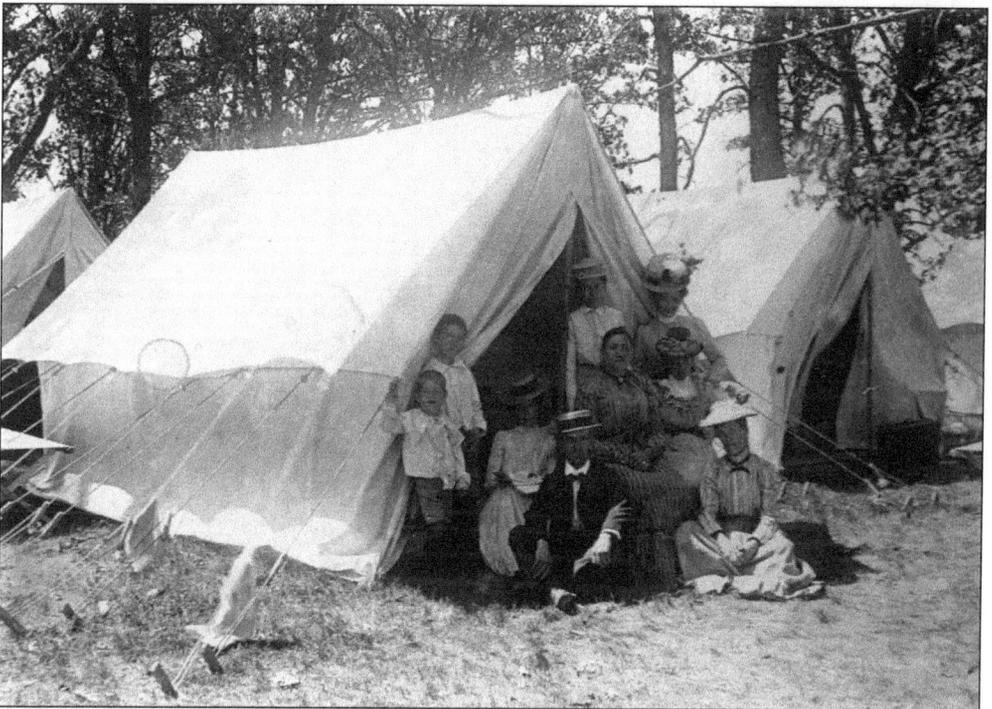

In 1901, Camp Esther (Tent City) sprang up west of the temple site. People coming to Zion City for the Feast of Tabernacles could rent a 9-by-14-foot tent with a board floor, a table and chair, and a slop bucket, with fresh water from Esther's Well. Both the camp and the well were named for Dr. John Alexander Dowie's daughter, Esther. Many families lived in Camp Esther until their homes were built.

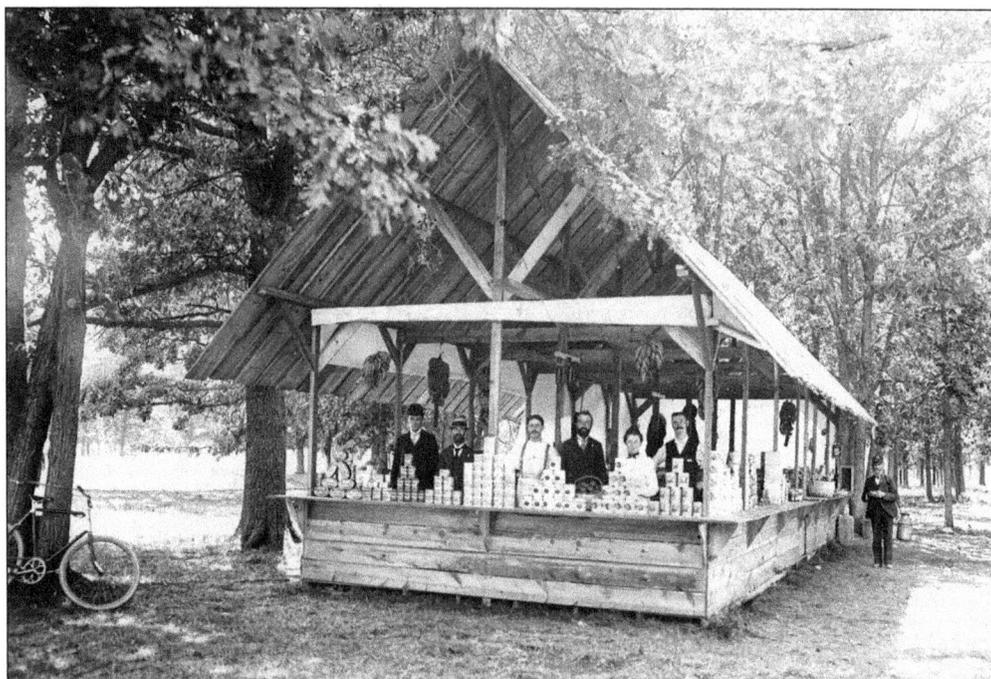

A makeshift store was built at Camp Esther which is now Shiloh Park. Behind the counter in July 1901 are, from left to right, J. H. Depew, I. J. Thurston, C. A. Brune, W. E. Greenfield, Miss Dey, and ? Robinsdon, with ? Huston off to the side.

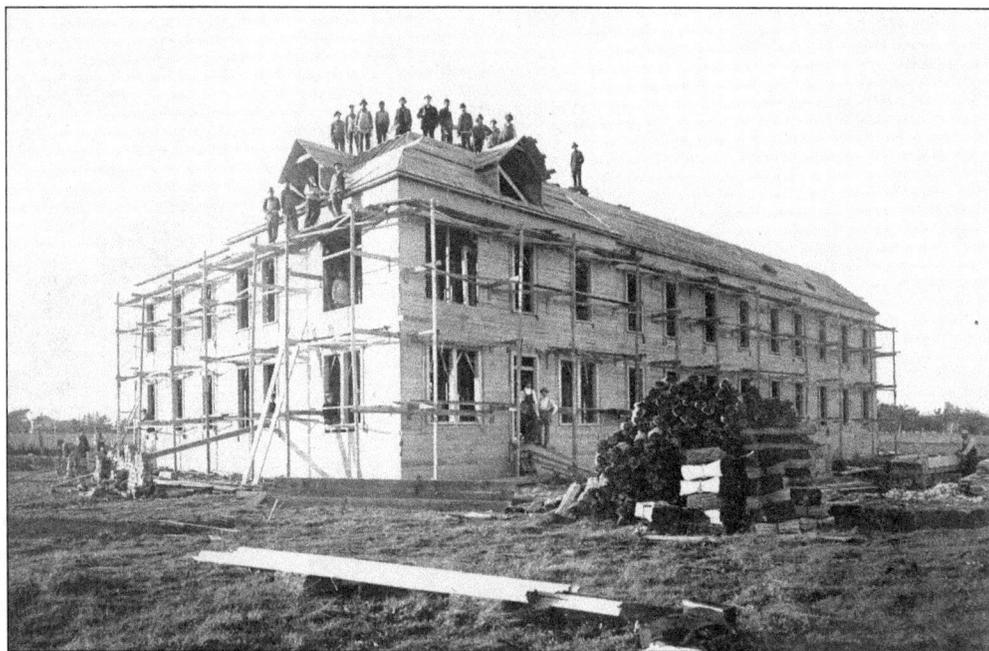

In 1901, a home was built for the lace workers brought to Zion City from England by Dr. John Alexander Dowie to work at the lace factory. This home became known as the Bethel. It was built at Twenty-ninth Street and Edina Boulevard and later moved to Twenty-ninth Street and Elizabeth Avenue.

Zion City was founded on the belief of Biblical tenets regarding clean living, one being that the consumption of pork was unacceptable. In 1901, Krause's Zion City Meat Market sold customers Zion beef bacon and Zion shortening. Grant Biddle managed the store located on the west side of Sheridan Road at Twenty-eighth Street. Mr. Collett, Mr. Hollitz and Mr. Nacker were employed as butchers and deliveries were made two or three time weekly.

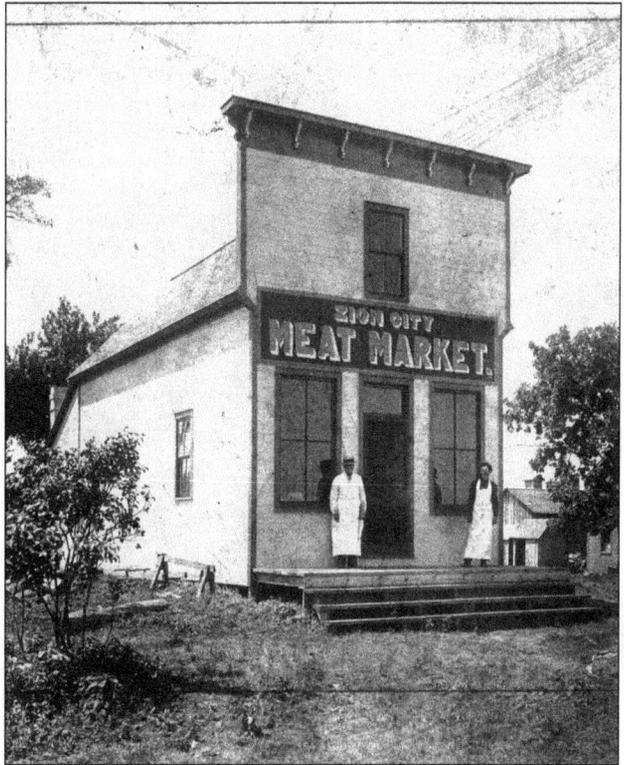

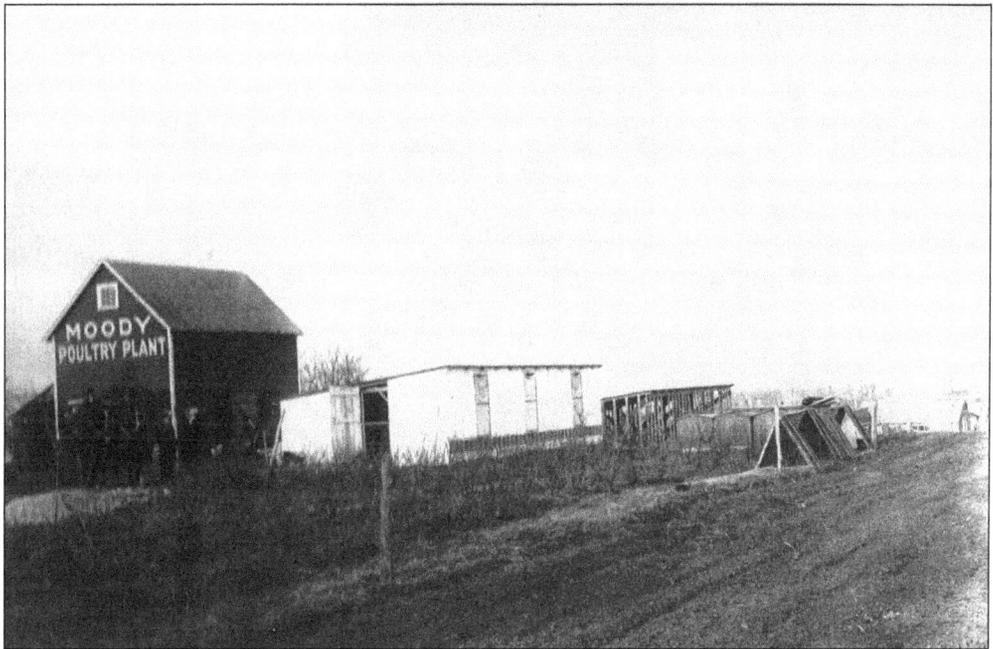

The Moody Poultry Plant, pictured here in 1916, was located at Gideon Avenue and Thirty-fifth Street. Living under a theocracy, the food consumed by followers was important, and certain foods were prohibited. Pure foods became a hallmark of Zion. No pork products were allowed, so "Mr. Moody" most likely ran a fairly lucrative chicken business.

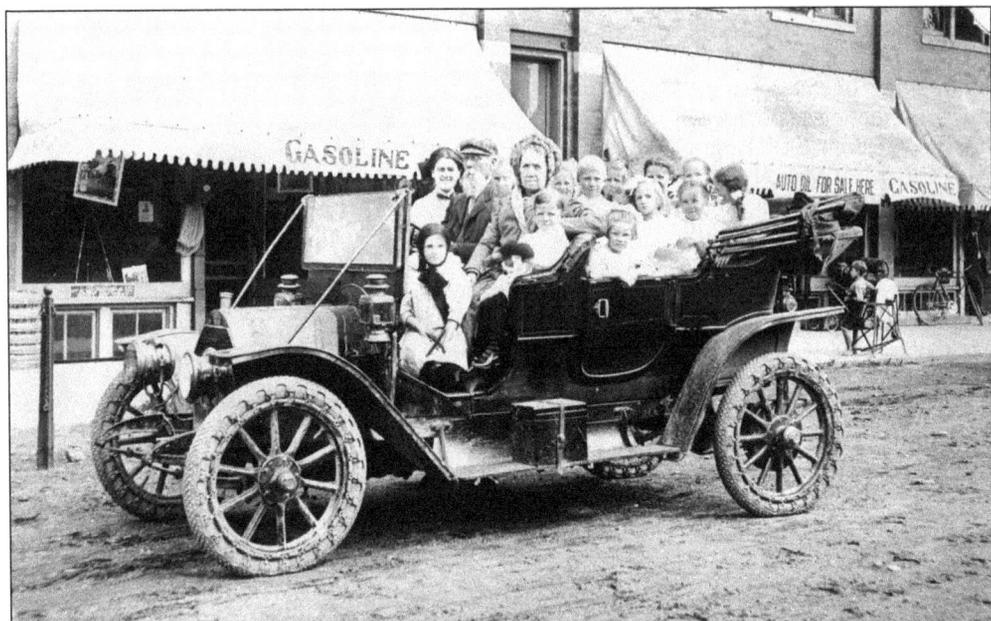

Charles Beebe was an Independent businessman who owned Beebe Hardware Store on the east side of Sheridan Road between Twenty-sixth and Twenty-seventh Streets. Mary Beebe was a Sunday school teacher. Charles and Mary treated her Sunday school class to a ride in their car in 1908.

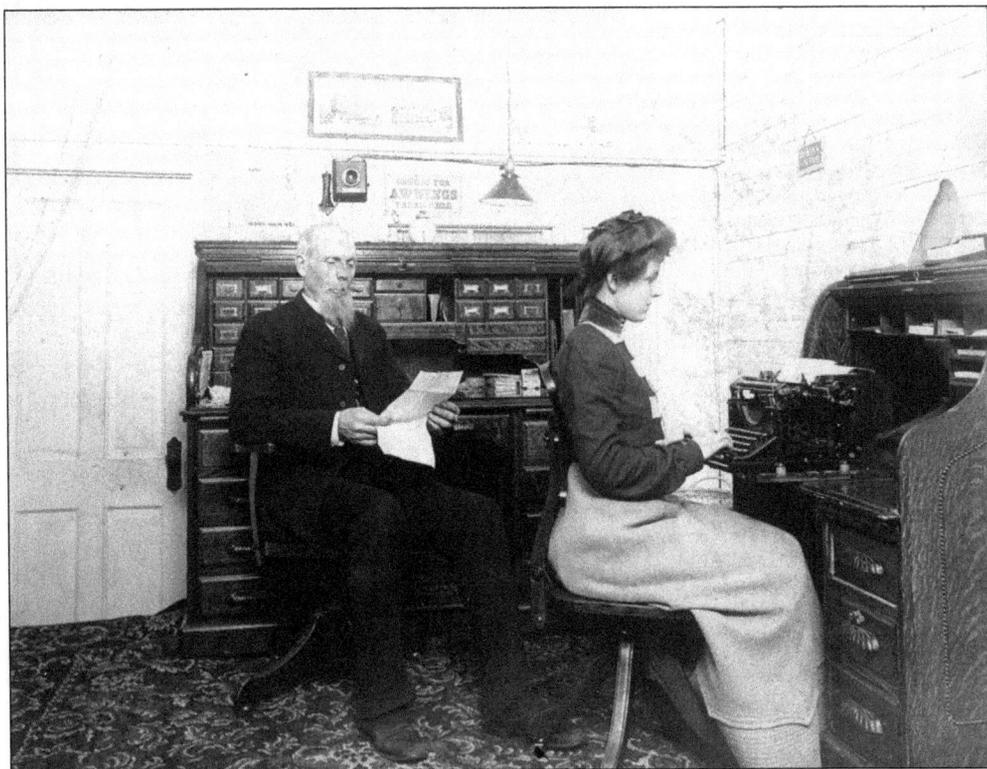

Charles Beebe, seated at his desk in 1903, managed the Beebe Hardware Store.

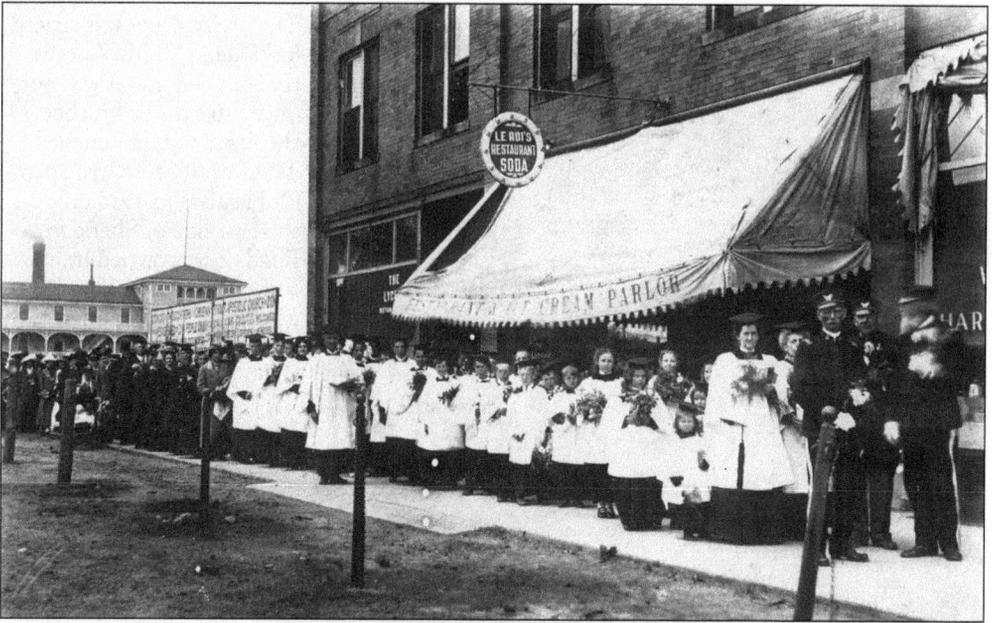

In 1920, on the east side of Sheridan Road between Twenty-sixth and Twenty-seventh Streets, residents and visitors could patronize LeRoi's Restaurant and Ice Cream Parlor and Beebe Hardware. Notice the horse ties in the foreground.

Deaconess Ellen Lloyd, a midwife, brought thousands of Zion babies into the world. Dr. John Alexander Dowie adamantly opposed use of medicine and doctors, making Lloyd a heroine to many Zion women. (Courtesy of Christ Community Church.)

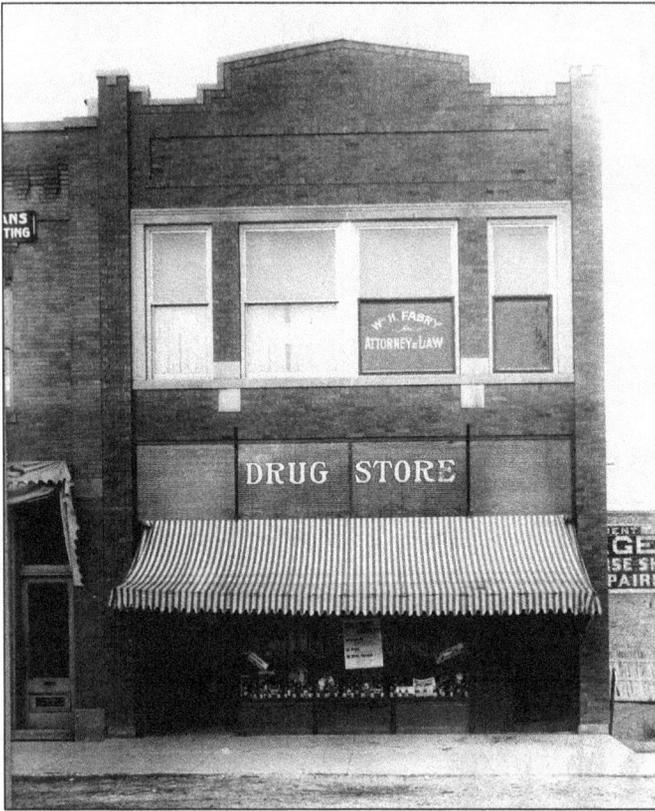

The use of drugs was strictly forbidden in early Zion by the founder, and it was not until after his death that the first drugstore opened. The Rexall Store was open for business in 1915 on the east side of Sheridan Road. It was owned by an Independent, William Fabry, who was an attorney in early Zion. His law office occupied the second floor.

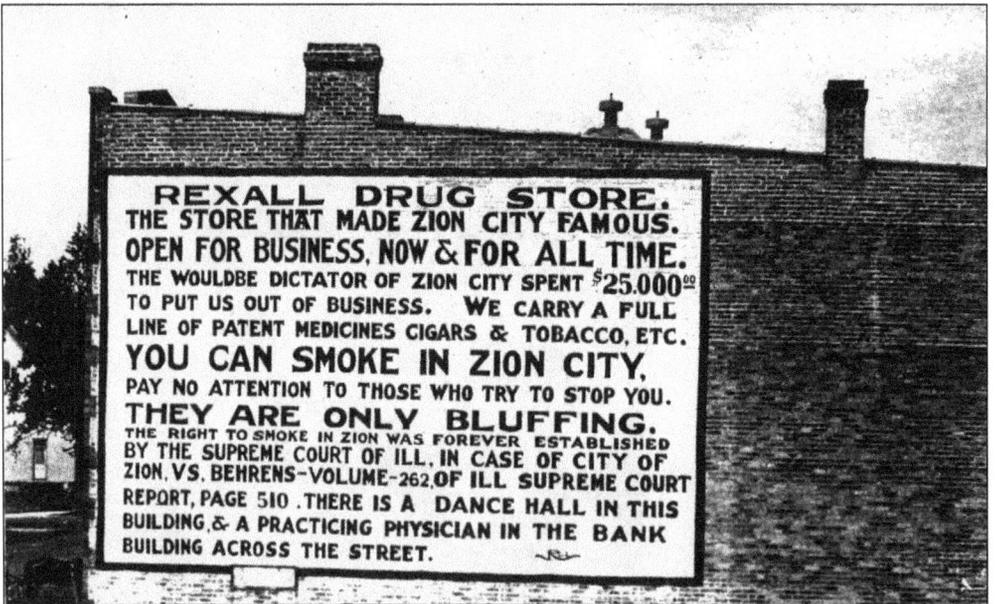

The Rexall Store also served as "Parham's Meeting Place." Charles R. Parham, a proponent of the Pentecostal movement, came to Zion seeking converts. During the reign of General Overseer Wilbur Glenn Voliva, in opposition to the ideals of the theocracy, this sign was posted on the south side of the building.

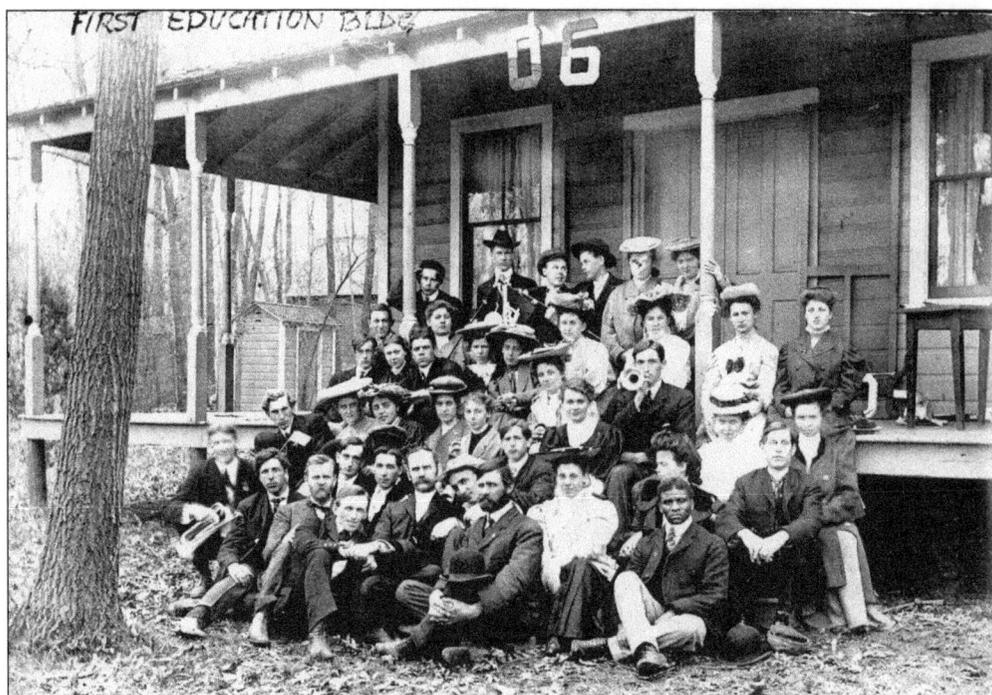

The first school bell, calling students to class, was rung by Olla F. Smith in the fall of 1901. The first school building was located in Shiloh Park. Children of Christian Catholic Church parishioners were tended in this building during worship services in Shiloh Tabernacle.

In 1905, four junior school buildings were completed, all of the same design, for kindergarten through eighth grade students. They were located at Twenty-sixth Street and Elim Avenue, Thirtieth Street and Elim Avenue (pictured), Thirty-first Street and Ezra Avenue, and Twenty-first Street and Hermon Avenue. Each building had four classrooms on each of the lower floors with a wide center stairway leading to an open room on the third floor, which was used for graduations and parties.

Teachers who were capable of instilling the Zion ideals in students were hired, most being recruited from the Zion community. Teachers were not well paid. They had to settle for self-satisfaction and knowing that they were part of the Christian Catholic Church's mission. Mr. Tuttle, pictured here in 1907, was a teacher at the Thirtieth Street School in Zion.

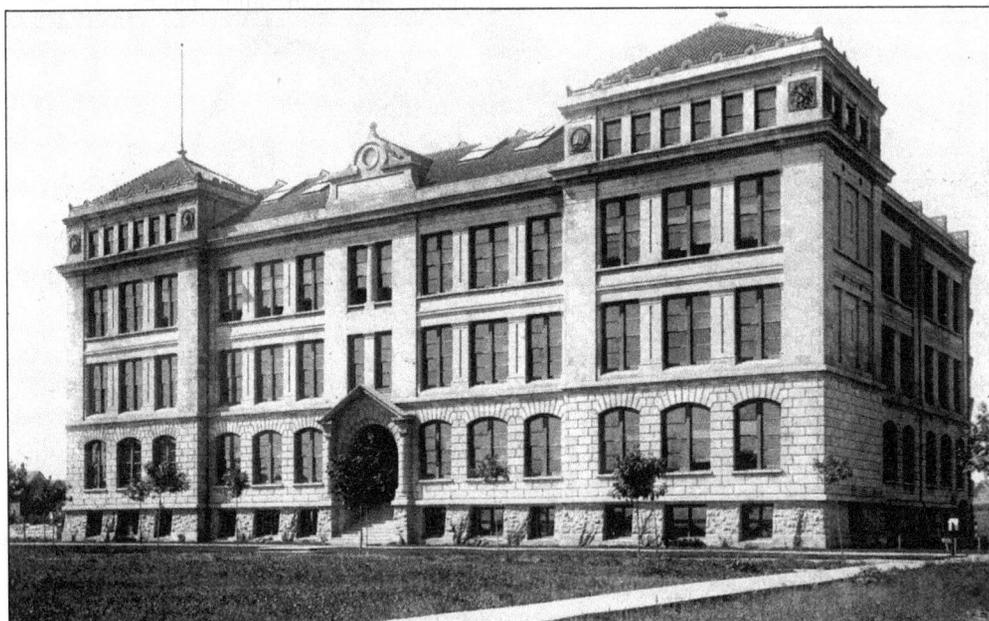

The cornerstone for the college building was laid by Dr. John Alexander Dowie on January 26, 1902, at Twenty-seventh Street and Enoch Avenue. Dowie was assisted by the contractor Herman Peterson in laying the enormous piece of Indiana limestone. All the factories and businesses closed for an hour for the ceremony. Dowie delivered a short speech and the crowd sang hymns.

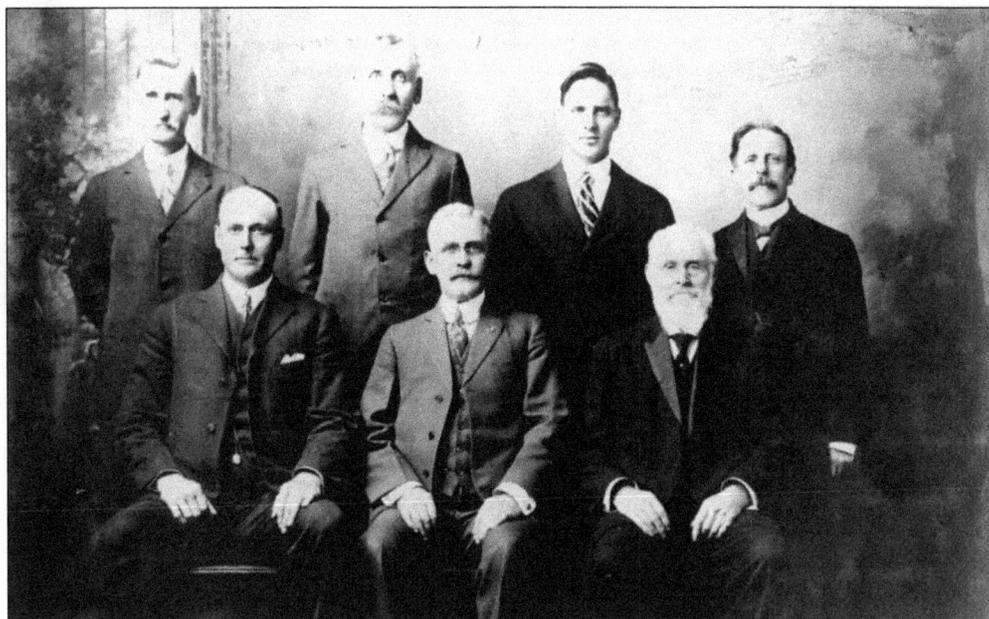

Just as all other facets of the planning of Zion City were, the educational facilities were well thought out. Attention was given to the details of their building design, placement, and organization. From 1912 to 1914, these men served on the Zion Public School Board. From left to right are (first row) Alexander S. Burgess, W. Hurd Clendinen, and George D. Chenoworth; (second row) John Dow, Isaac E. Mill, Conrad A. Brune, and Eustace L. Carey.

Zion educational facilities were provided by the Christian Catholic Church. When the schools were reorganized in 1916, two of the four junior school buildings remained open as independent schools for children of families who were not Christian Catholic Church members. The last class of eighth graders to graduate from the parochial schools was in 1939.

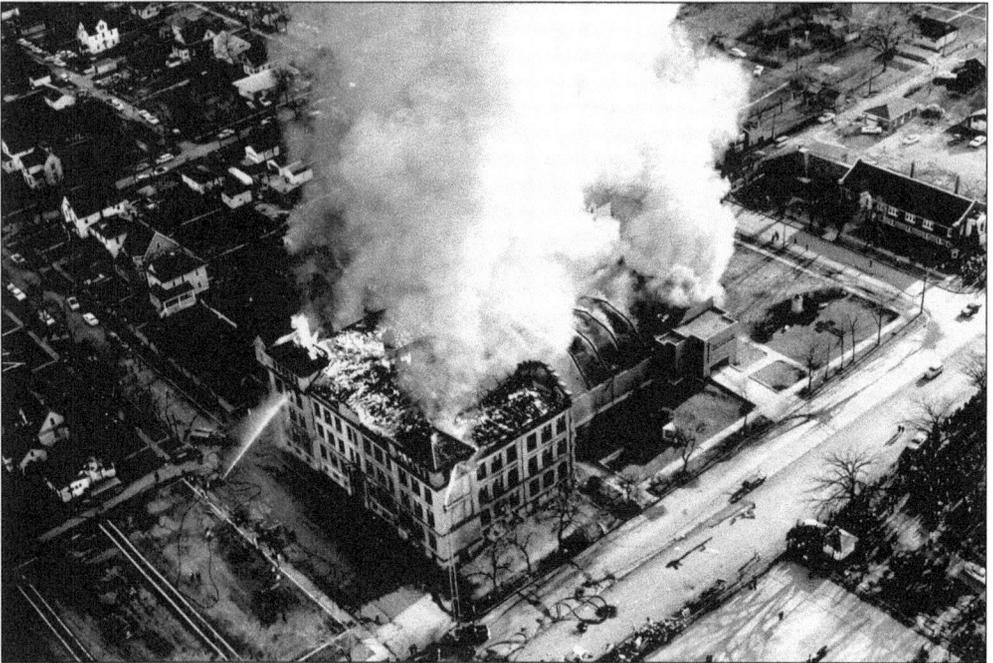

In October 1957, the college building burned. After Shiloh Tabernacle burned in 1937, the church was holding services on the west side of the college building, so at this point, the church was "homeless" again. It was discovered that cans of paint used to paint the scenery for the Passion play contributed to the cause of the fire.

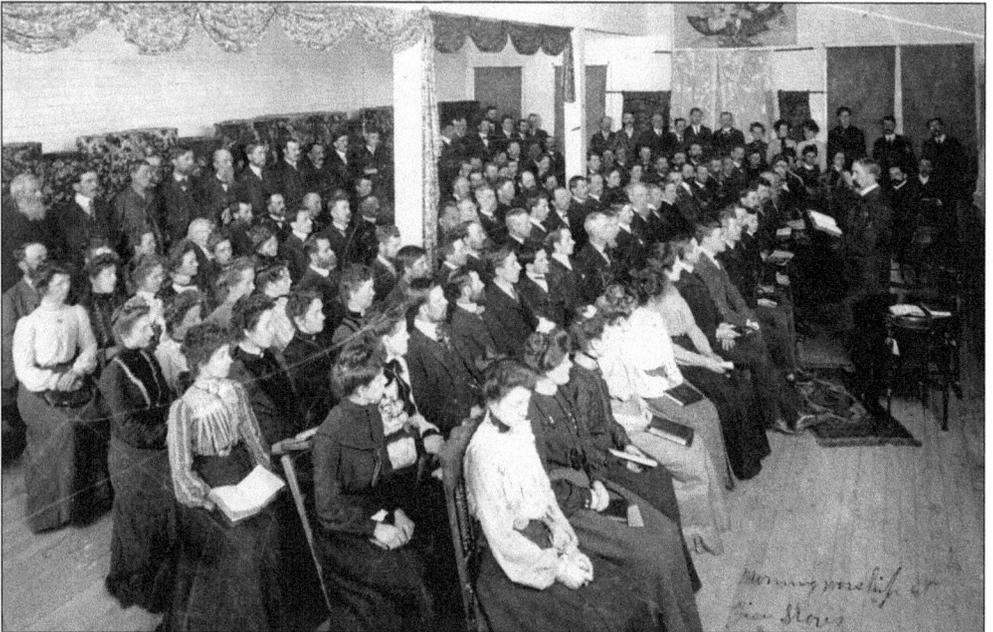

Worship and prayer were part of Zion residents' daily routines. Each day at 9:00 a.m. and p.m., a bell tolled, the signal for all to immediately cease activity and engage in two minutes of silent prayer. There was a worship service held for general store employees every morning before the store opened. Pictured here is a group of employees at morning worship in 1903.

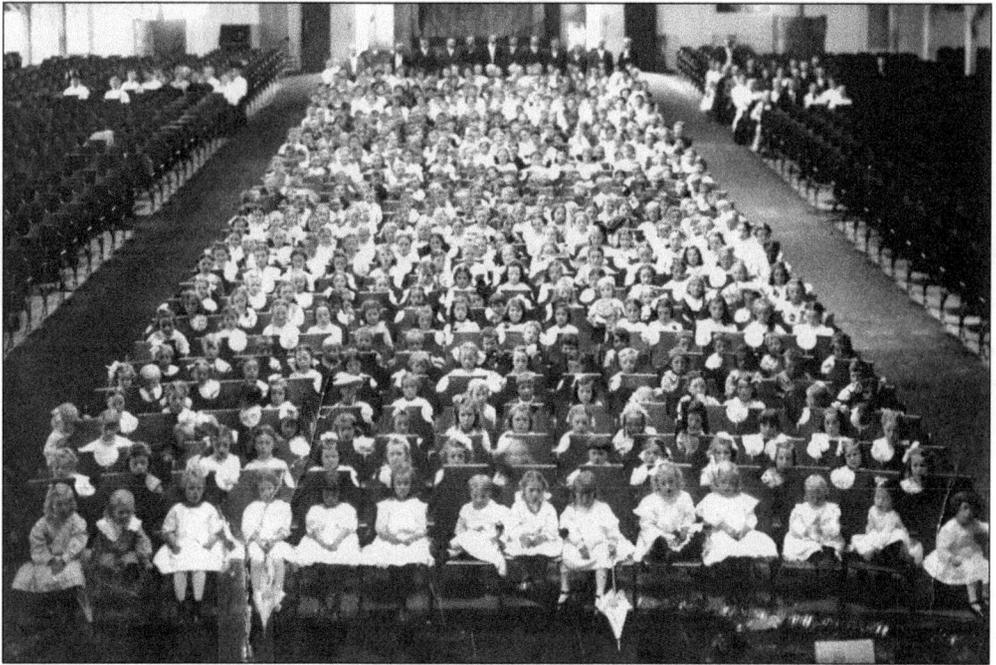

General Overseer John Alexander Dowie had great expectations from the children of Zion City, many of whom are pictured here in Sunday school at the Shiloh Tabernacle in 1915. Dowie believed the first principle to be ingrained in a child is the supremacy of God and his right to exercise free will. A child had to be a Christian in order to graduate from high school and a church member in order to graduate from college.

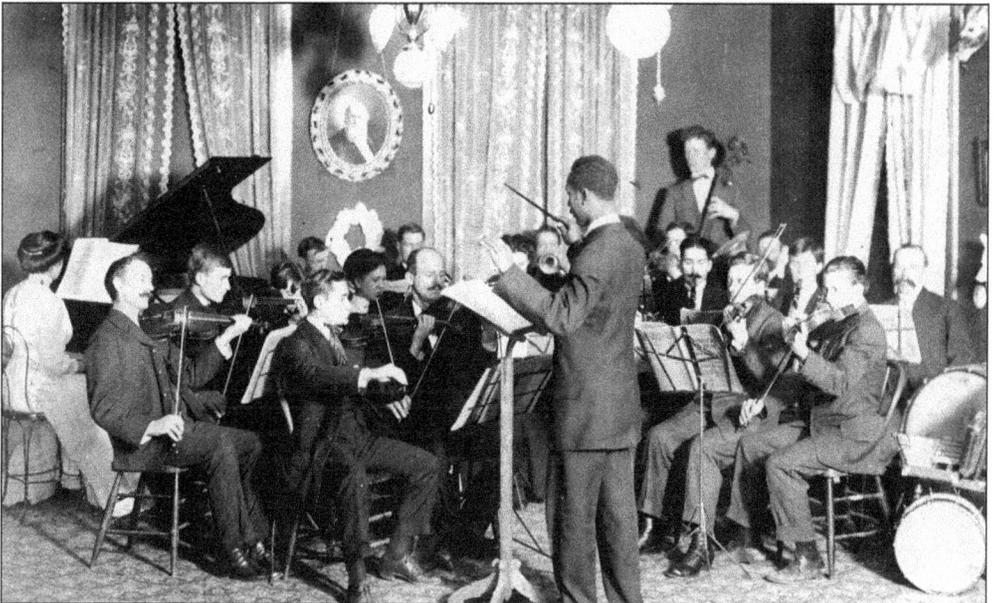

Music was an important part of the lives of the people in Zion. The Zion Orchestra, under the direction of John D. Thomas, entertained at the Elijah Hospice (Zion Hotel) on occasion. During this performance, Hyland M. Wilson conducted the orchestra. A photograph of Dowie, Zion's founder, hangs on the wall behind the orchestra.

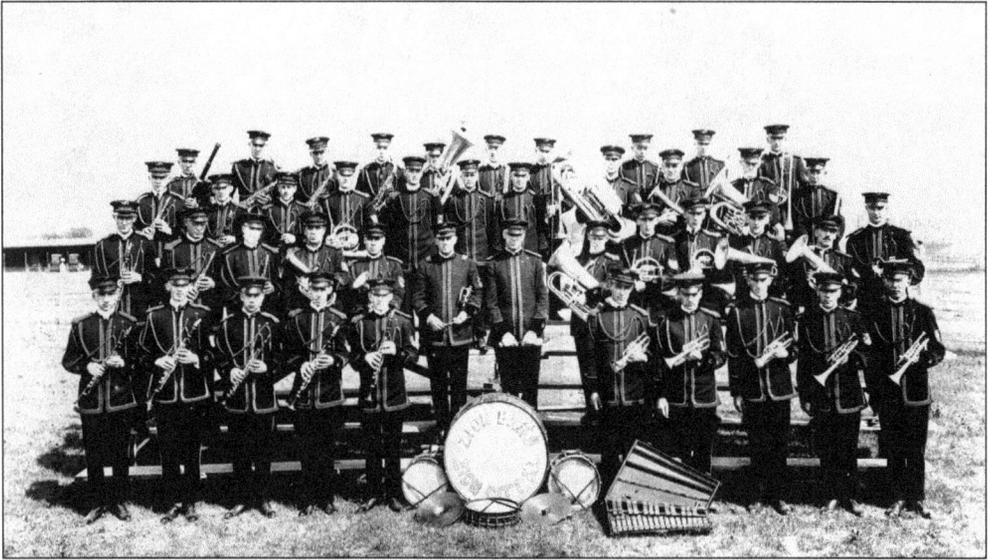

Zion City residents were proud of their musical organizations. The Zion Band, led by Deacon F. A. Bosworth in the early days, provided the community and surrounding area with free concerts. The Zion Band, shown here in 1920, was directed by noted musician, P. B. Newcomer.

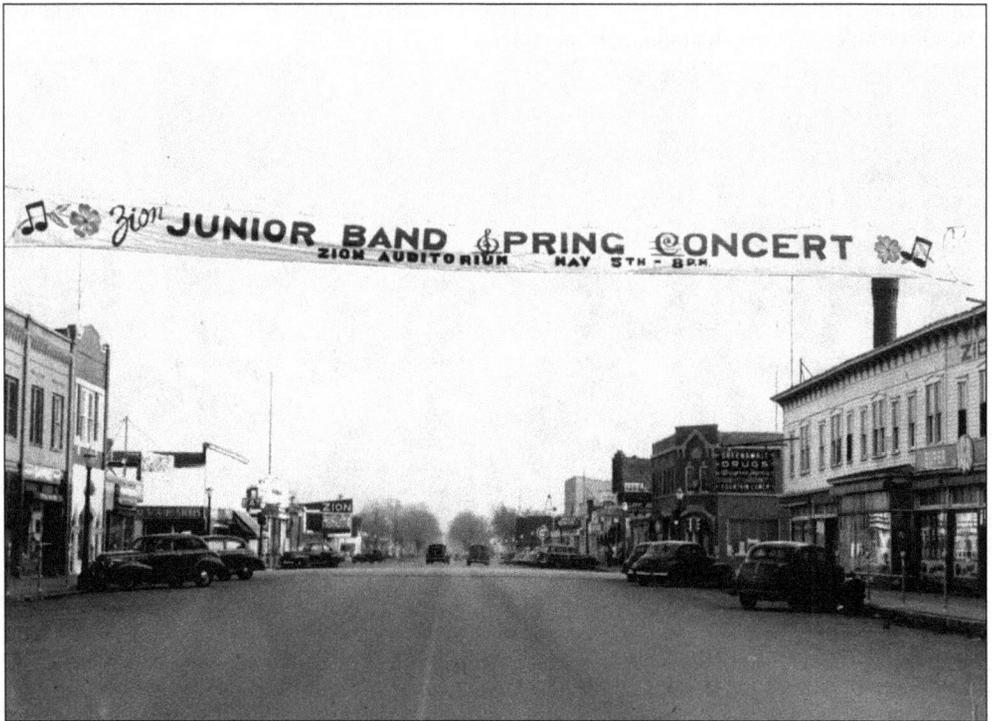

The Zion Junior Band performed a spring concert in the Zion Auditorium in the mid-1940s as advertised on this banner spanning Sheridan Road just north of Twenty-seventh Street.

Some residences in early Zion were meager. This structure was the first house west of Howard's Secondhand Store at Twenty-seventh Street and Elisha Avenue. It was torn down in 1933.

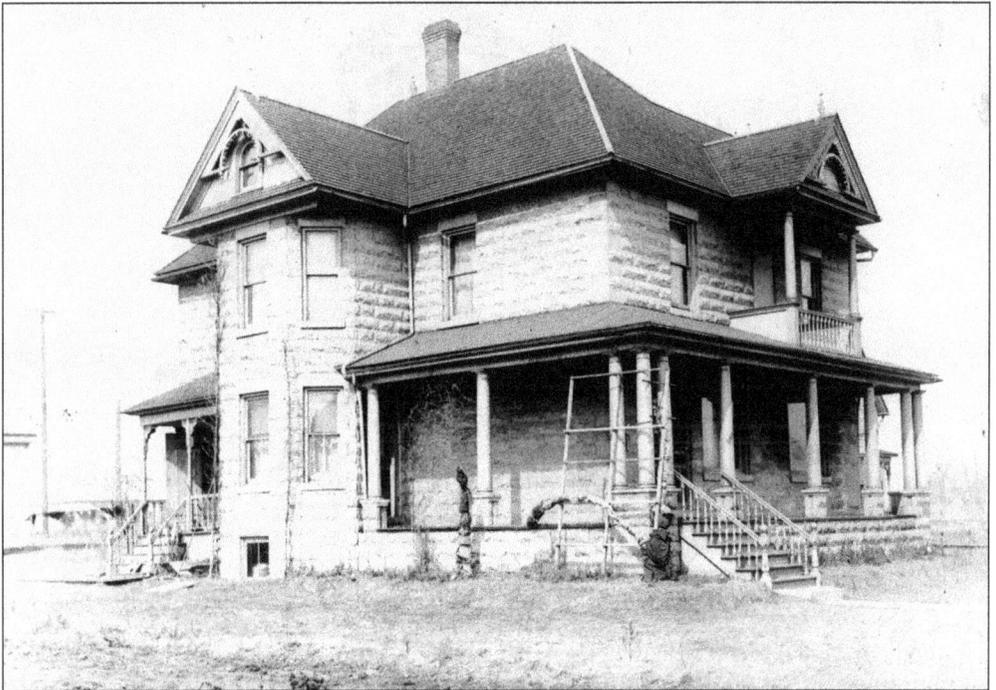

The Schattschneider's home was built at 2500 Elim Avenue. The city engineer, Burton Ashley, planned mostly brick or masonry homes in Zion.

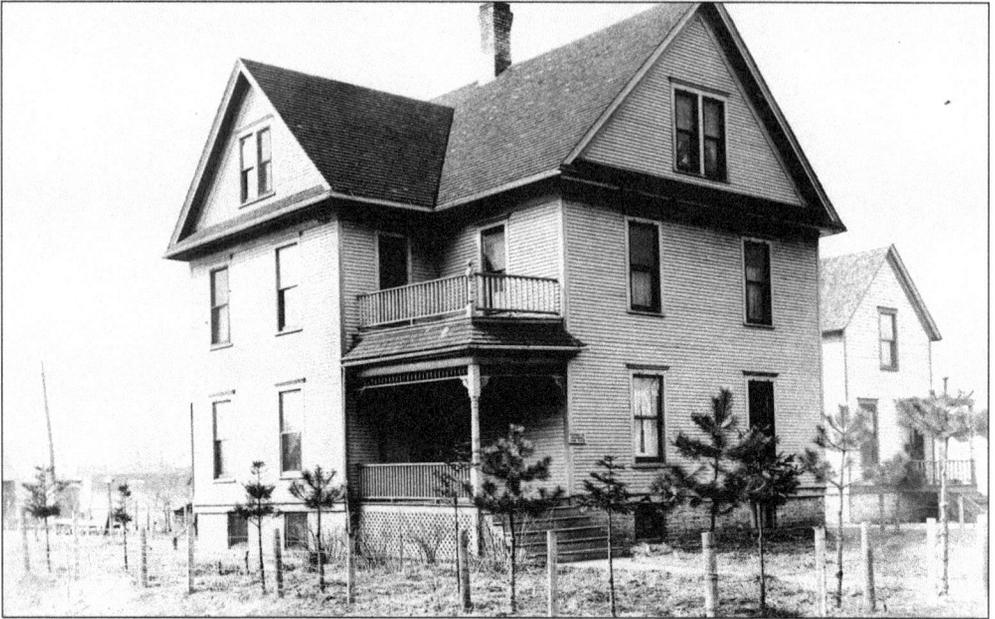

Dr. Linde's home was built at 2816 Elizabeth Avenue. By mid-1901, more than 40 new houses had been built, and many more were under construction. Many homes were intended to be temporary due to a short supply of building materials. These mainly one- and two-story wood-frame houses were built at the rear of the lots, allowing ample space for a permanent structure to be built in front.

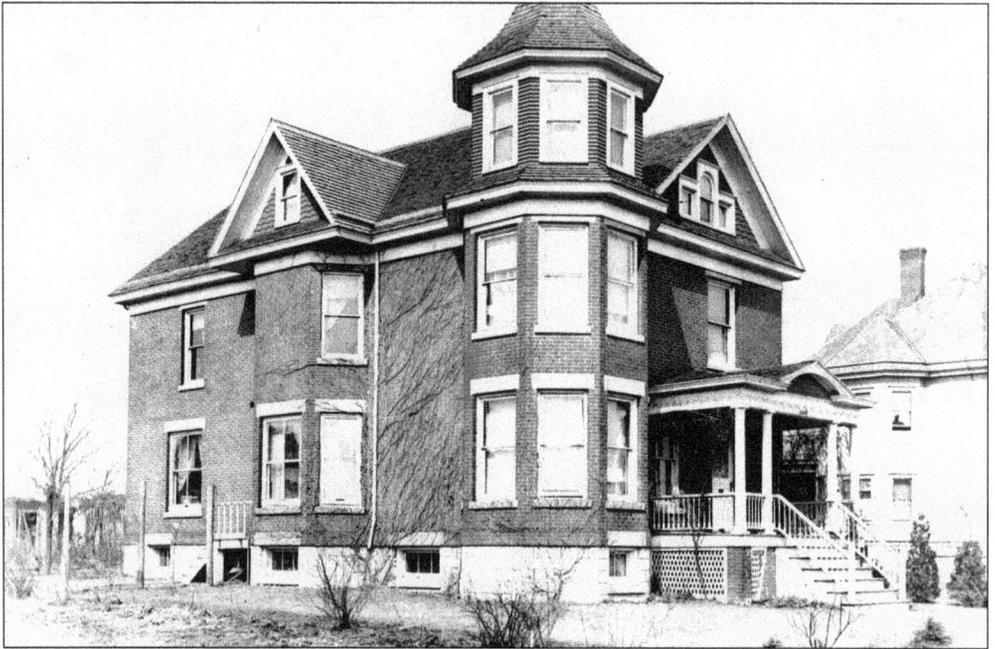

This home at 2408 Elisha Avenue was the Flower family residence. In the early 1900s, this block on Elisha Avenue was known as "Apostle's Row" since many church officials lived there to be near Shiloh House, the residence of Dr. John Alexander Dowie, leader of the Christian Catholic Church. Henry G. Hayes was the architect of many of these homes.

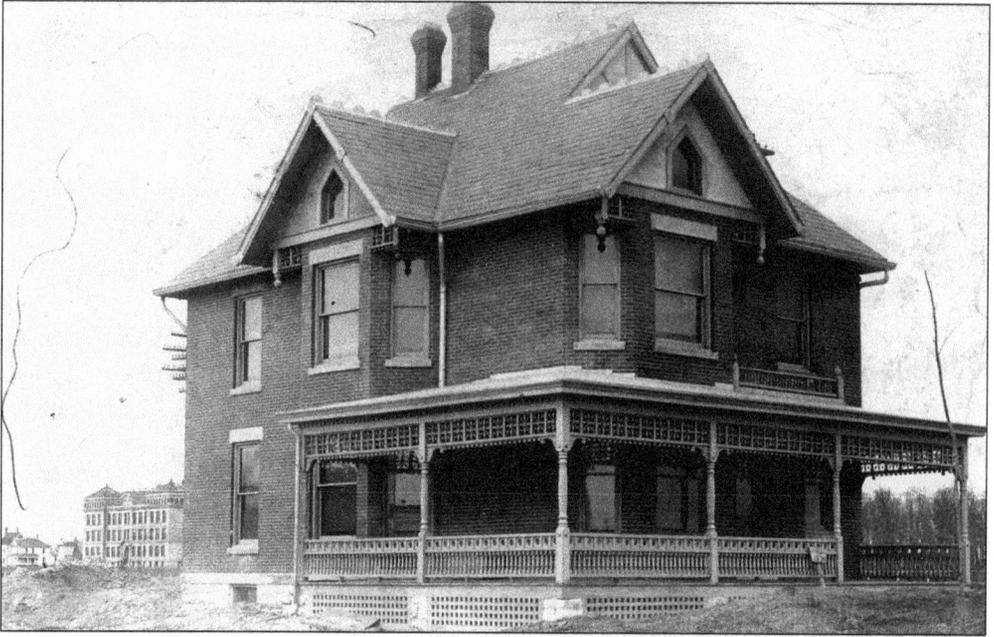

Based on his experience, city engineer Burton Ashley advised future home builders on proper construction and improvements including drainage and landscaping via articles in Zion publications. Much time and effort were spent on building beautiful buildings, as evidenced by the Beebe family home at Elisha Avenue and Shiloh Boulevard. Dowie, Zion's founder, insisted the present and future builders of Zion City preserve the idea of beauty in Zion City homes.

This modest home at 2618 Elisha Avenue was owned by Rev. Jabez Taylor from 1926 to 1933. Reverend Taylor joined the Christian Catholic Church ministerial staff in 1930. He worked with the youth program and assisted the choir conductor with dramatic productions. He presented the first Zion Passion Play in Shiloh Tabernacle in 1935.

The Paddock farm was located at Thirty-third Street and Bethel Boulevard. Deaconess Jennie Paddock was matron of the Home of Hope for Erring Women. This facility was established for the purpose of rehabilitating homeless girls and prostitutes. The house was later moved to a farm on Kenosha Road.

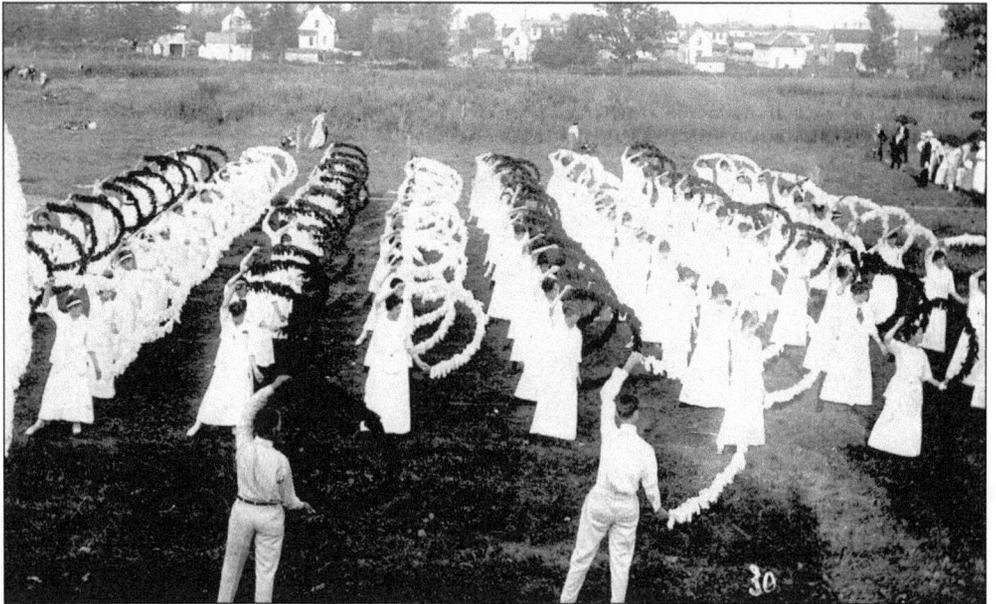

A wide variety of recreational activities were integrated into the social life of Zion City youth and adults. An extensive park system was provided for Zion residents. The wide-open spaces offered plenty of room for picnics and sports. At a picnic on July 15, 1915, wand exercises, led by Paul LaRose, were included in the picnic activities.

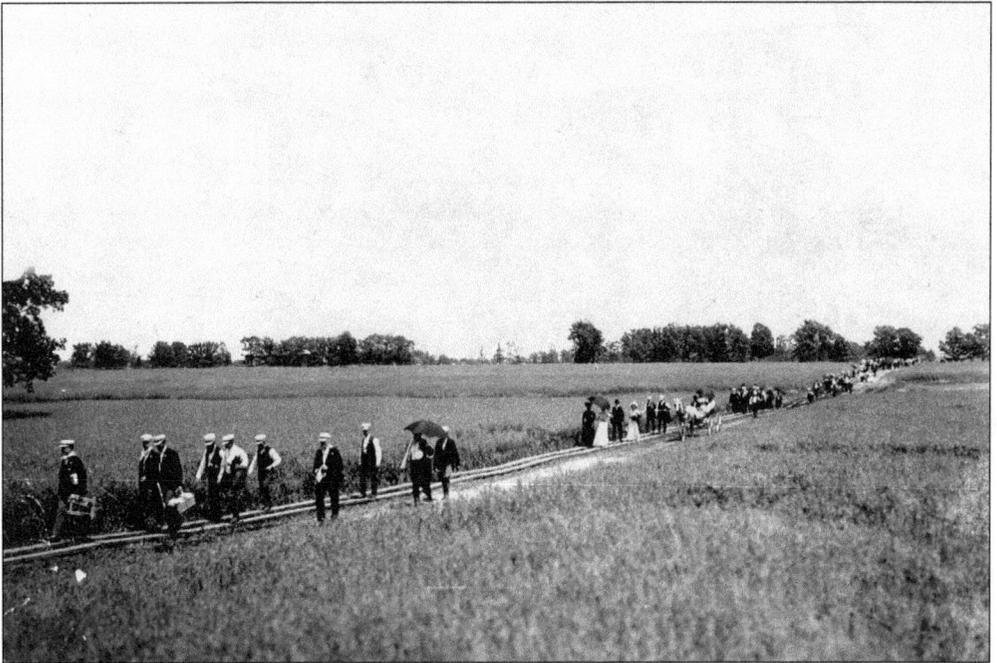

Zion City residents enjoyed picnicking on the shore of Lake Michigan. In what was probably a two-mile walk from downtown, residents made their way east on a boardwalk leading to the beach. Some carried baskets, some umbrellas to protect themselves from the hot sun.

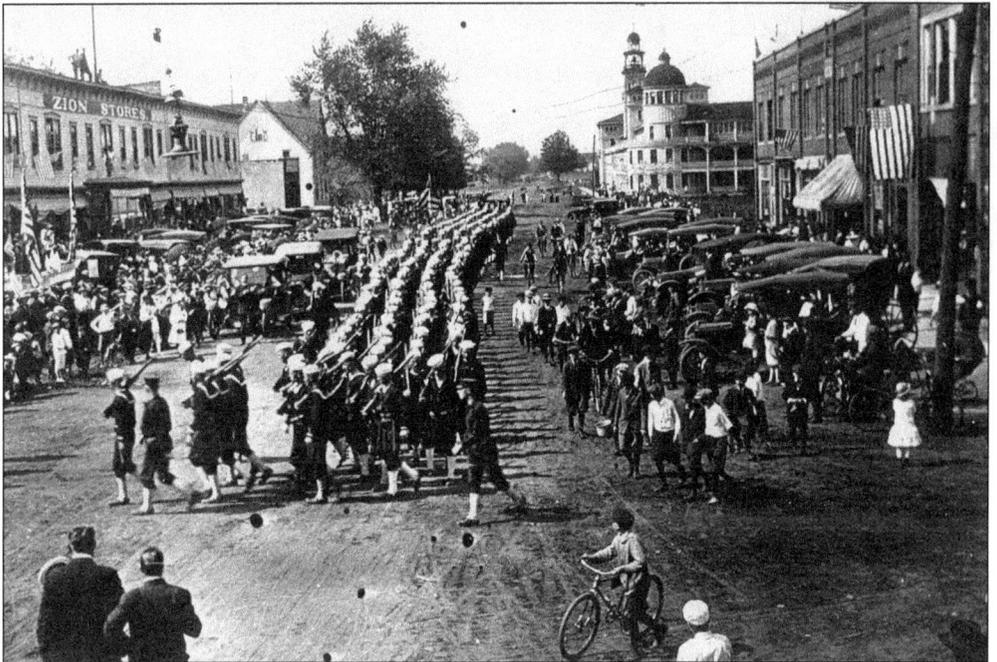

The residents of Zion have always enjoyed a good parade. This parade, most likely held during World War I, featuring sailors from Great Lakes Naval Station, made its way south on Sheridan Road before the road was paved. Spectators are perched on the roof of the Zion Department Store (top left). The Zion Hotel is visible in the background (top right).

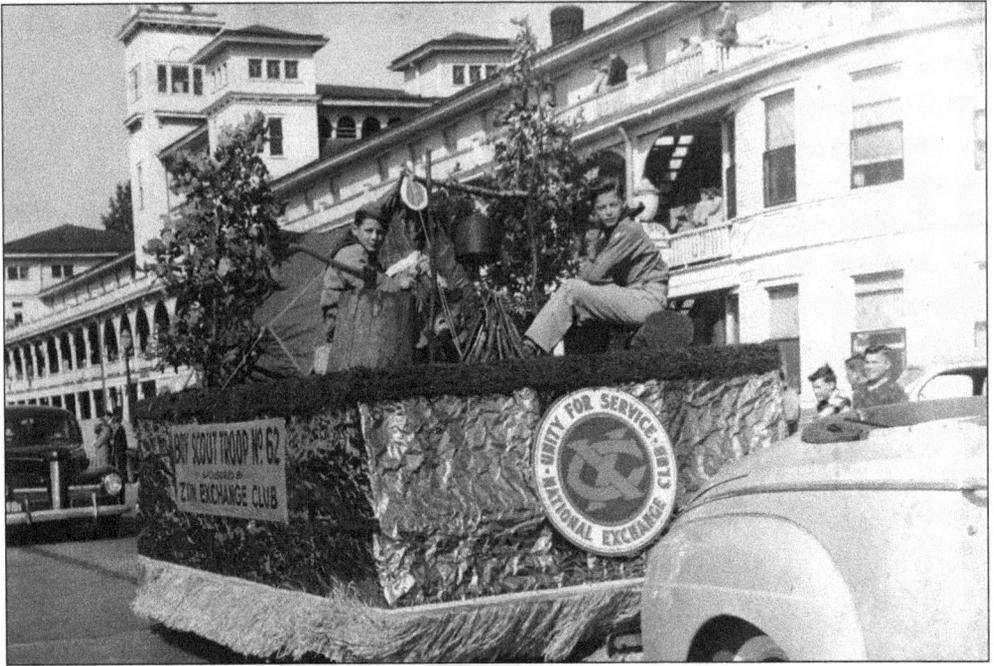

In a homecoming parade in the 1950s, two Boy Scouts "cook up a storm" on the Boy Scout Troop No. 62 float sponsored by the Zion Exchange Club. The Zion Hotel, on the east side of Sheridan Road between Twenty-fifth and Twenty-sixth Streets, consumes the background.

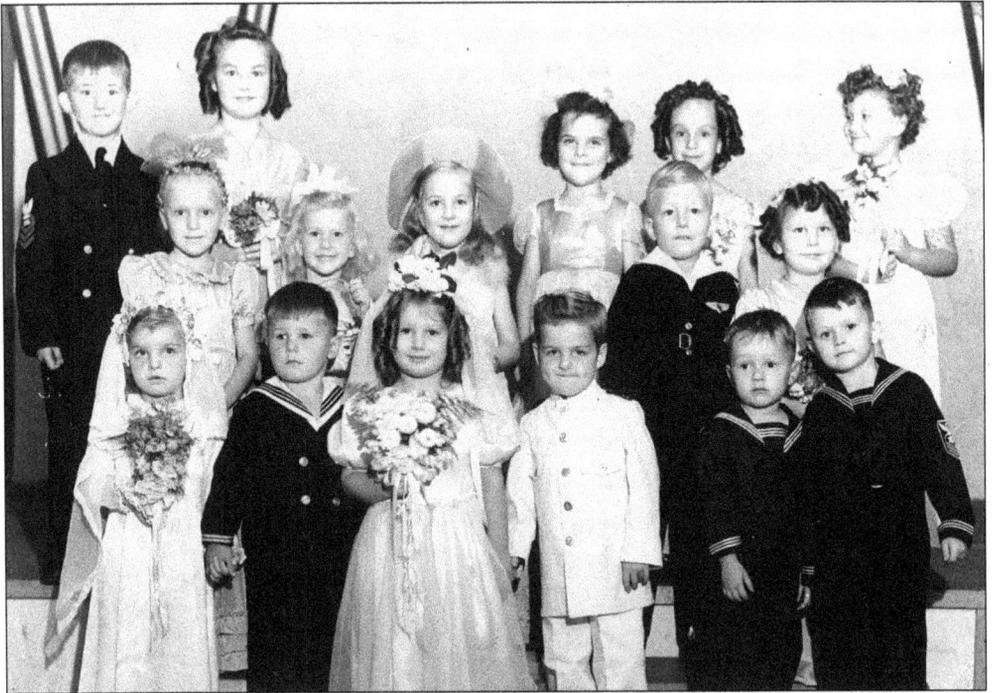

Beginning in the 1920s, Tom Thumb weddings were a fad. Children would be dressed in formal wedding attire and participate in a mock wedding, being a sort of play acting. This wedding, characterized as a social event, was staged at Grace Missionary Church in Zion in 1944.

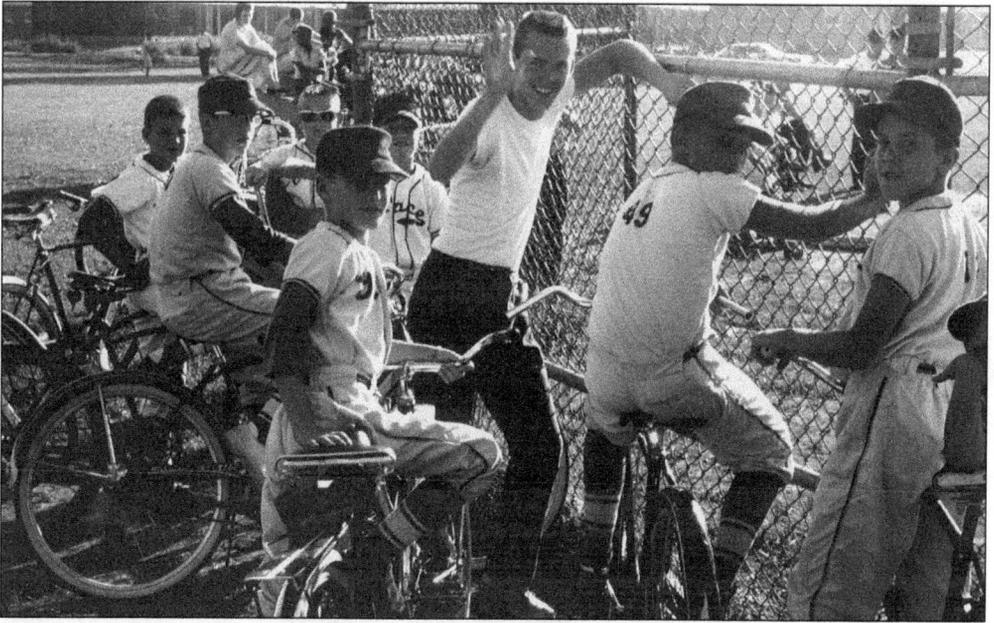

High importance was placed on recreation in Zion, thus the Zion Park District was organized in 1946. Baseball has always been included in the summer schedule and kids of all ages participate. These young men of the late 1960s pause to check out the league competition. (Courtesy of Zion Park District.)

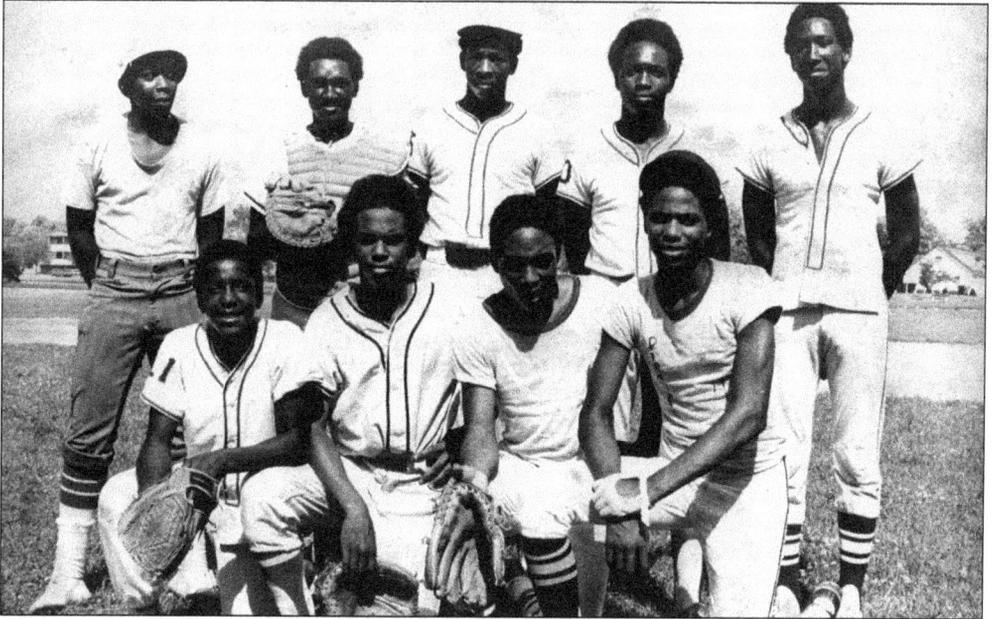

Zion boys played "Zion Block Baseball." Block baseball teams were comprised of boys from various geographical blocks in the city. This team, the "Pirates," represented blocks on Carmel Boulevard and Gilead Avenue. They took second place in 1974. Team members are, from left to right, (first row) Mike Cain, Joe Bowles, Abner Davis, and Reggie Farris; (second row) unidentified, Roy Davison, Charlie Fisher, Amos Taylor, and Robert Lewis. (Courtesy of Zion Park District.)

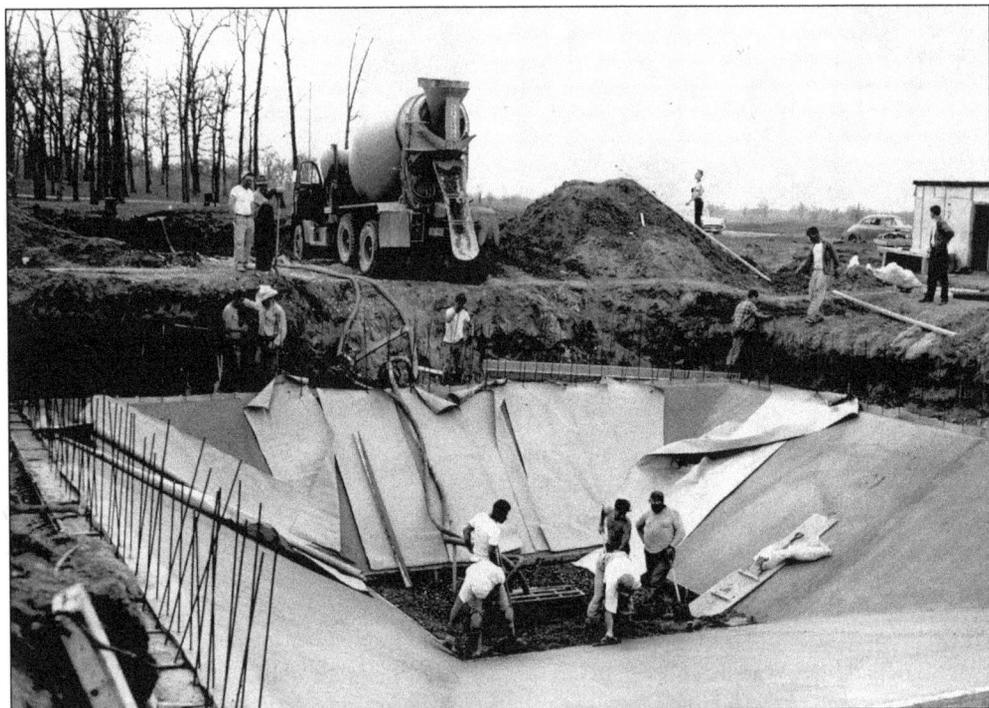

In 1962, the Zion Park District began construction of the Shiloh Pool on Shiloh Boulevard. (Courtesy of Zion Park District.)

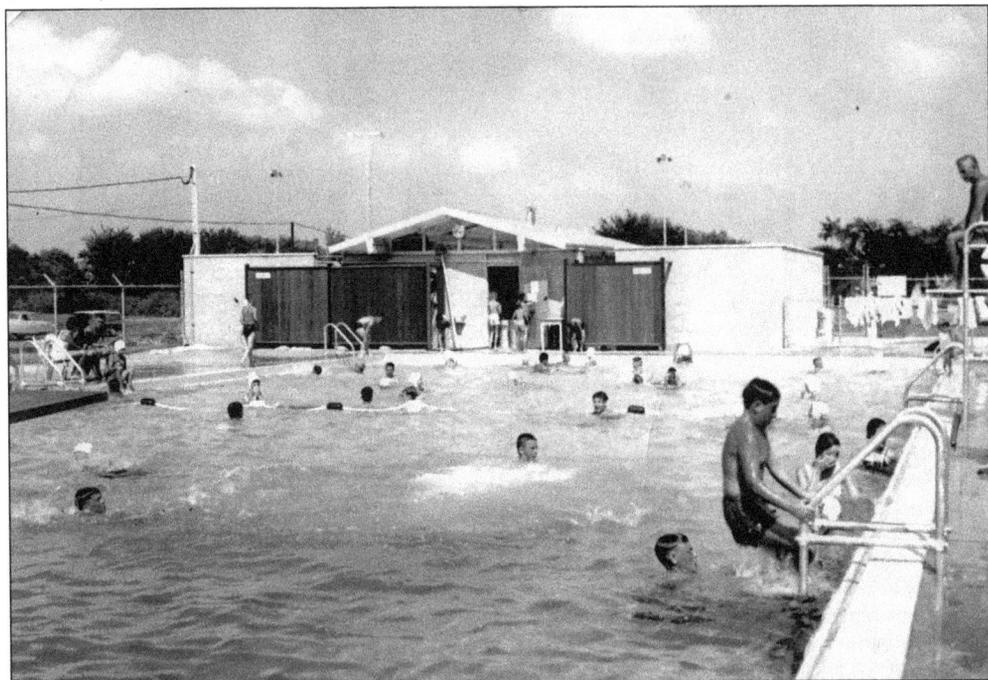

In the same year, Shiloh Pool was completed with all the amenities including a bathhouse and a diving board. Swimming became an integral part of Zion's summer recreation program. (Courtesy of Zion Park District.)

Six

WILBUR GLENN VOLIVA

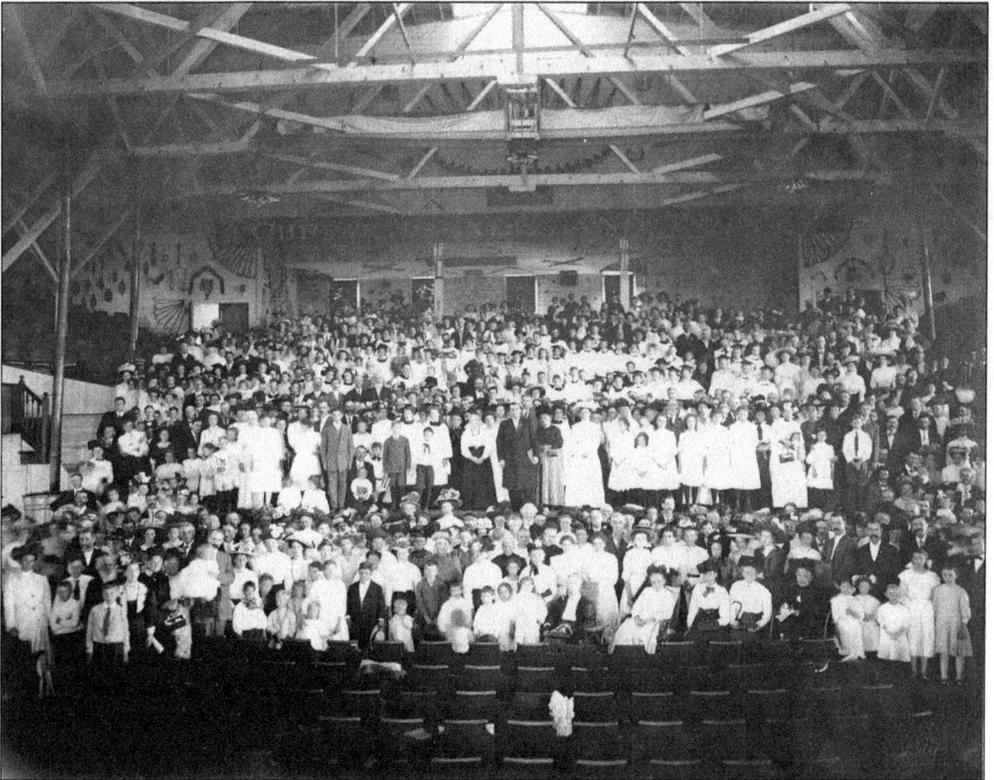

In 1906, in Shiloh Tabernacle, as Dr. John Alexander Dowie's health was declining, the Christian Catholic Church congregation rallied around Wilbur Glenn Voliva (center of photograph). Reverend Voliva was appointed by Dowie to be his successor and was then democratically elected as general overseer of the church.

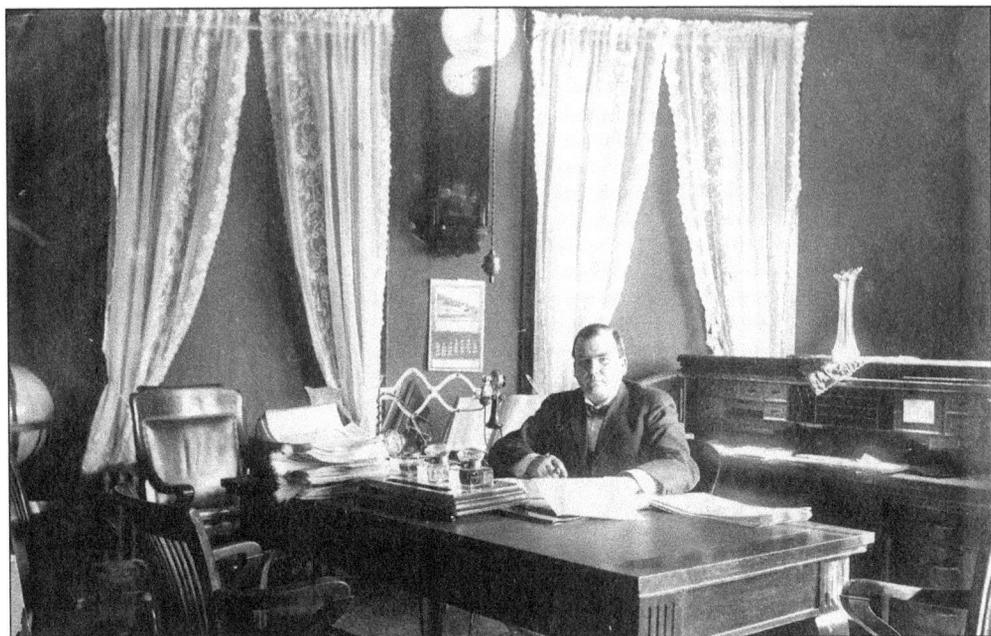

Wilbur Glenn Voliva, general overseer of the Christian Catholic Church, poses for a photograph in his office in the administration building on Sheridan Road. Perhaps he was working on the special issue of *Leaves of Healing*, in which he attempted to prove with maps, charts, and photographs his "flat earth theory." Based on a Bible verse which referenced the four corners of the earth, he believed the Earth was round and flat like a plate with the North Pole in the center and the Earth being stationary with the other planets moving around it. This theory earned him more attention than his rigorously enforced blue laws.

Mollie Steele Voliva, of Palestine, Illinois, was the wife of General Overseer Voliva. She met her husband in college, and after an appropriate courtship, they married on August 11, 1891. She was quiet, kind, and supportive of her husband's ministry. Mollie suffered for 16 months from an infection of the lymphatic glands and died February 4, 1915, at the age of 45.

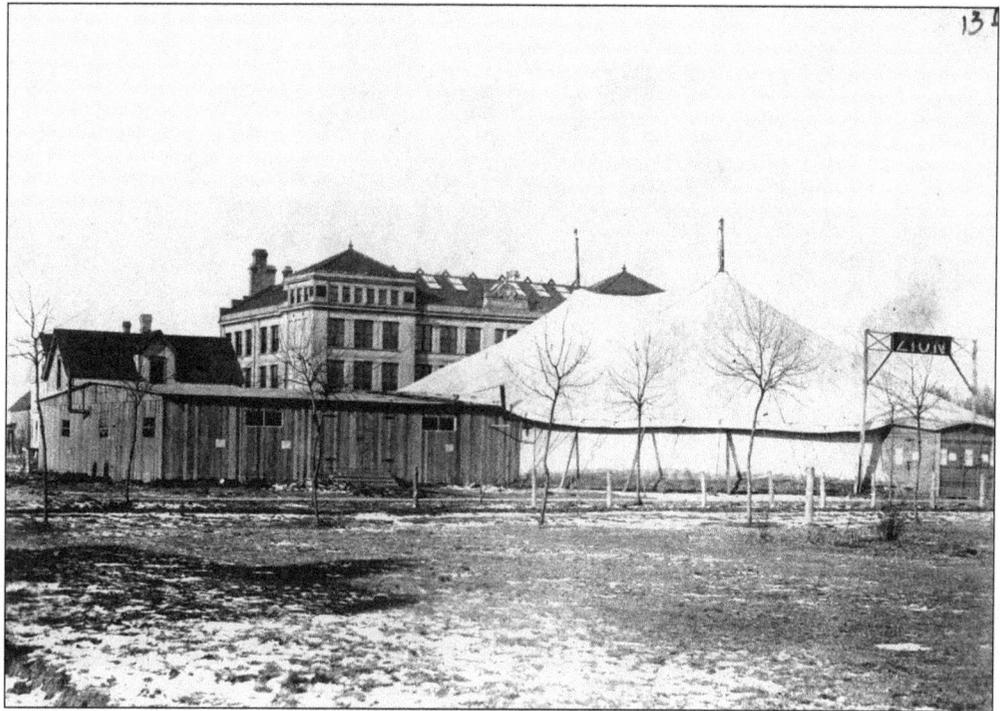

From 1906 to 1909, Zion City was held in receivership. Parishioners opposed to Reverend Voliva forced the Christian Catholic Church out of Shiloh Tabernacle. The temporary meeting place was in this tent, seating 1,200. It was erected at Emmaus Avenue and Twenty-seventh Street. The tent did have a board floor and strategically placed potbellied stoves.

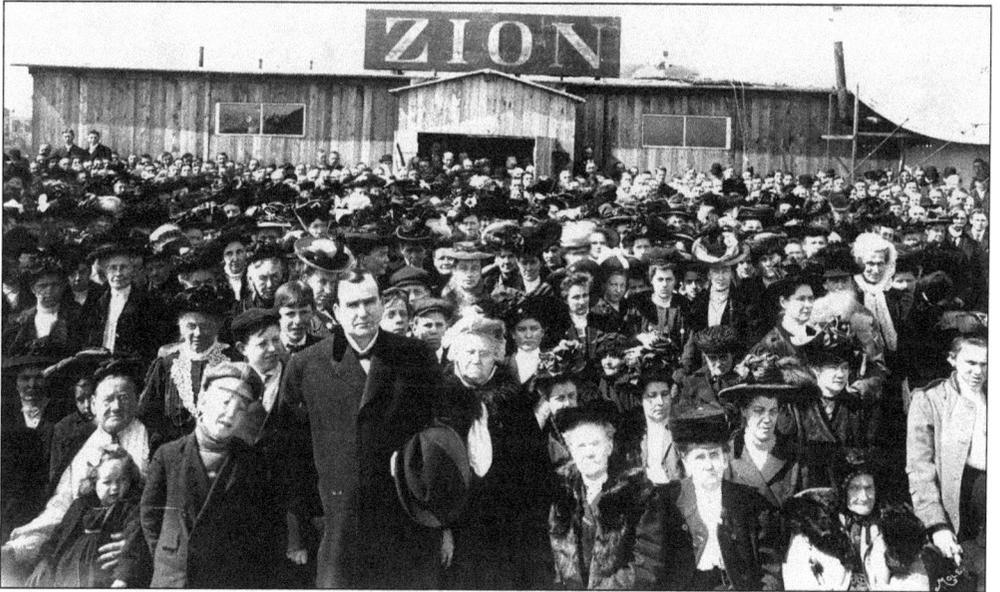

After being forced out of Shiloh Tabernacle, the Christian Catholic Church congregation met in a tent. In July 1908, Reverend Voliva negotiated the purchase of the tabernacle, paying $12,000 over a two-year period. Reverend Voliva (front center, with hat in hand) is surrounded by his loyal followers, eager to reclaim Shiloh Tabernacle.

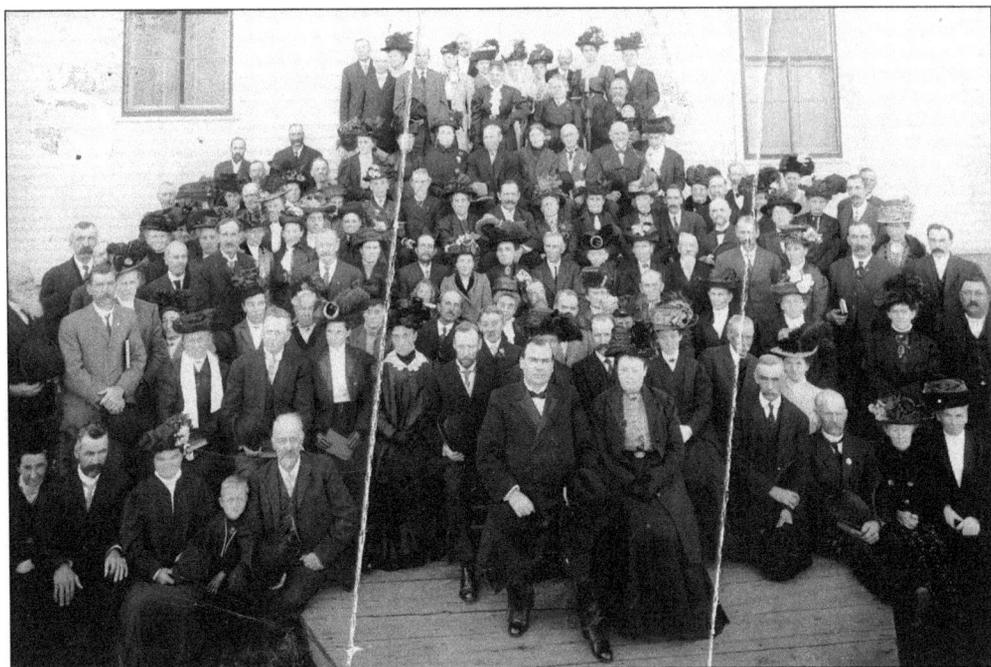

In 1910, this group of supporters, many who were church officers, "put up" their homes as security in support of General Overseer Wilbur Glenn Voliva's (front center) plan to buy back the Zion estate from the receiver. An offer of $900,000 was made. Negotiations were made through a Chicago bank, and once again, the Zion estate was the property of the Christian Catholic Church.

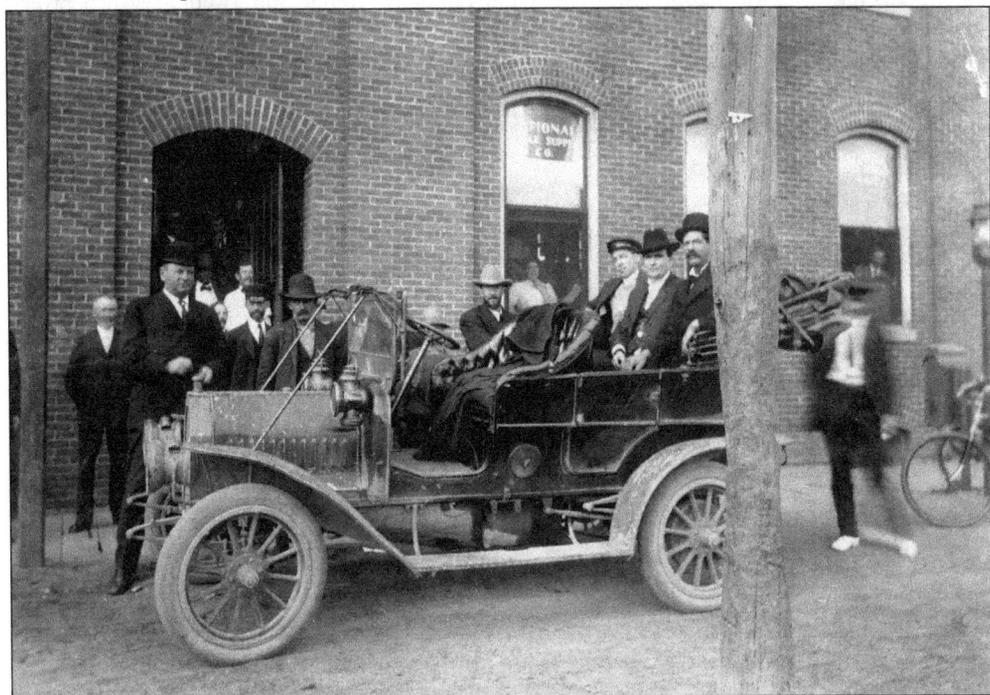

Reverend Voliva (center, in the back seat) poses proudly in his first car outside the National Office Supply Company, which was purchased from the receiver in 1908.

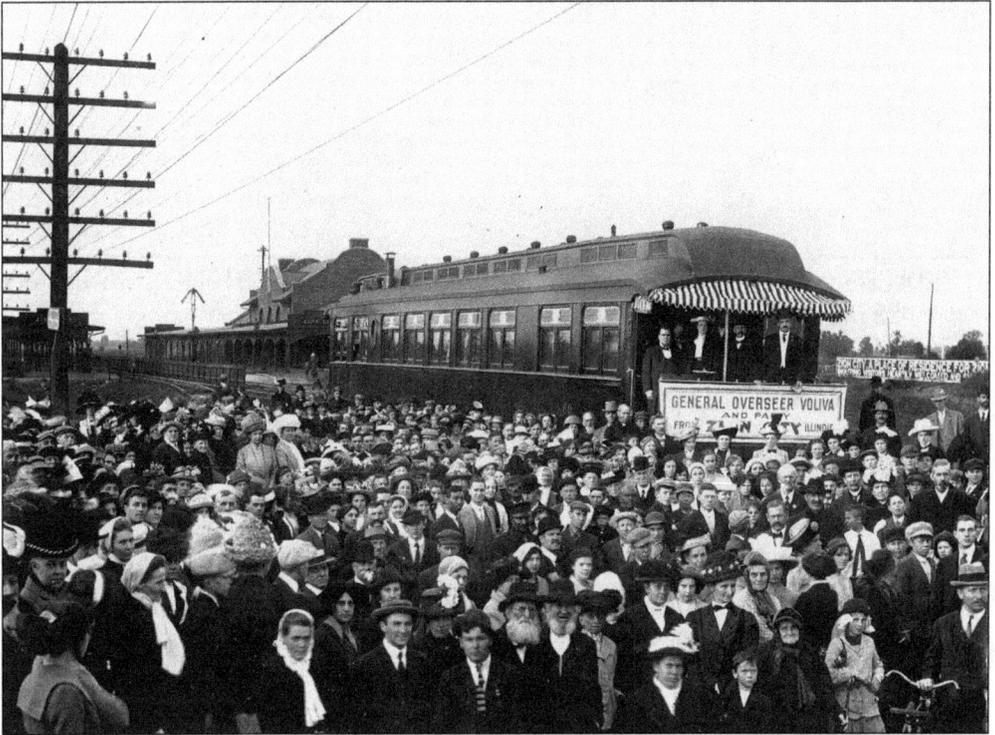

Reverend Voliva and a party of 21 were granted use of a private railway coach to transport them during their "Tour of the West Coast" which departed from the Chicago Northwestern Railroad Station in Zion City in September 1912. General Overseer Voliva planned to visit 11 communities, preaching and promoting Zion.

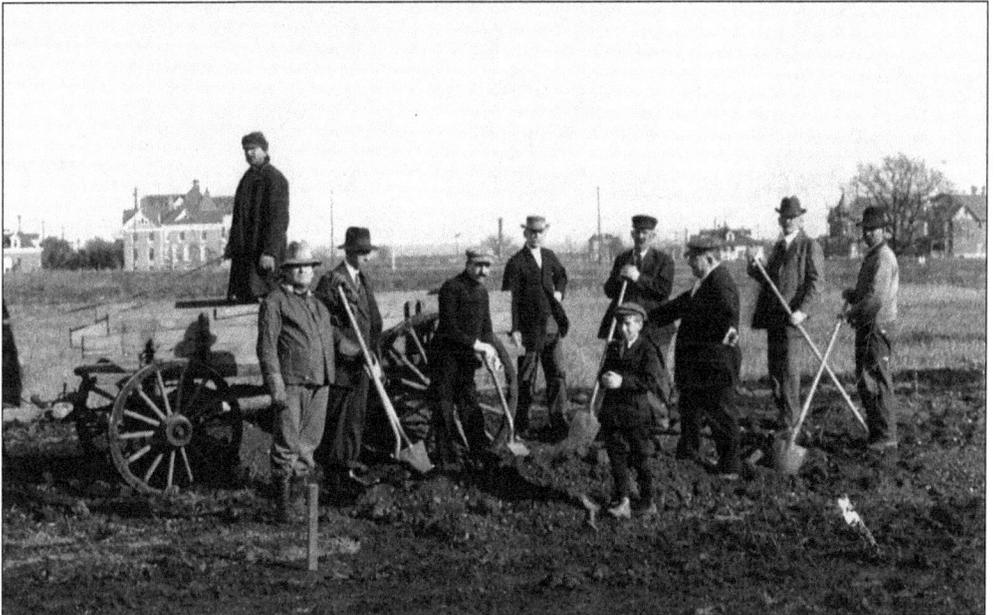

General Overseer Voliva (left, first man standing on the ground) joined a crew working on the road around the temple site in 1913.

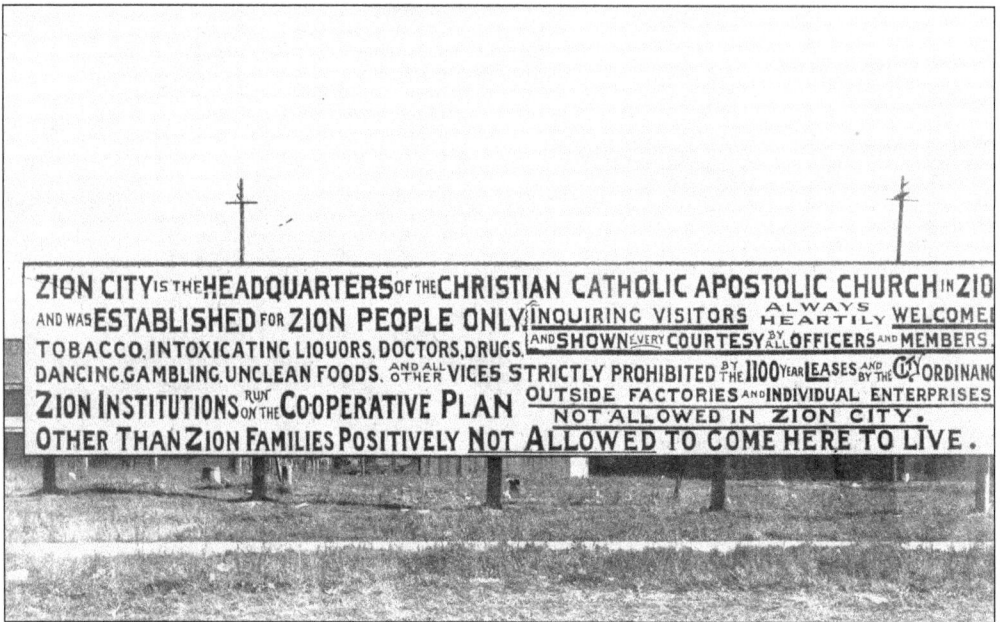

ZION CITY IS THE HEADQUARTERS OF THE CHRISTIAN CATHOLIC APOSTOLIC CHURCH IN ZIO
AND WAS ESTABLISHED FOR ZION PEOPLE ONLY. INQUIRING VISITORS ALWAYS HEARTILY WELCOME
AND SHOWN EVERY COURTESY BY ALL OFFICERS AND MEMBERS.
TOBACCO. INTOXICATING LIQUORS. DOCTORS, DRUGS. DANCING, GAMBLING, UNCLEAN FOODS. AND ALL OTHER VICES STRICTLY PROHIBITED BY THE 1100 YEAR LEASES AND BY THE CITY ORDINANC
ZION INSTITUTIONS RUN ON THE COOPERATIVE PLAN OUTSIDE FACTORIES AND INDIVIDUAL ENTERPRISES NOT ALLOWED IN ZION CITY.
OTHER THAN ZION FAMILIES POSITIVELY NOT ALLOWED TO COME HERE TO LIVE.

Once General Overseer Wilbur Glenn Voliva reclaimed the Zion estate in 1911, he became more determined than ever to enforce the "holy living" principles. He had large billboards erected at various locations in Zion City. They stated in no uncertain terms under what conditions people could live in the city.

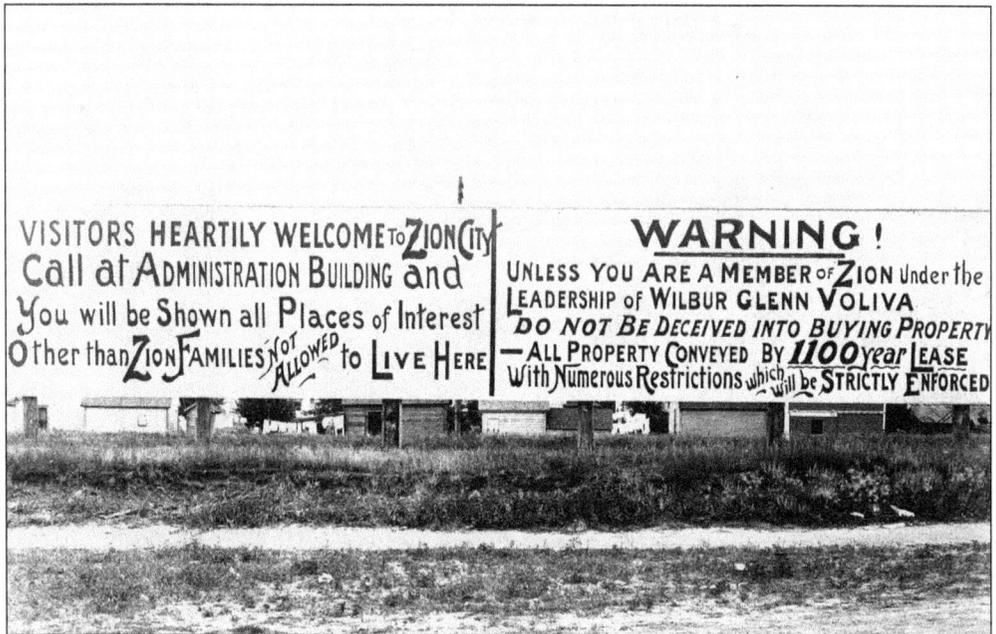

VISITORS HEARTILY WELCOME TO ZION City Call at ADMINISTRATION BUILDING and You will be Shown all Places of Interest Other than ZION FAMILIES NOT ALLOWED to LIVE HERE

WARNING!
UNLESS YOU ARE A MEMBER OF ZION Under the LEADERSHIP of WILBUR GLENN VOLIVA DO NOT BE DECEIVED INTO BUYING PROPERTY —ALL PROPERTY CONVEYED BY 1100 year LEASE With Numerous Restrictions which will be STRICTLY ENFORCED

The billboards often referred to the 1,100-year land leases, which discouraged the purchase of property in Zion City. The signs emphasized the restrictions outlined in the leases and promised that they would be strictly enforced.

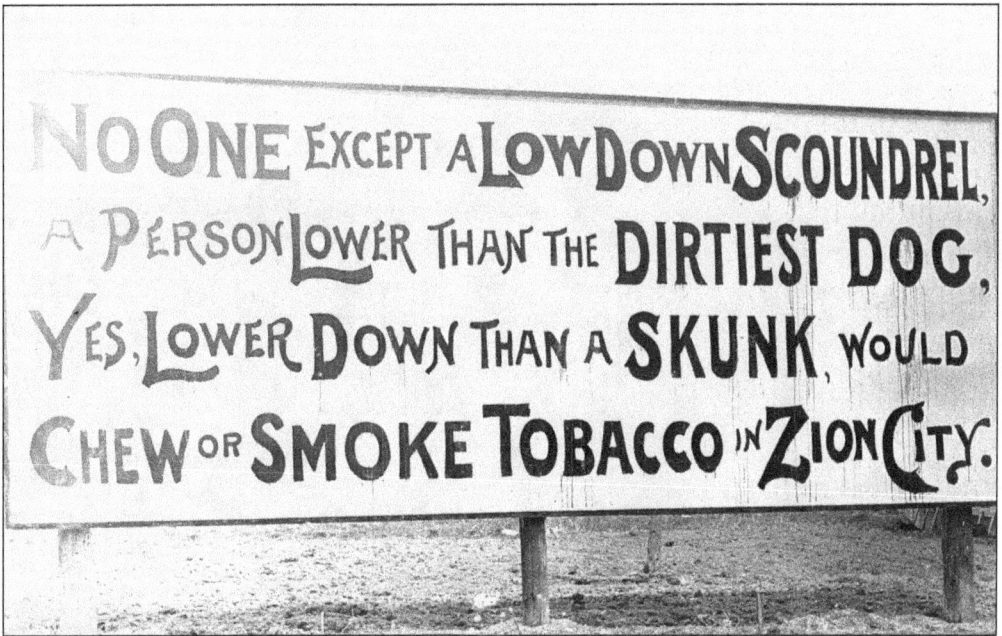

The billboards clearly stated that unclean habits like the use of tobacco, alcohol, gambling, dancing, the eating of unclean food, and doctors and drugs would not be tolerated in Zion City.

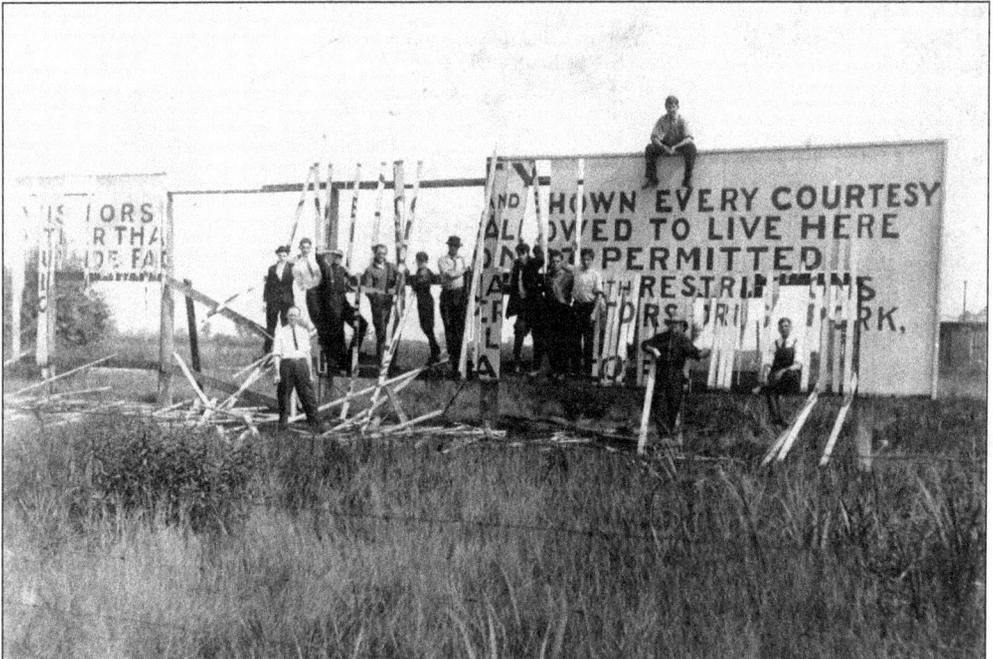

The two major factions in Zion at the time, the Voliva supporters, called Theocrats, and the Independents, often brawled over the billboards. These skirmishes became known as the "Sign Board Wars." The Independents, who opposed General Overseer Voliva's theocratic principles, often burned, tore down, or defaced the billboards. This billboard, located at Twenty-fifth Street and Deborah Avenue, fell victim to such destruction.

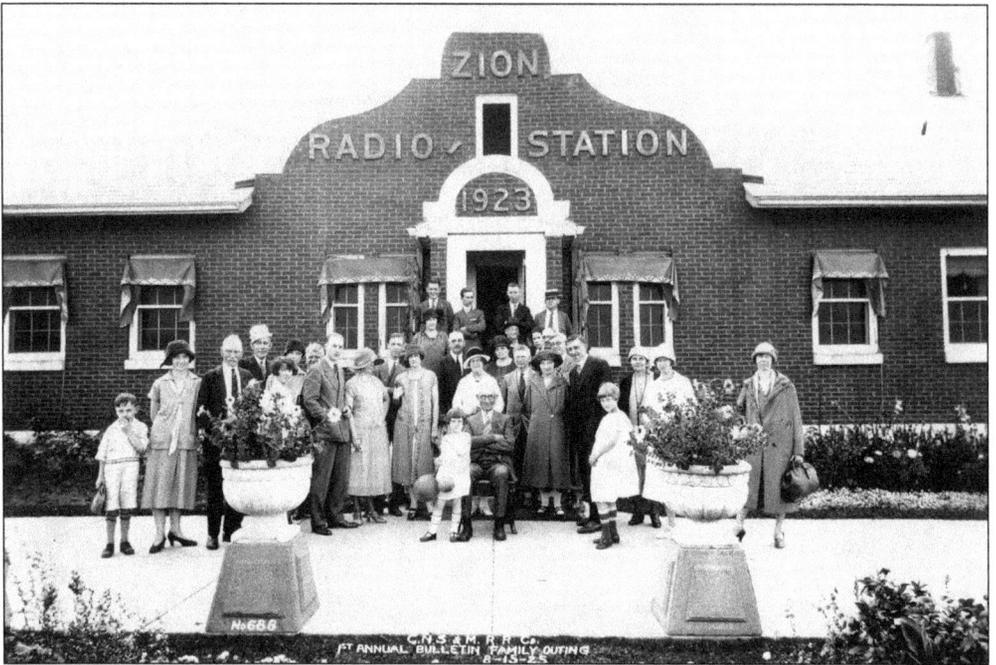

In 1922, Christian Catholic Church overseer Michael Mintern became interested in starting a radio station. In 1923, the WCBD radio station was built, and Deacon Jasper DePew became the first station manager. For many years, programs were aired all day every day with no commercial sponsorship. General Overseer Wilbur Glenn Voliva preached every Sunday afternoon and could be heard as far away as New Zealand.

Jasper Depew was appointed as the colonel of the Zion Guards and served as the chief radio announcer for Zion radio station WCBD. The radio station motto was "Warning comes before destruction." Depew is seated at the microphone in 1933.

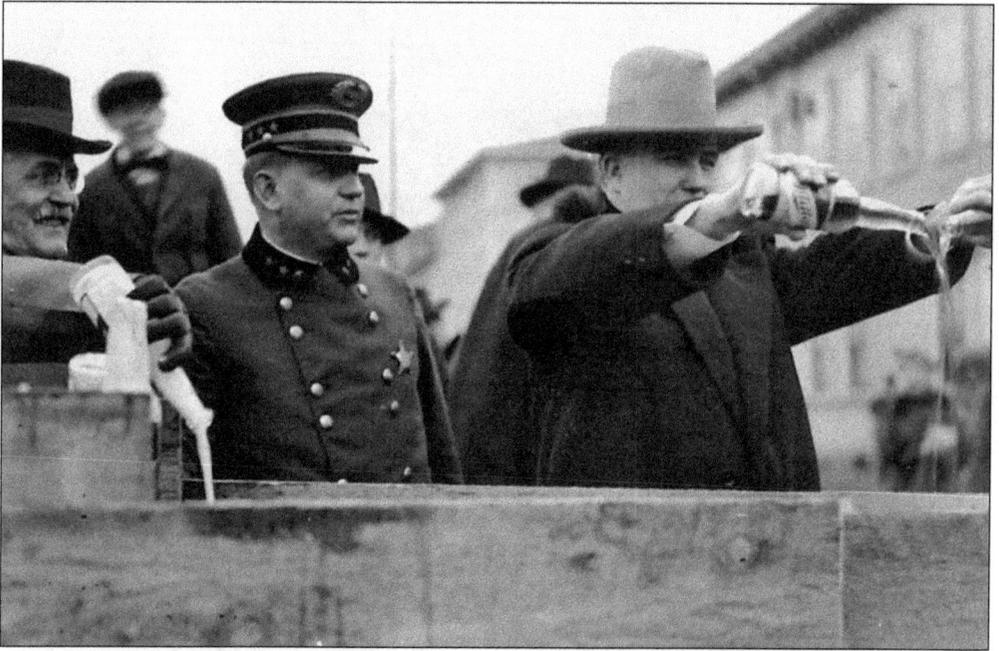

The consumption of alcohol of any kind was prohibited in Zion City. City officials (left to right) Mayor W. Hurd Clendinen, Police Chief Theodore R. Becker, and Christian Catholic Church general overseer Wilbur Glenn Voliva participated in the pouring out of gallons of beer and alcohol.

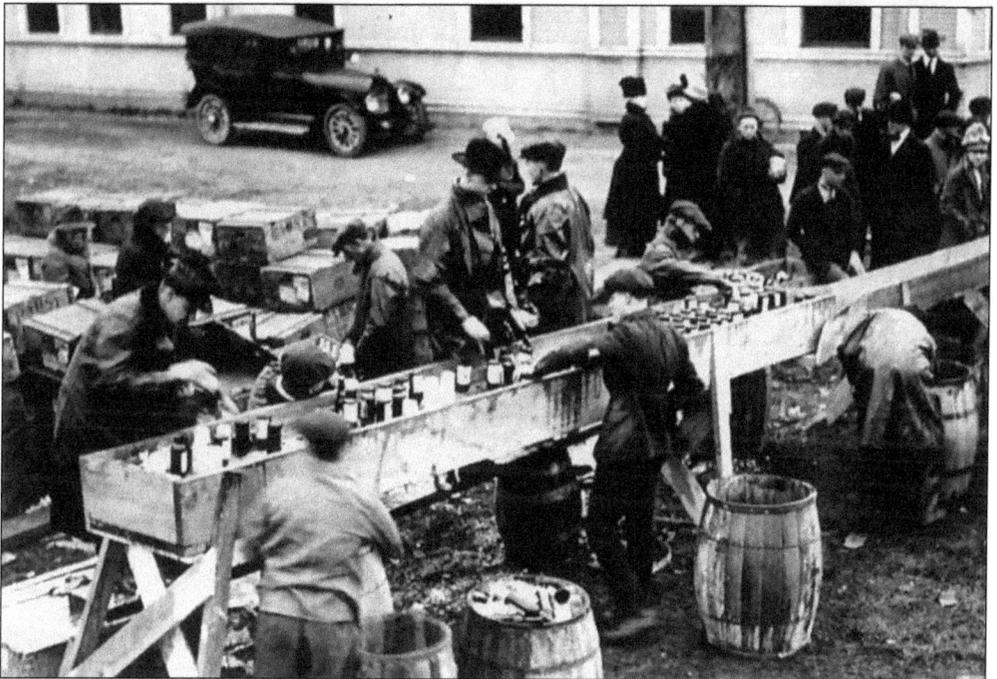

Trucks hauling beer and alcohol were not allowed to pass through Zion City. Case after case of the spirits was confiscated and destroyed. A trough was built to carry the liquor poured from bottles into the sewer.

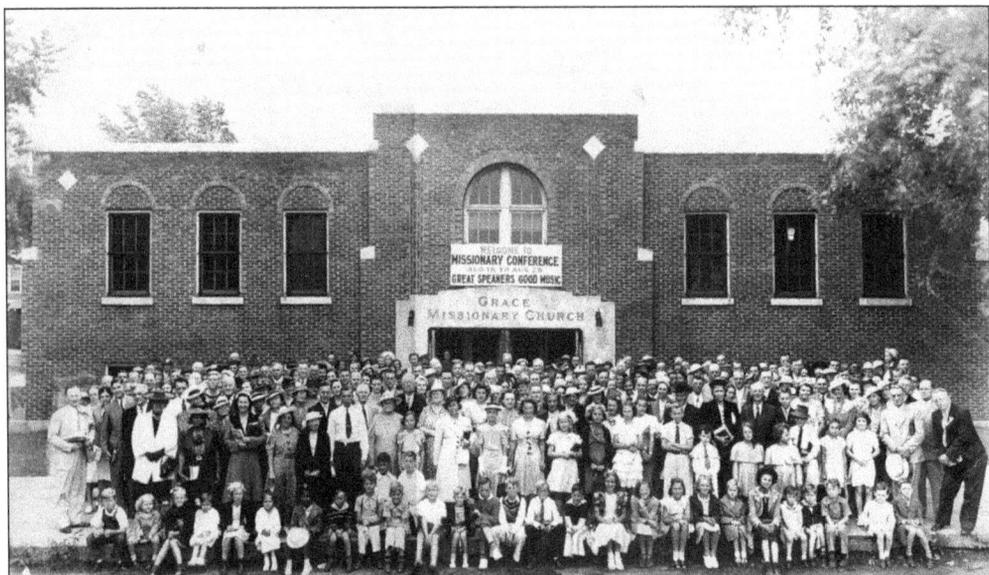

Grace Missionary Church is located at Twenty-seventh Street and Enoch Avenue. Church members attended a missionary conference there in 1940. Both Theocrats and Independents claimed to be the heir to Dr. John Alexander Dowie's theocracy, and the result was often bitter and violent partisanship in both religious and political affairs. General Overseer Wilbur Glenn Voliva, a Theocrat, referred to Grace Missionary Church, a congregation of Independents, as the "Goat House."

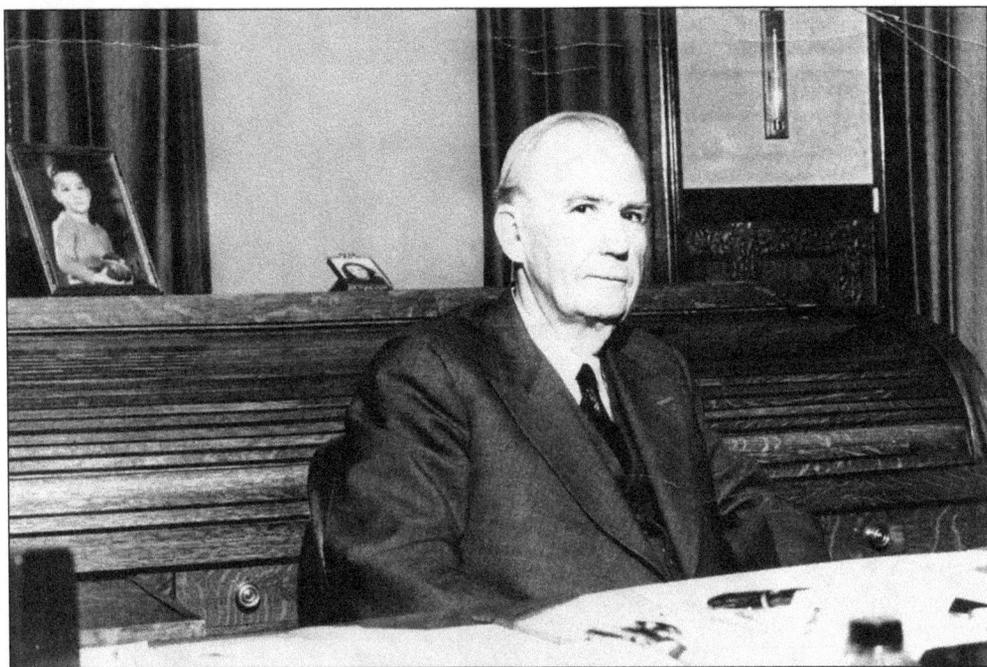

General Overseer Voliva sits at his desk in 1940. From 1939 until the spring of 1942, he was intermittently residing in Zion. Due to poor health, he spent the greater part of his time in Florida. He returned to Zion in the summer of 1942 but was unable to return to his southern home. He died in Zion in October 1942.

98

Seven

ZION INSTITUTIONS AND INDUSTRIES

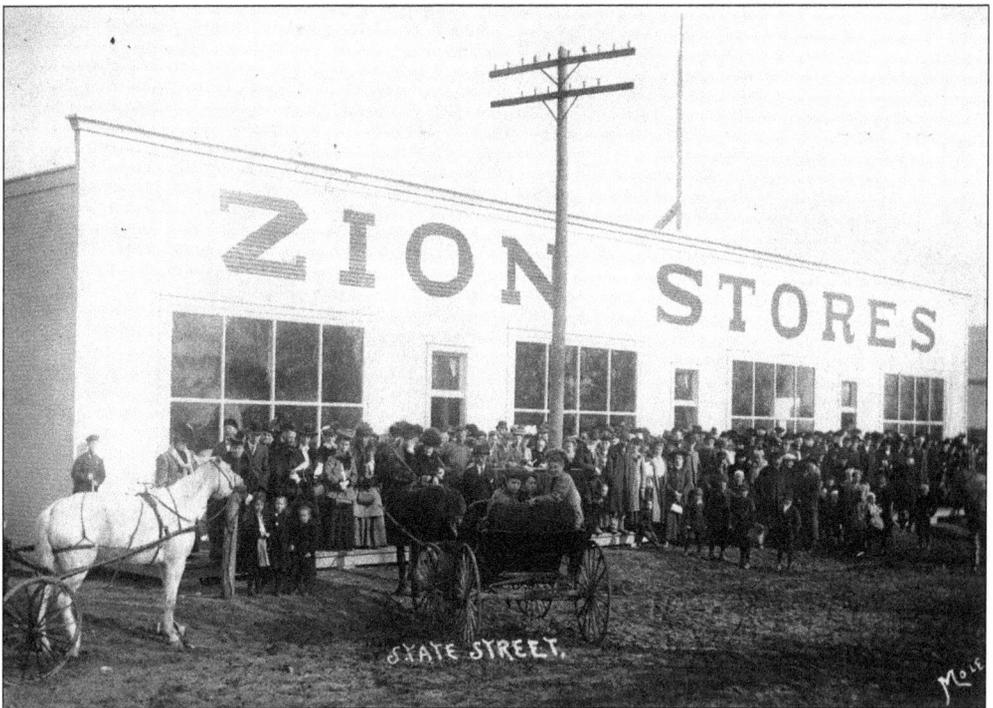

In the early 1900s, Zion Stores was located on South Sheridan Road near Thirty-fifth Street.

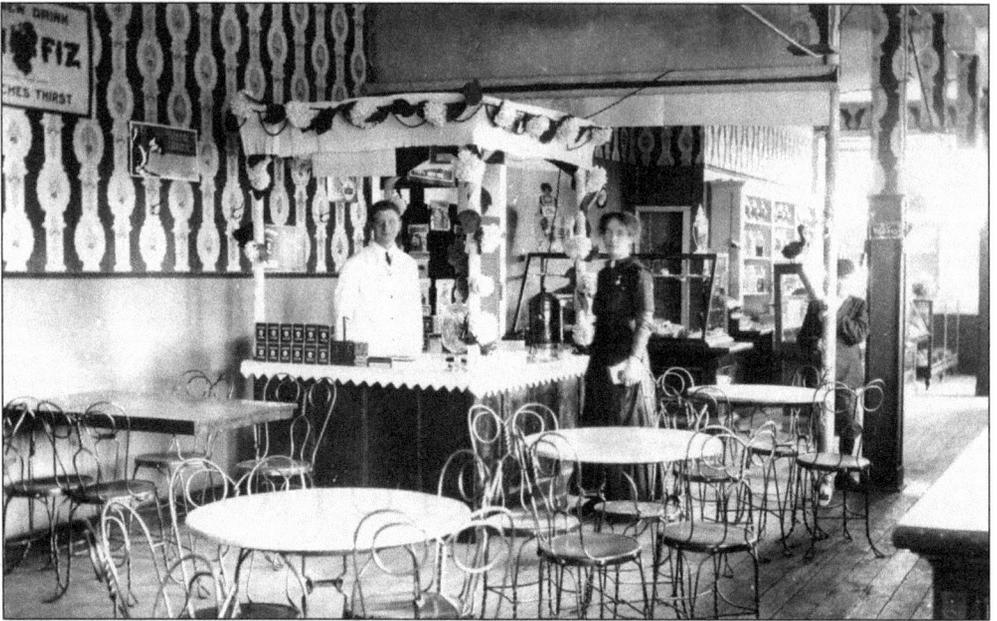

In the early 1900s, a restaurant and ice cream parlor, with candy counter and soda fountain, was located in the Zion Stores.

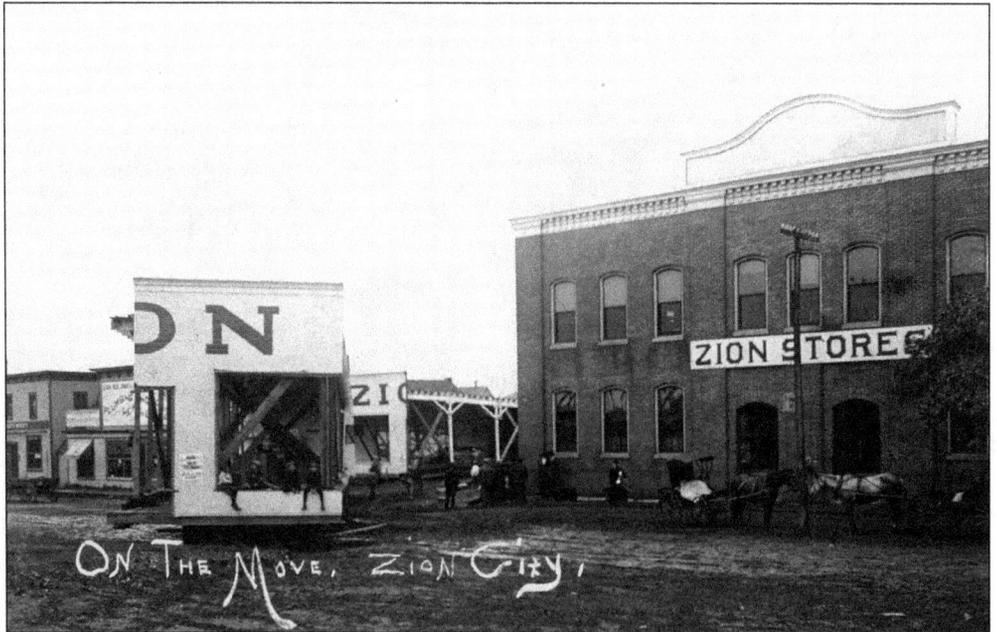

In 1908, Zion Stores was moved to Twenty-seventh Street and Sheridan Road.

In the early 1900s, Zion City Fresh Food Supply served the public from its location on the southwest corner of Twenty-seventh Street and Sheridan Road (Elijah Avenue). Behind the food supply, across the alley, was Johnson's Livery Office. The intersection of Twenty-seventh Street and Sheridan Road became the thriving center of Zion City's shopping district.

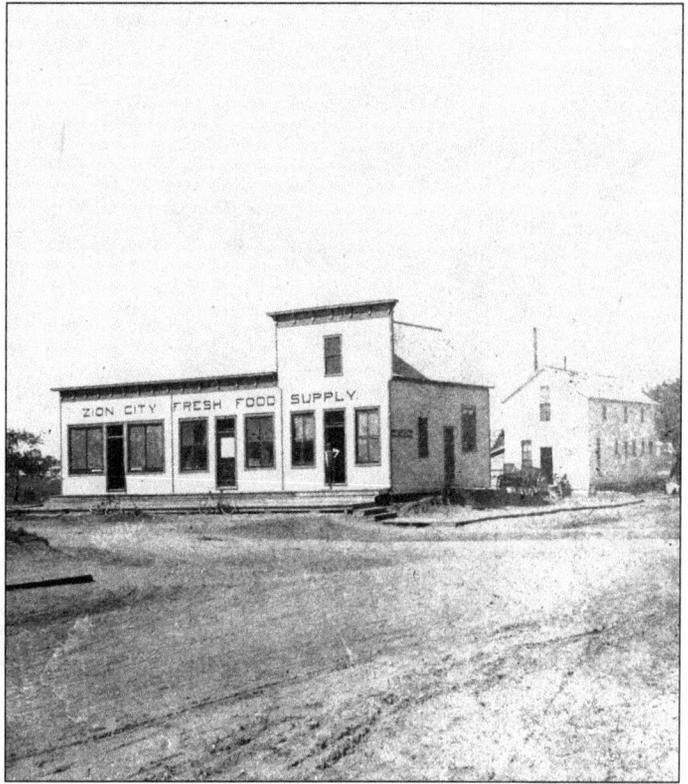

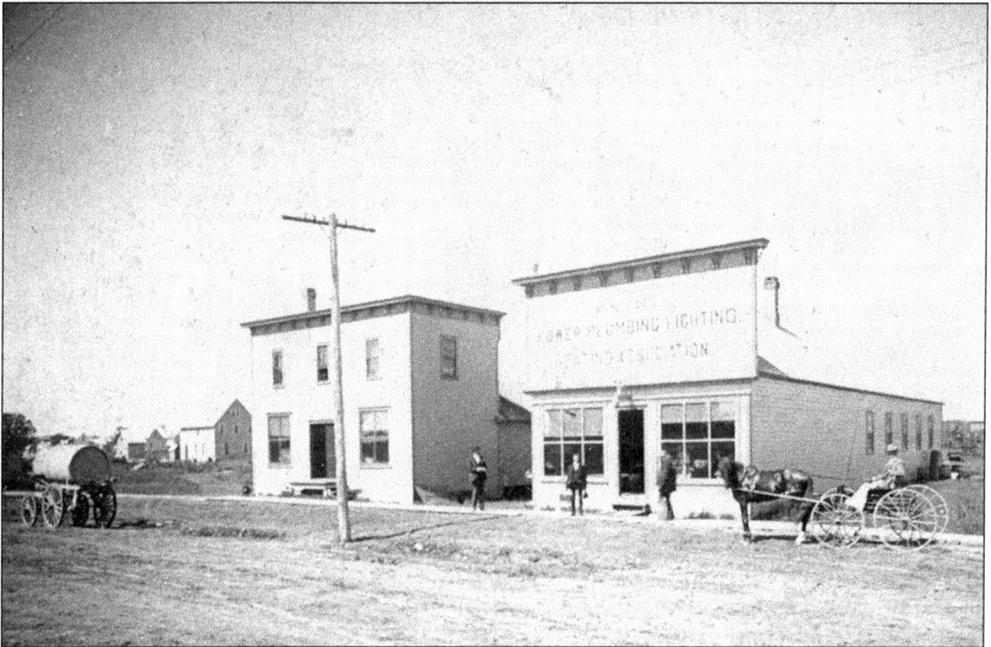

Around 1900, the Zion City Power, Plumbing, Lighting and Heating Association building (right) was located at Twenty-sixth Street and Sheridan Road.

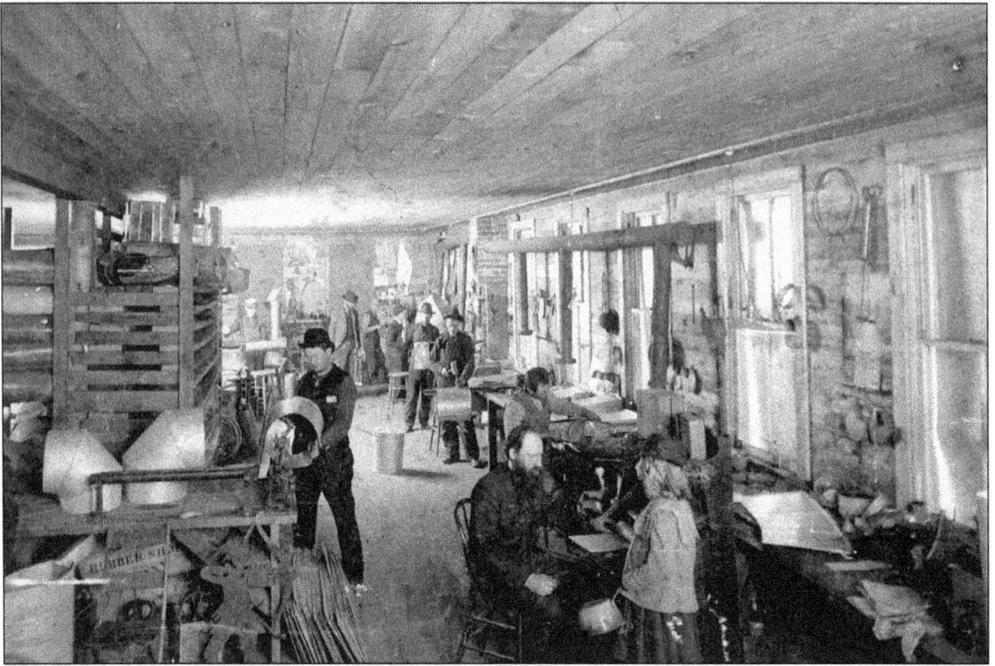

In the heating and plumbing workshop in the rear of the Zion City Power, Plumbing, Lighting and Heating Association building, tinsmiths use a vise and hand tools to roll sheets of tin into ductwork.

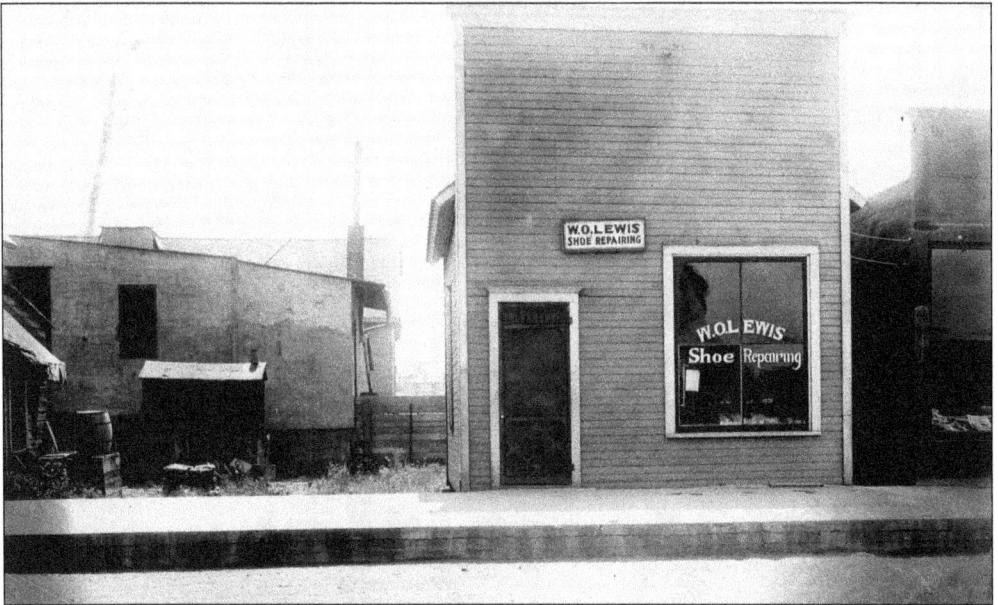

W. O. Lewis's shoe repair shop was located on the south side of Twenty-seventh Street west of Sheridan Road. Other businesses on the block in 1910 were Rose Mercantile, Sabine Meat Market, Rockefeller Grocery, Marvin and Vinnedge Barbers, Cutler Meat Market, Andrew Moe Bookstore, and Newton Hoyt's Variety Store. The business community was sharply divided by church affiliation and economic rivalry. These stores were owned by Independents and were referred to as "Rat Row" by General Overseer Wilbur Glenn Voliva, a Theocrat.

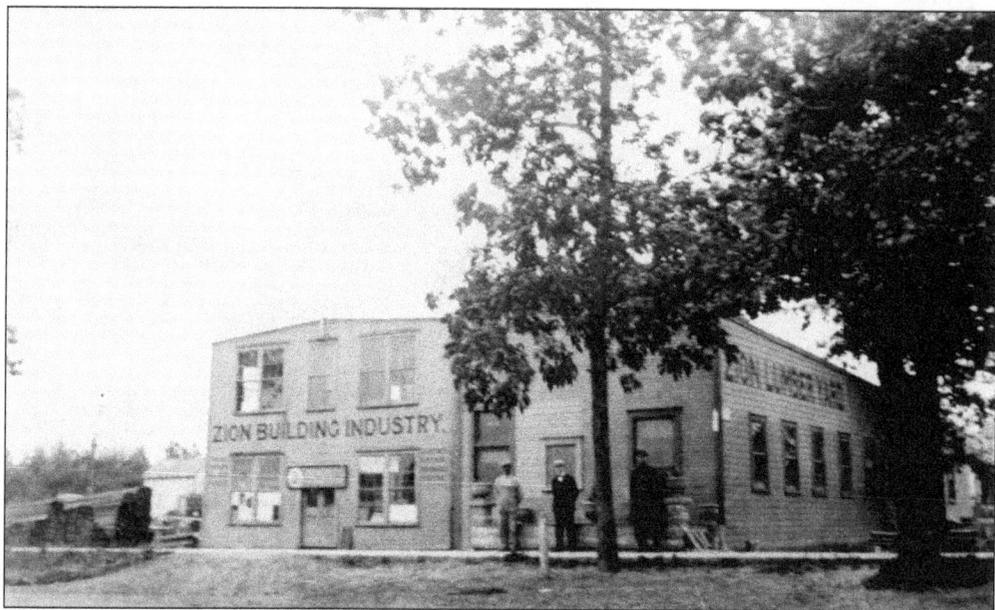

The Zion Building Industry Offices and Zion Lumber Yard was located at Twenty-ninth Street and the Chicago Northwestern Railroad tracks. Building was at its peak in the summer of 1902. In May alone, 100 to 125 wagonloads of lumber were delivered to construction sites throughout the city. The yard employed 30 men, and 4 men worked in the office.

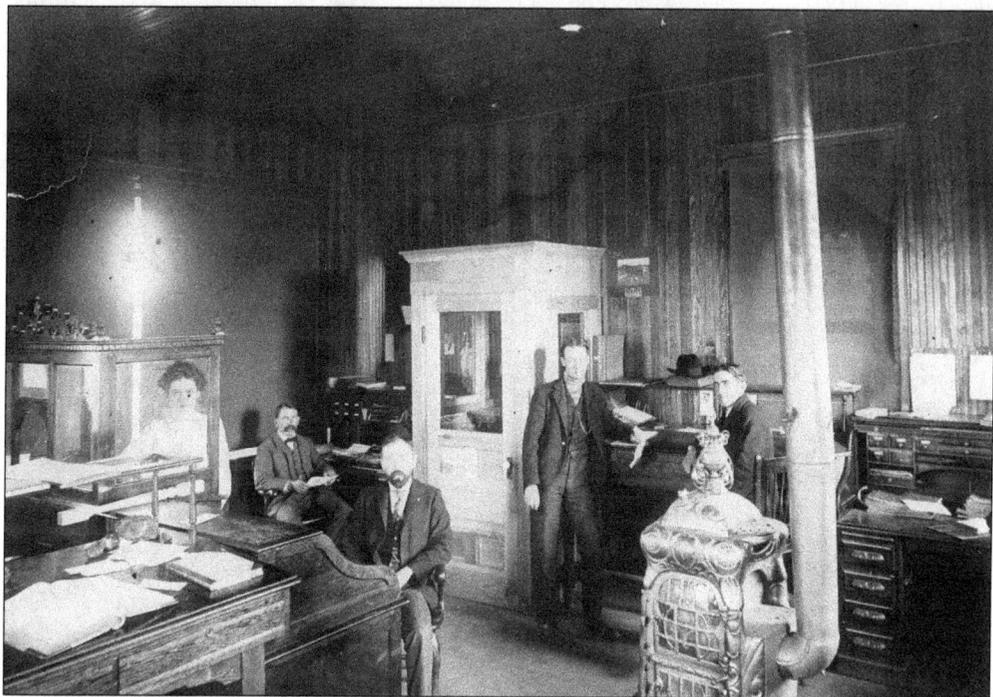

Employees at the Building Industries Office kept construction affairs in order. The Zion Manufacturing and Building Association was created in March 1903. It was to be a profit sharing venture. Shares were sold for $20, so workers could afford them. Seven percent interest was paid after the first six months.

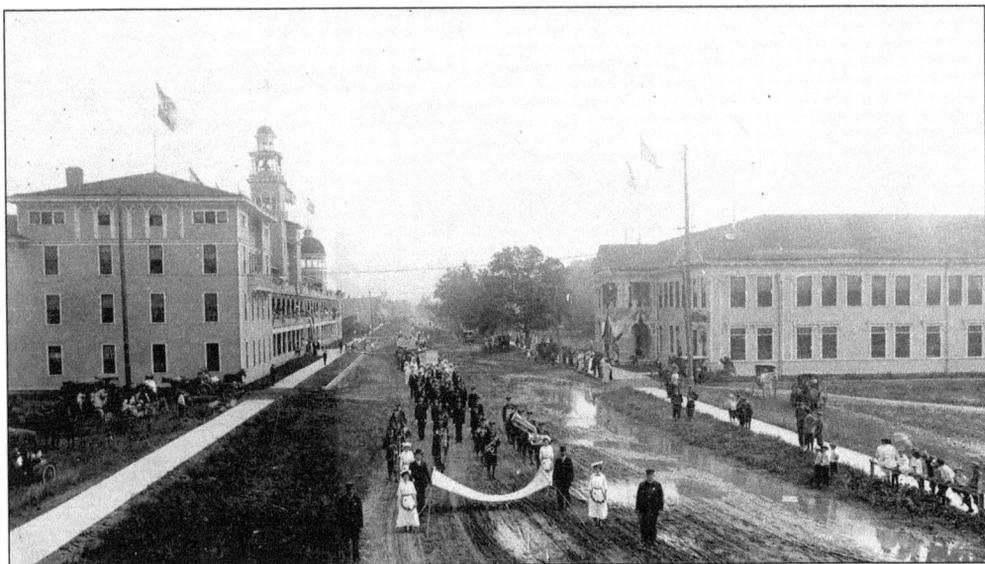

In July 1902, the Industry Day parade proceeded north on Elijah Avenue (Sheridan Road) in celebration of Zion City's industrial growth. Dr. John Alexander Dowie and his wife, Jane, viewed the parade from the balcony of the administration building (right). Of the 2,000 people that passed by, over 1,700 were Zion Institutions and Industries employees. Twenty-nine industries and institutions participated, each displaying their own banner. All marchers wore a wide sash displaying Zion's colors—blue, white, and gold—draped from the right shoulder to the left hip.

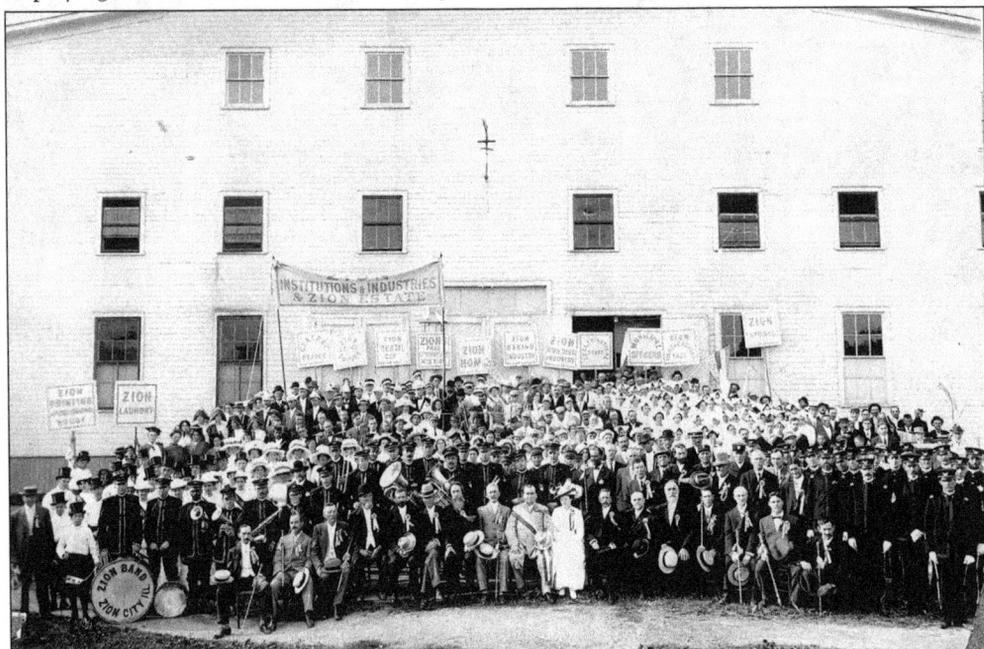

From 1902 until Dowie's death in 1907, the Industry Day parade participants proceeded to Shiloh Tabernacle to hear Dowie address the crowd. Members of the mounted police, Zion city band, Zion Guards, the mayor and city officers, and the industries and institutions employees filled every seat in Shiloh Tabernacle. In this 1912 photograph, General Overseer Wilbur Glenn Voliva (seated, center, next to Mollie Voliva dressed in white) delivered the address.

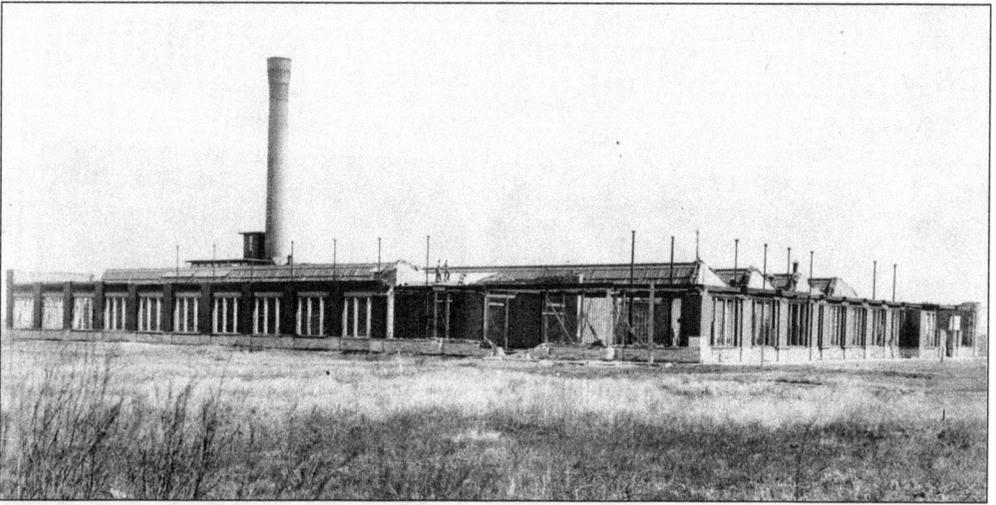

The Zion Printing and Publishing building was built on the corner of Twenty-fifth Street and Deborah Avenue. *Leaves of Healing* was printed here along with tracts, sermons, testimonies, and literature. Printing services were sold to other customers needing printing in large volumes. Color presses were installed to offer high-quality printing. This building later became home to the office supply company of Burgess, Anderson and Tate.

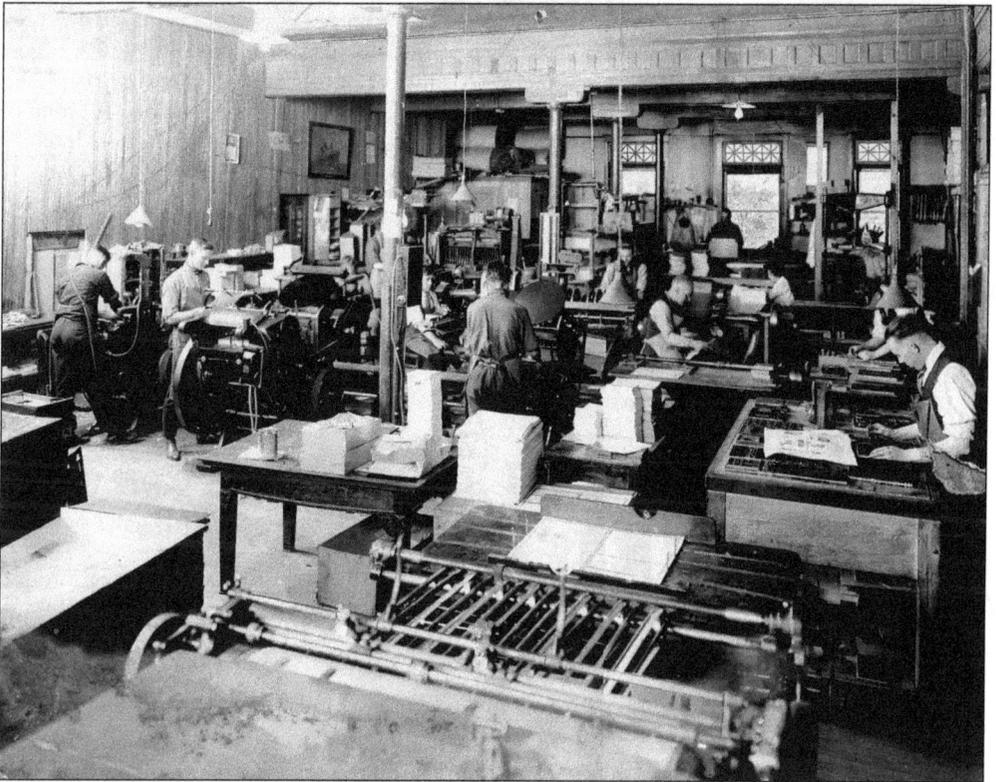

Pressmen demonstrate their skill printing *Leaves of Healing* (right) and various small tracts (stacked on the table, center) promoting the work of the Christian Catholic Church.

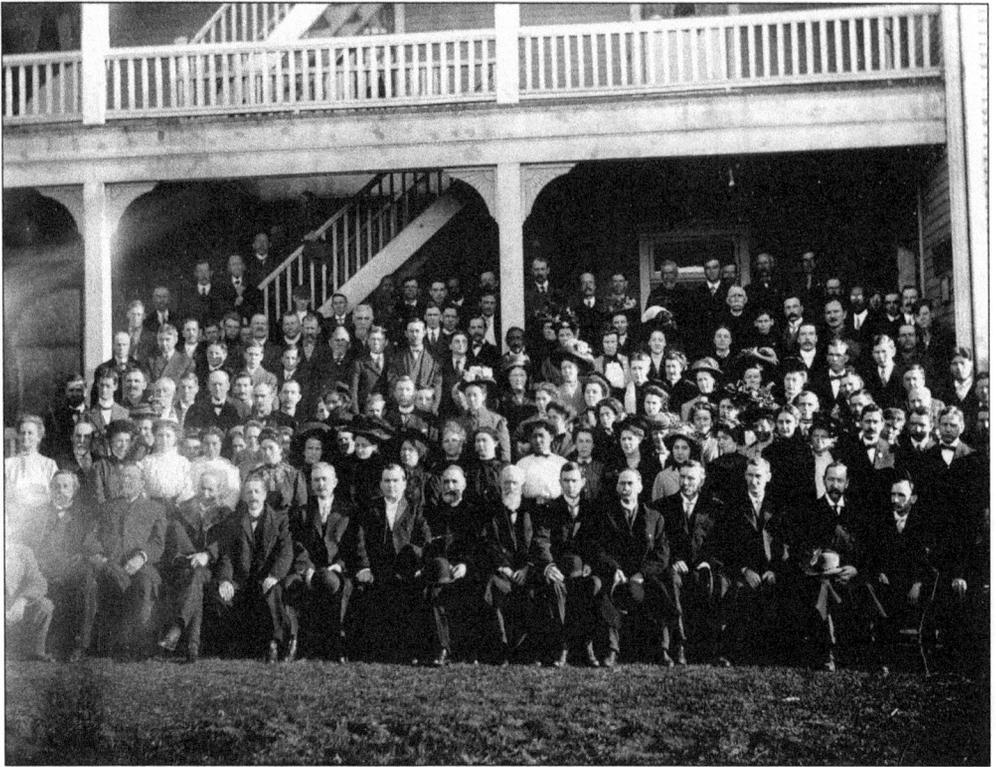

The Zion Institutions and Industries were owned and operated by the Christian Catholic Church. They provided employment and goods and services for Zion City residents. A group of church officers and industry employees are pictured here in 1916 in front of the Zion Hotel on Twenty-sixth Street and Sheridan Road.

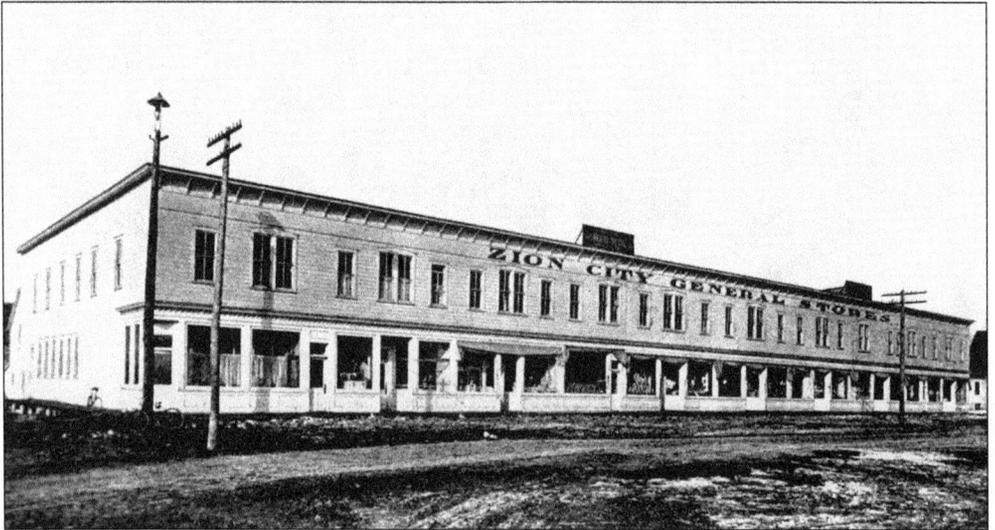

Zion Department Store, operating as part of Zion Institutions and Industries, occupied the entire block between Twenty-sixth and Twenty-seventh Streets on the west side of Sheridan Road from 1907 to 1954. It sold goods via more than 16 "departments" offering produce, groceries, clothing, hardware, pottery, millinery, shoes, toys, plumbing, meat, and the like.

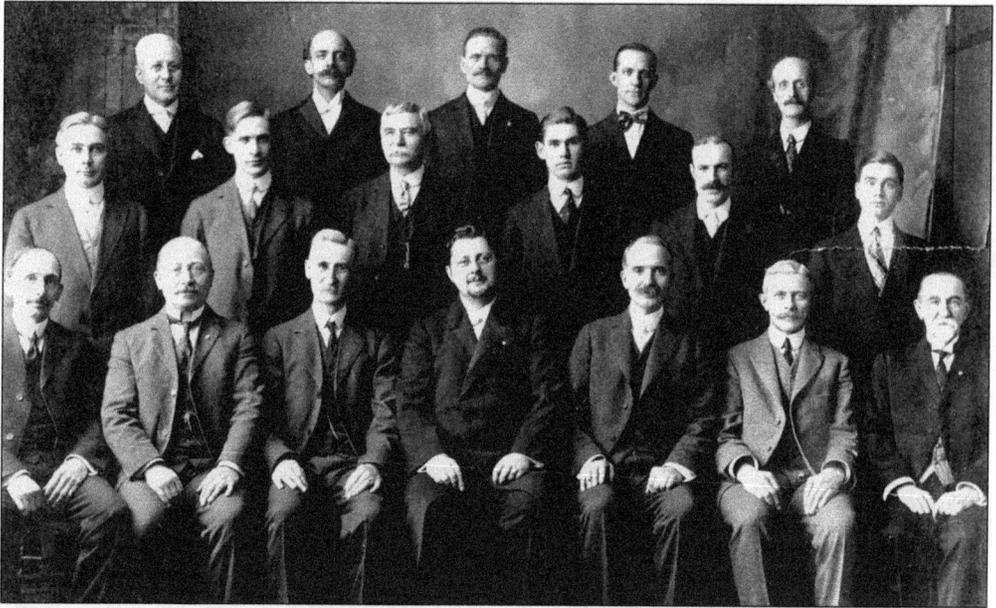

A manager oversaw each department of the Zion Department Store. The managers were photographed in 1915. The managers are, from left to right, (first row) W. J. Bull (bank), A. Bolken, John Dow, William E. Schmalfuss (grocery), William Greenfield, William Valkenaar (dry goods), and R. Stewart; (second row) ? McNeil, Harry Taylor, Charles Nelson, Ivan Beall, Charles Butz (barber), and Ray Congdon; (third row) Charles Bilby, Otis Scripter (undertaker), Grant Biddle, John Taylor, and A. E. Sach.

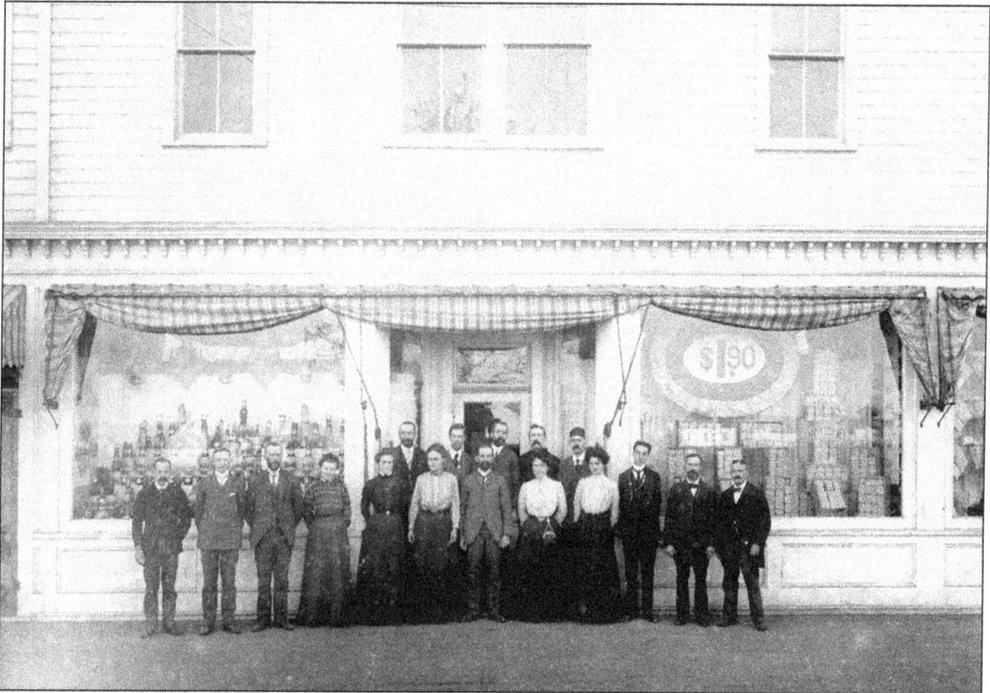

In the early days, employees stand on the board sidewalk in front of the windows of the grocery department of the Zion Department Store on Sheridan Road.

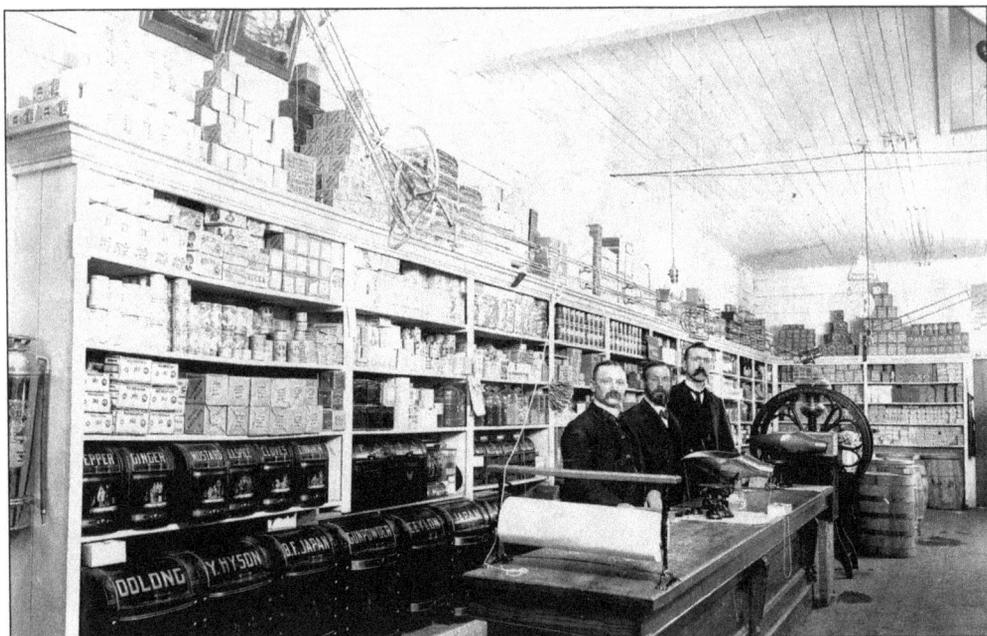

The interior of the grocery department, managed by William E. Schmalfuss, offered all the staples required to prepare the best meals in any Zion kitchen. The shelves were lined with essentials such as cocoa powder, baking soda, spices, and tea.

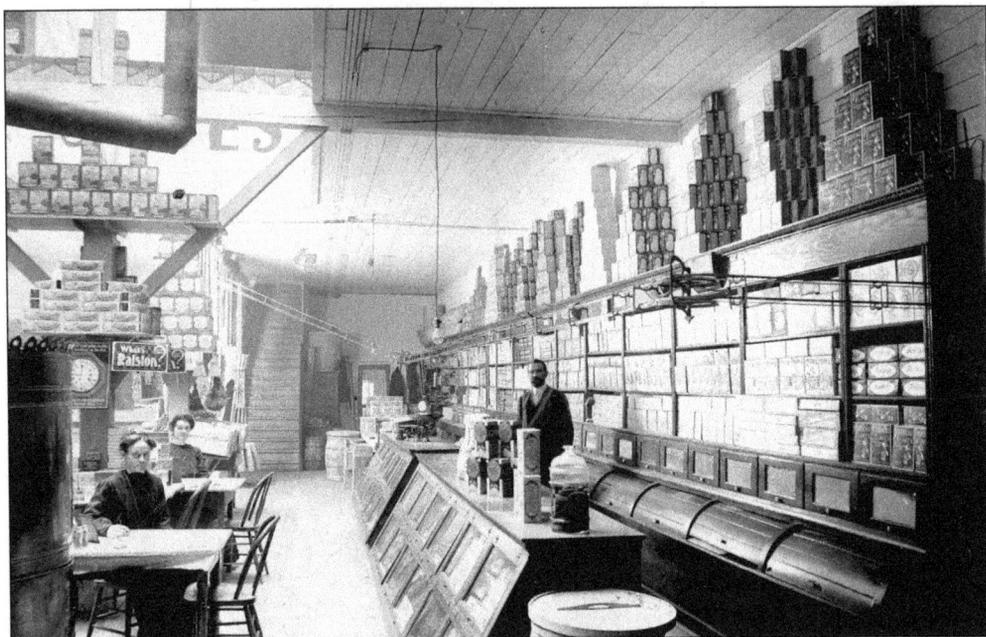

Items for the grocery department, as well as the other departments in Zion Department Store, were purchased in bulk and sold at just enough over purchase price to cover the cost of shipping and handling. The Zion Department Stores were established based on profit sharing and customers would realize a return proportionate to the amount they spent. The section of the department shown here sold oats, rice, and cereal from the bins behind the counter and pickles from the jar at the end of the counter.

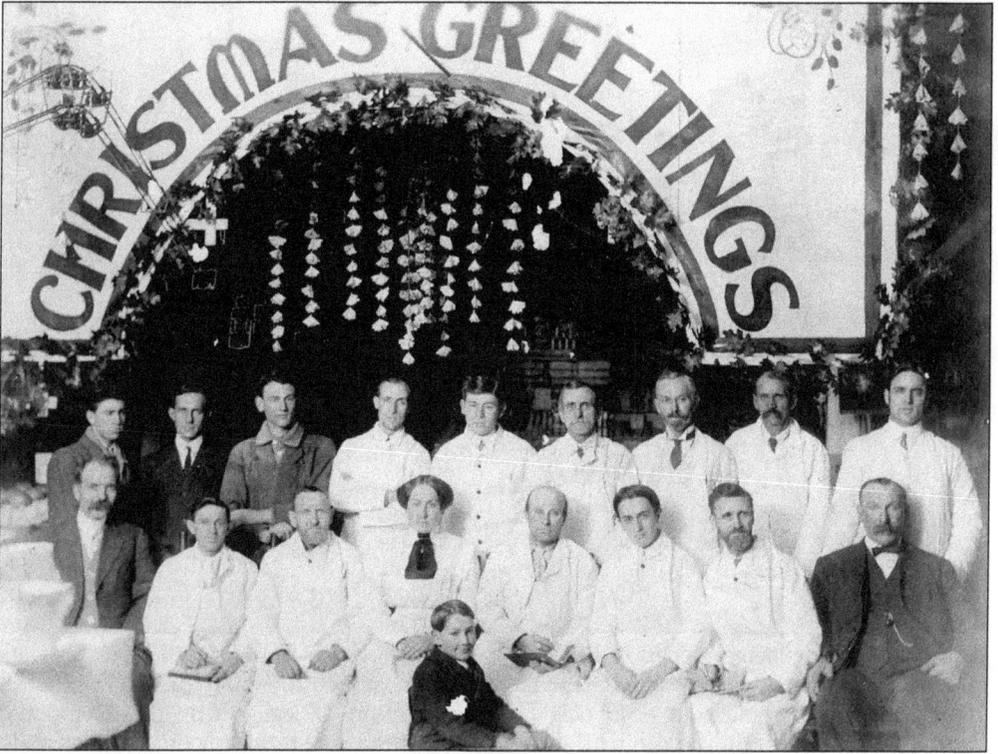

Zion Department Store grocery department clerks and deliverymen celebrate Christmas in 1916.

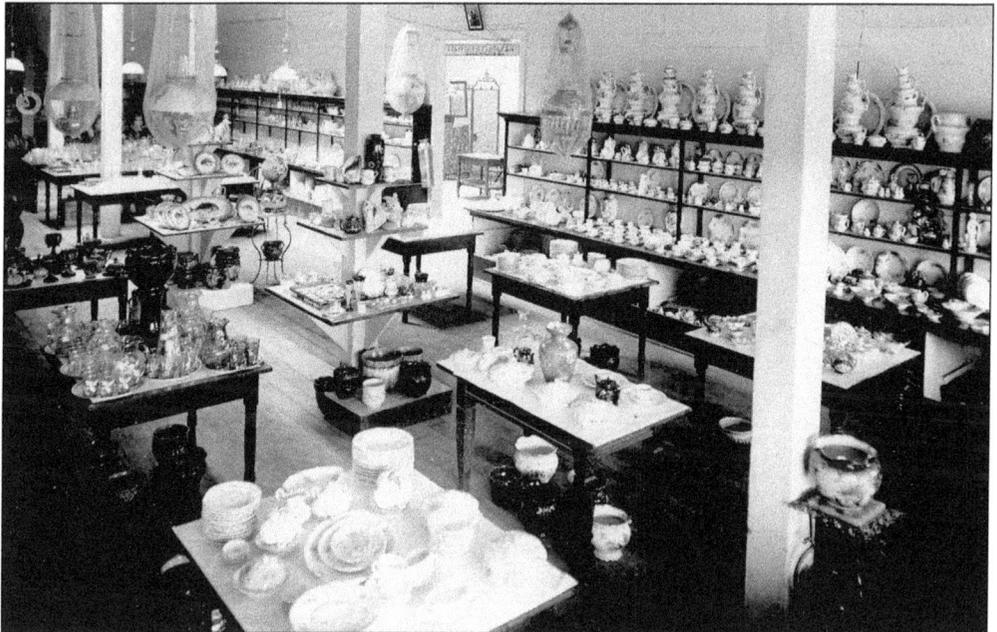

Zion Department Store boasted a fine pottery, china, and glassware department. Pitcher and bowls, teapots, beverage sets, vases, flowerpots, platters, and complete sets of fine china were among those items for sale.

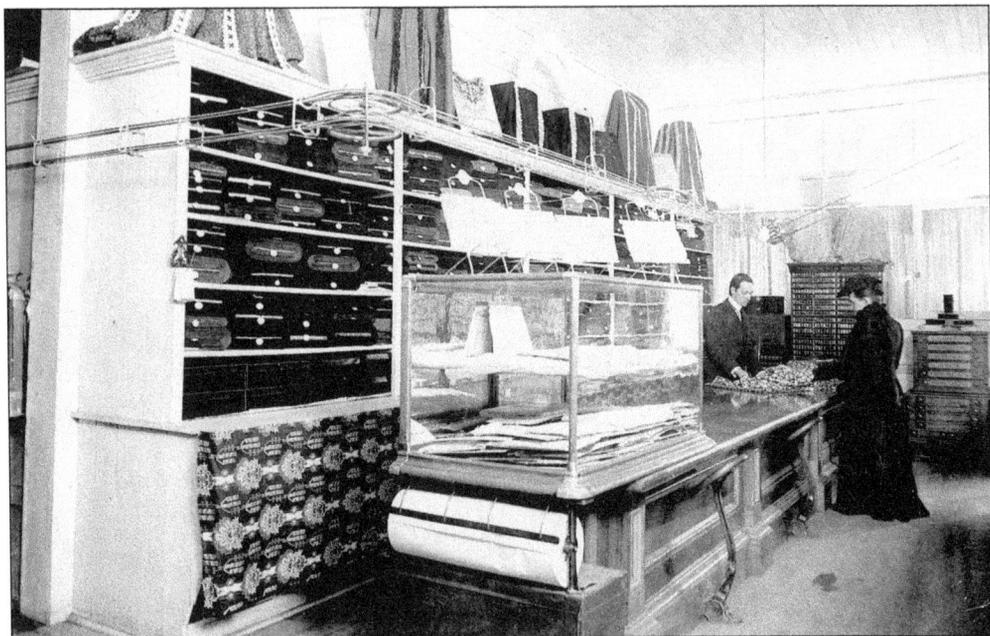

A dry goods department was part of the Zion Department Store. In the early 1900s, this clerk assisted his customers with the purchase of fabrics, trims, lace, buttons, and thread. The shelves behind the counter hold bolts of fabrics. The glass case on the counter (in the foreground) displayed lace and trims. The cabinets at the far end of the counter neatly organized threads, buttons, and other small notions.

The first men's clothing department of Zion Department Store was located on the upper level. Bowties and long johns hang on the wire stretched over the counter (left). Neckties are on display in the glass case. Wool jackets are arranged in three piles in the foreground. Hatboxes and trousers are neatly stacked on tables along the wall (right).

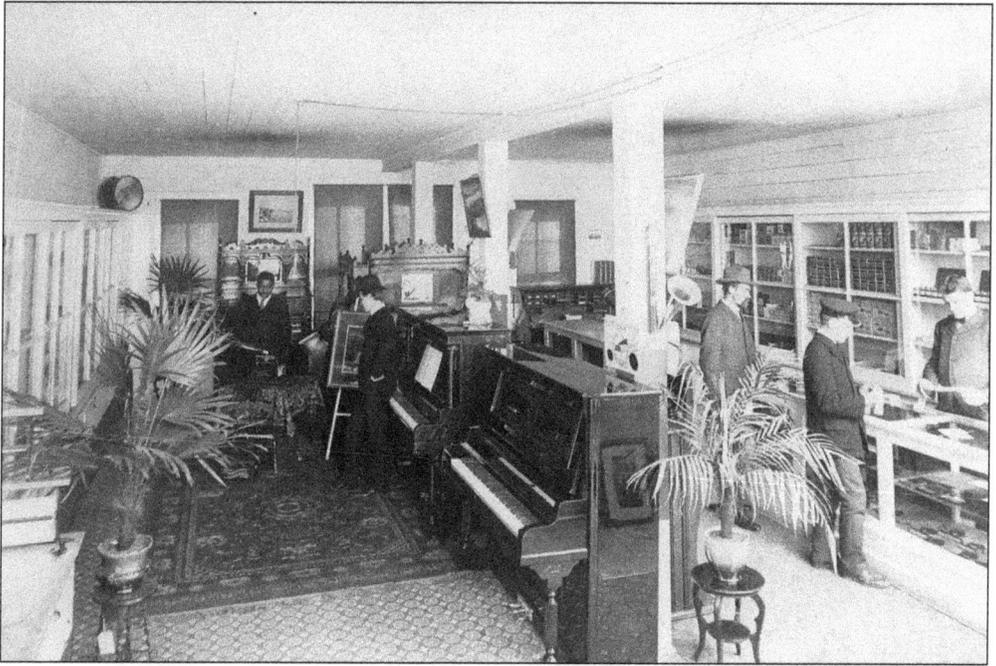

The music department of Zion Department Store catered to Zion residents with an ear for music. Along with sheet and music primers, it sold organs, pianos, and phonographs.

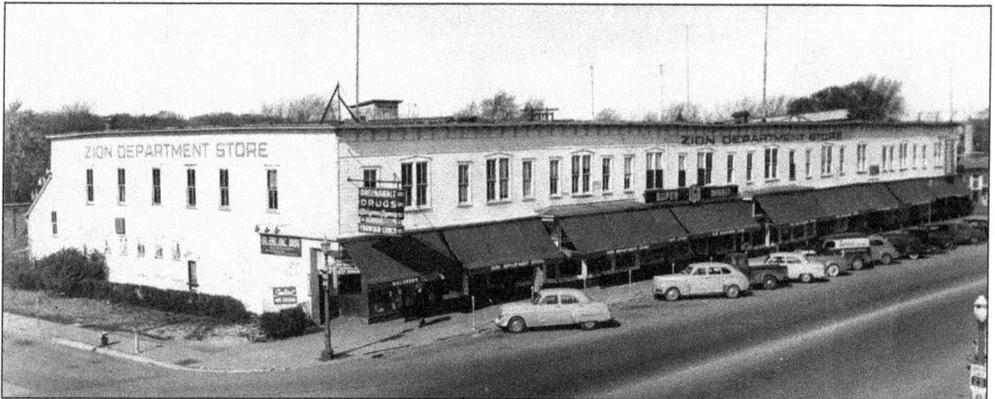

In the late 1940s, Zion Department Store housed, among others, Greenwalt Drug Store (a Walgreen Agency), the Super IGA Market, and the Zion Hardware Store. (Courtesy of Christ Community Church.)

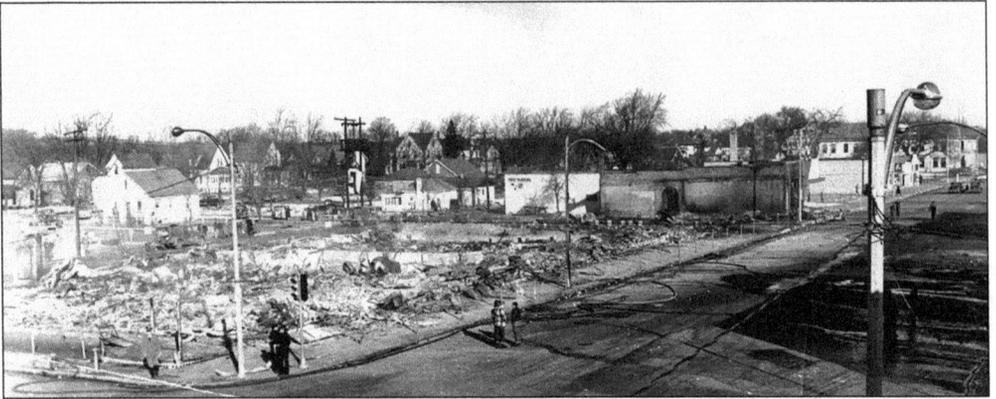

On February 7, 1954, flames fanned by a brisk northwest wind swept through the entire block from Twenty-sixth to Twenty-seventh Street on the west side of Sheridan Road. The Zion Department Store was reduced to smoldering rubble—a total loss. (Courtesy of Christ Community Church.)

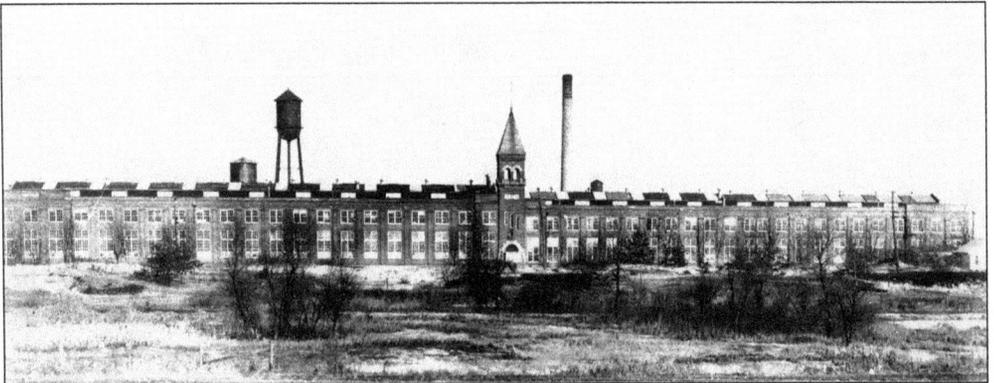

The Zion Lace Factory was built on Deborah Avenue at Twenty-seventh Street in 1901. Dr. John Alexander Dowie brought English lace manufacturer Samuel Stevenson of Nottingham, England, along with about 100 lace workers, to Zion to begin the manufacture of Zion lace. Marshall Field and Company of Chicago bought the factory from the receiver in 1907 and continued making lace until the early 1950s. Later the building was home to Warwick Electronics, who made television sets for Sears, Roebuck and Company, and later American Air Filter.

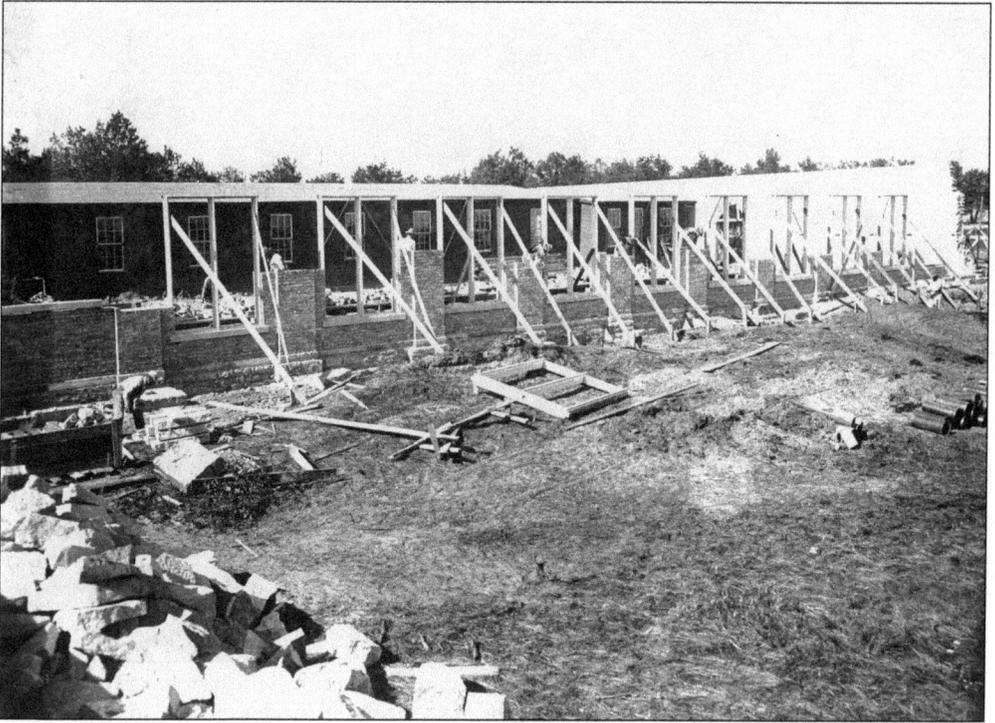

The south and east wall of the Zion Lace Factory were under construction on October 29, 1901.

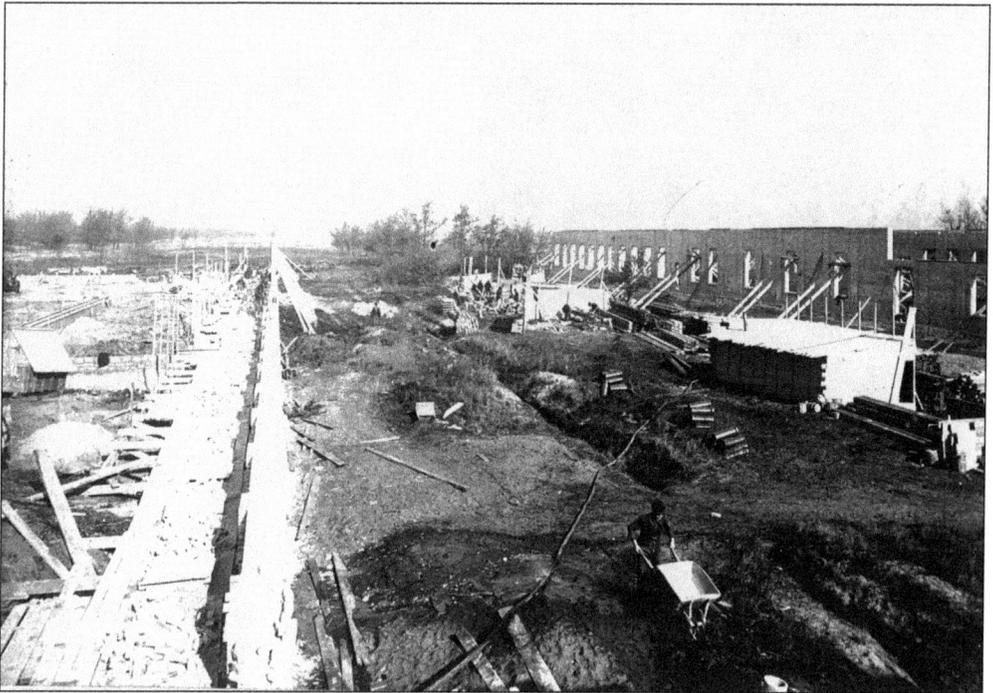

The foundation of the east wall (right) of the main building of the Zion Lace Factory had been poured by November 21, 1901.

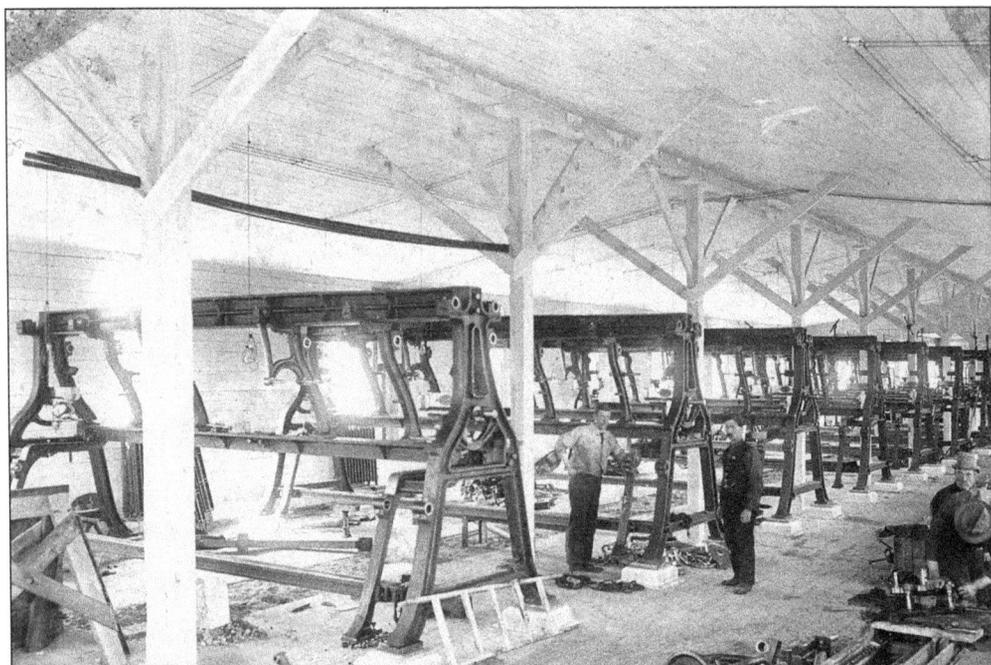

Lace machines were shipped from England and stored in Chicago until the factory was completed. Once ready, crews worked steadily assembling the great machines, each weighing 16,000 pounds. In Europe, each phase of the manufacture of lace is conducted in separate factories as distinct industries. In Zion City, the entire lace piece, from thread to finished bolt, was made in one building.

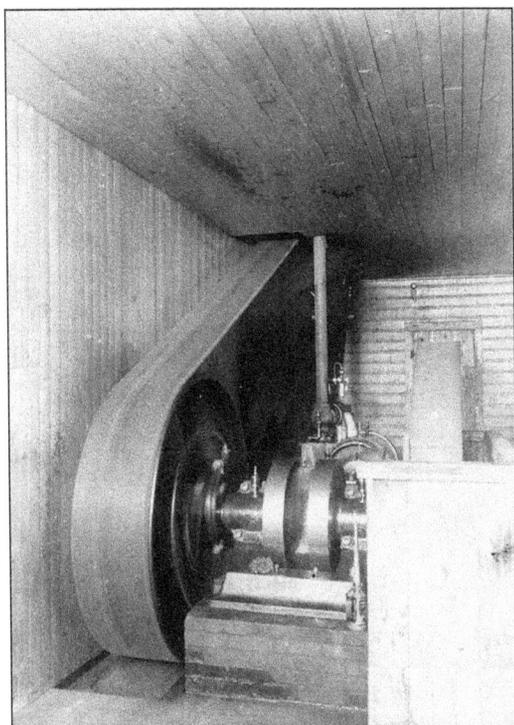

In 1902, this great machine provided the power for the Zion Lace Factory.

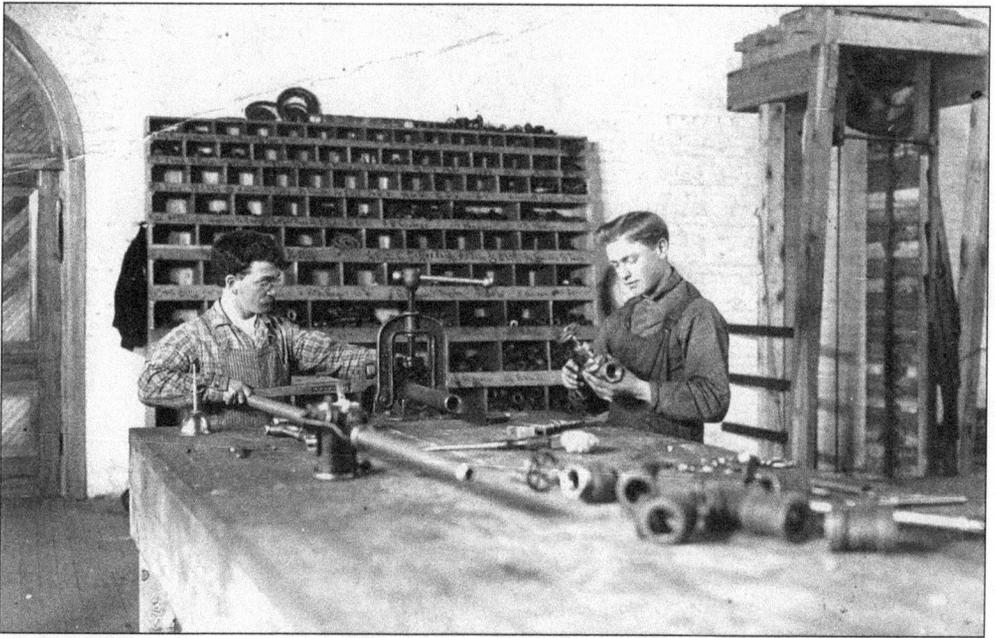

The Zion Lace Factory had its own water supply and plumbing and repair shop. The worker on the left is cutting a pipe, and the one on the right is repairing a valve.

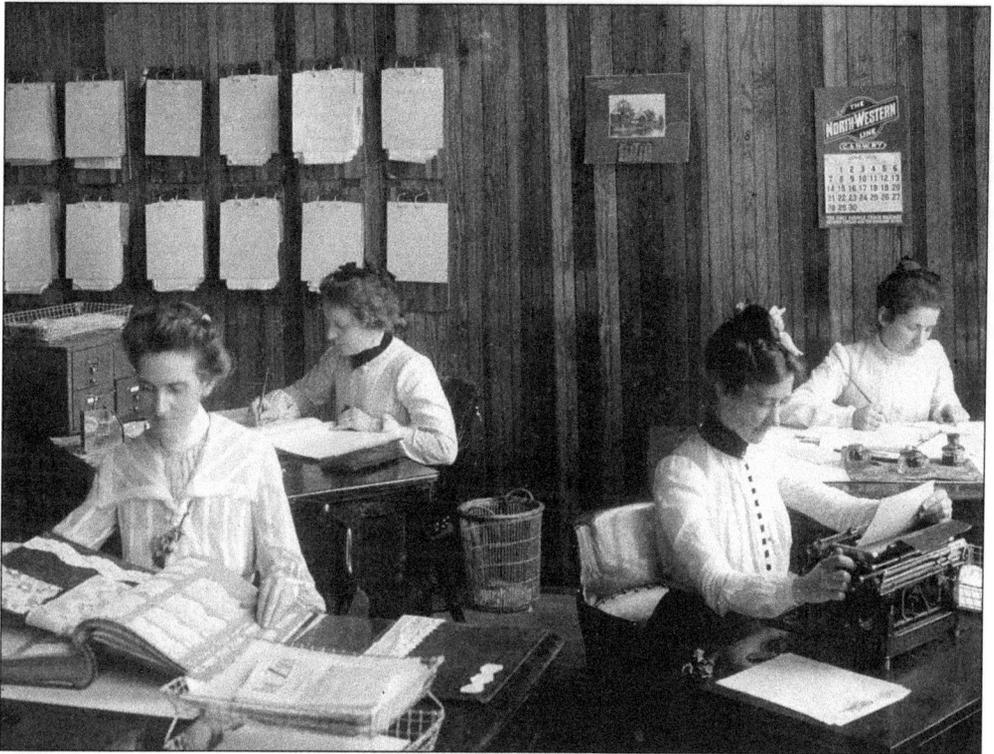

The Zion lace factory employed an office staff, shown here in June 1903. Work orders in various stages of completion hang on the back wall. A worker (left, front) examines a lace sample book.

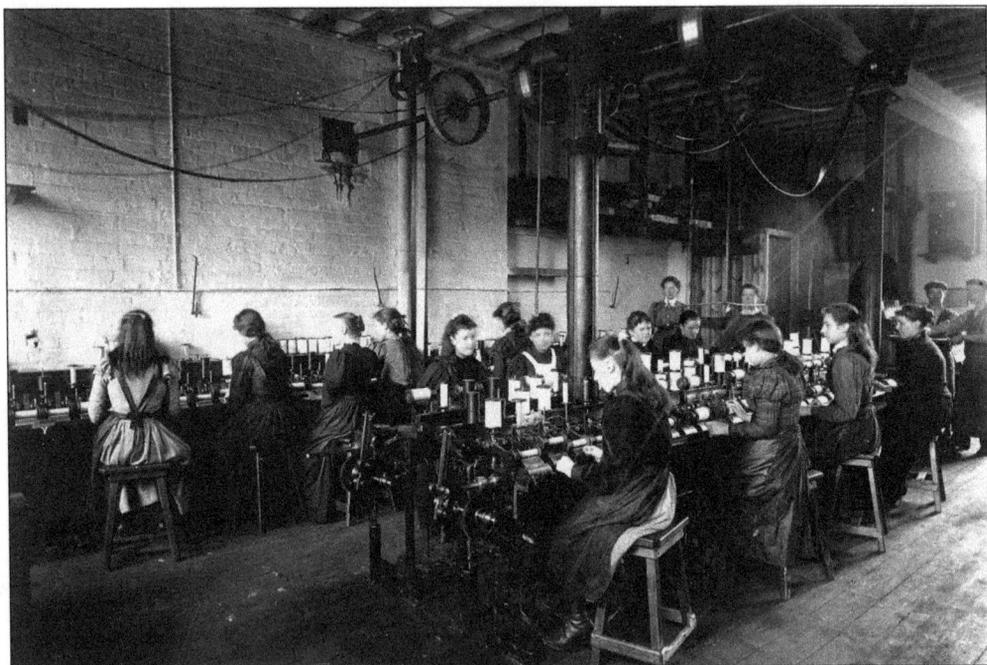

In the bobbin winding room of the Zion Lace Factory, women wind fine cotton thread from skeins onto bobbins to be loaded into the lace machines. Each lace machine required approximately 4,000 bobbins. About 120 bobbins were wound at a time, with about 120 yards of thread to a bobbin. One machine could wind 300,000 yards of thread per day.

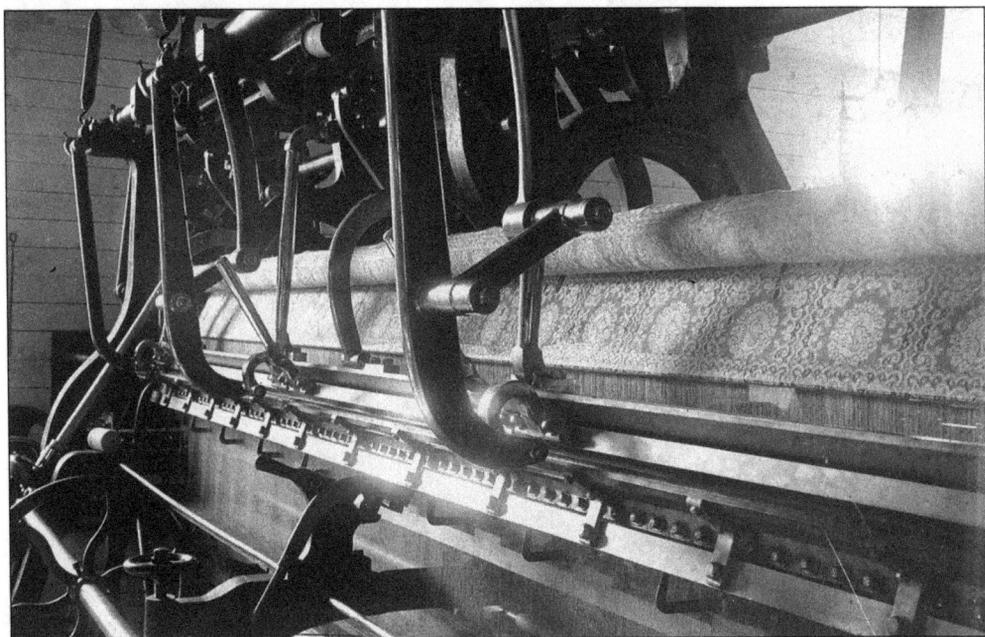

The Zion Lace Factory machines worked at a tremendous rate of speed. The machine was threaded by hand working from specifications prepared by draftsmen. Some 8,000 threads were carried up, placed into position, and firmly moored. It took two skilled workers two weeks to complete the threading process.

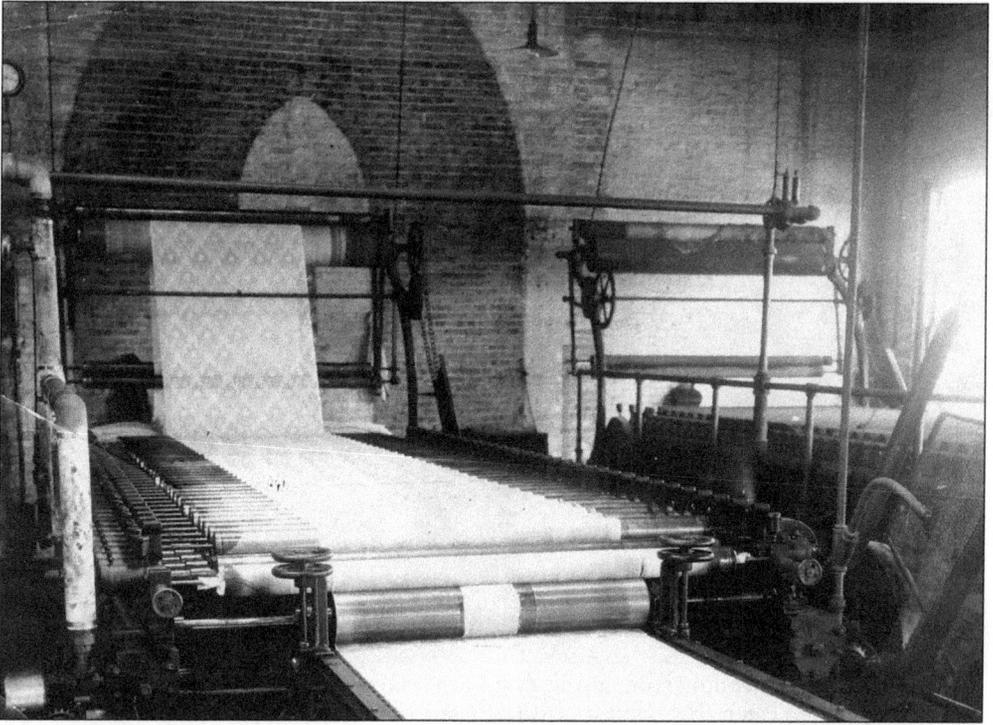

This machine at the Zion Lace Factory is drying curtains. The lace factory originally made lace edgings in all widths and sizes, but eventually made lace curtains, tablecloths, bedspreads and lace garment fabric. The average length of lace, 30 yards, was woven in 30 hours. Workers removed the lace from the machine and left it in large piles.

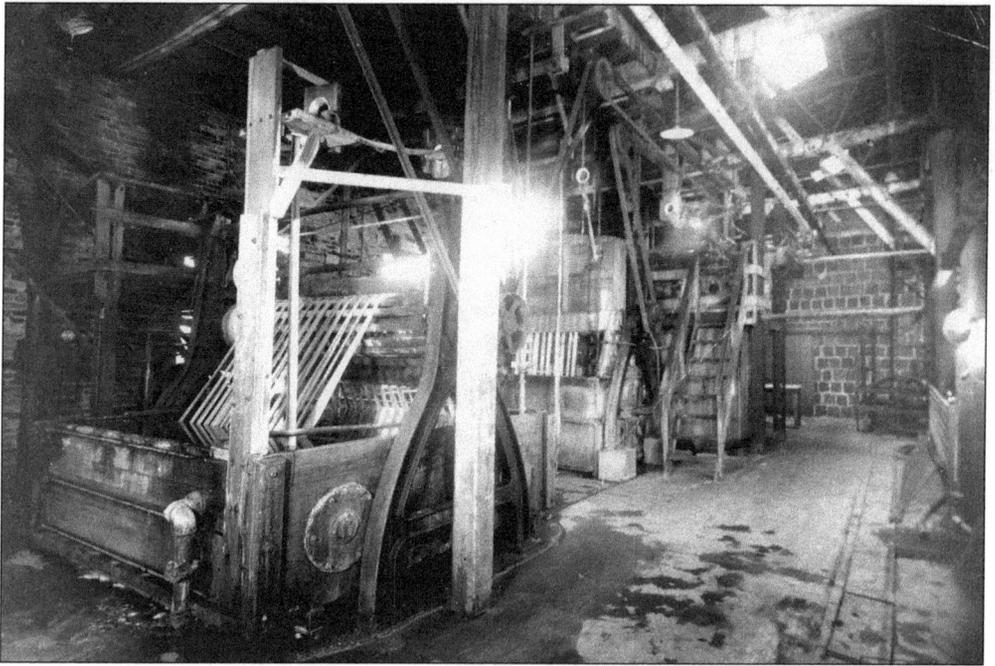

In this room at the Zion Lace Factory, curtains were bleached and washed.

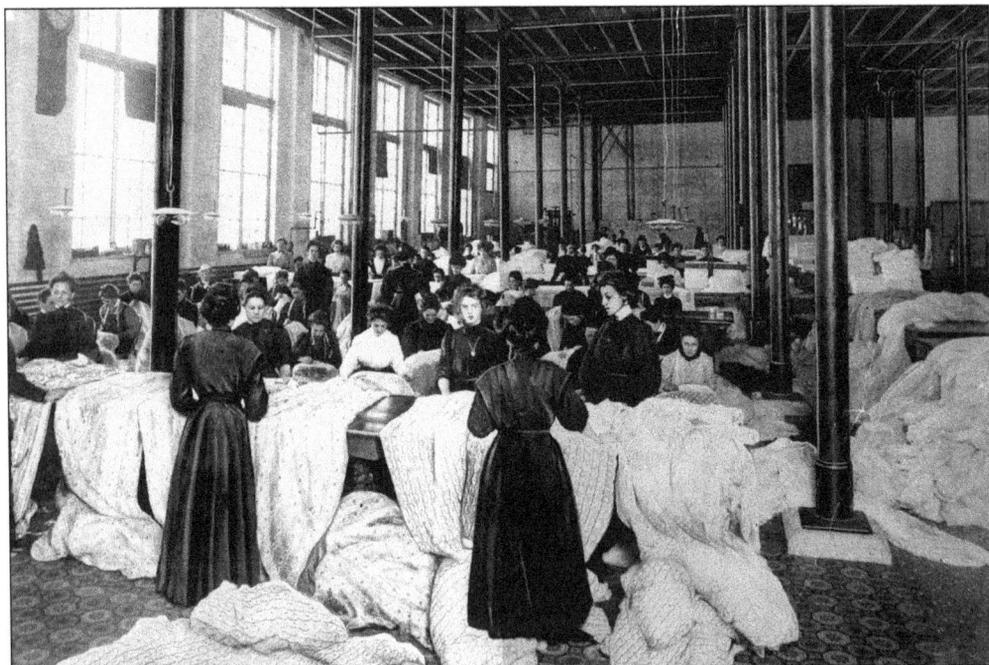

The inspection and mending room at the Zion Lace Factory provided jobs for women. A keen eye was required to catch the slightest defect or tear in the lace as it passed over smooth, dark topped tables. When a flaw was detected, a loose knot was tied to mark the spot for the menders. Clean cuts in the lace were mended by machine, but the majority of repairs were done by hand with the pattern being restored by the seamstresses' needles.

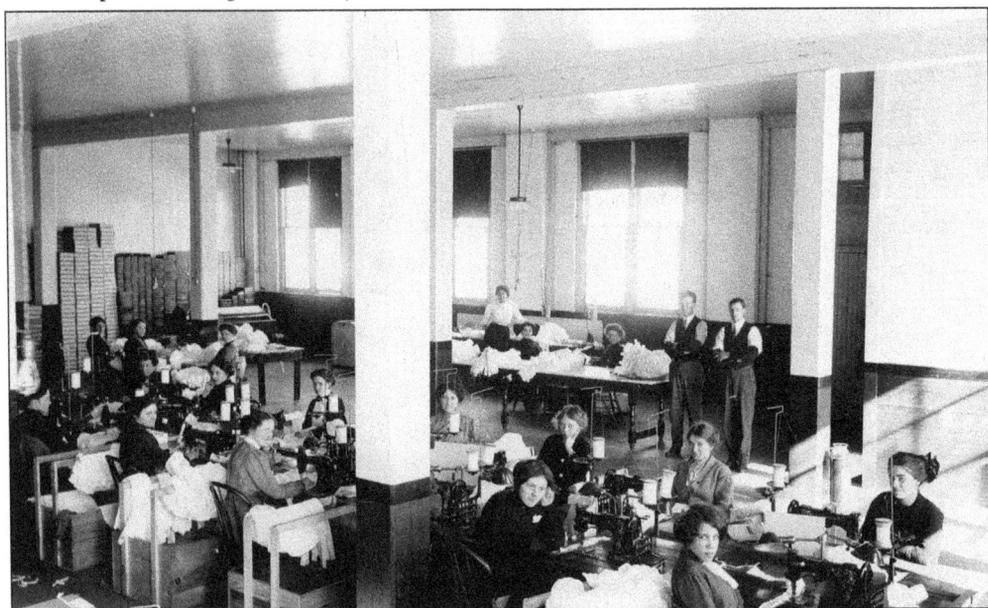

Seamstresses at the Zion handkerchief factory sew handkerchiefs and aprons under the watchful eye of their male supervisors (right, back). The factory was located on the second floor of the old city hall building between Twenty-seventh and Twenty-eighth Streets on the west side of Sheridan Road. Handkerchiefs were also made at the Zion Lace Factory.

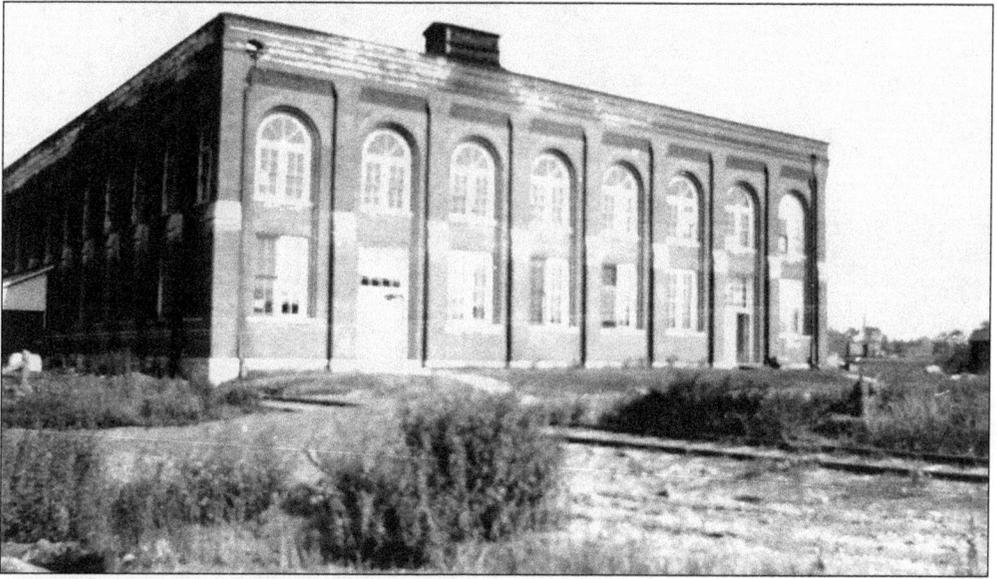

In 1902, plans were well underway to open the Zion Bakery, which would become the most lucrative of all the Zion Institutions and Industries. It was located on the south side of Twenty-seventh Street, just west of Deborah Avenue.

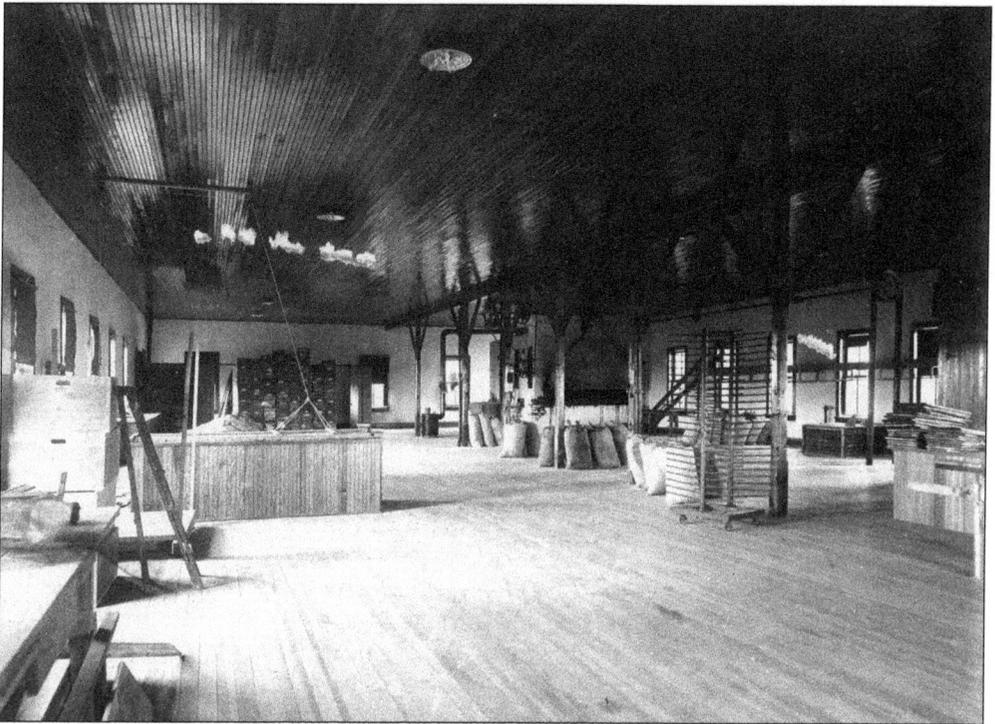

Flour sacks, a cooling rack, and stacks of baking sheets (right) are being stored on the second floor of the Zion Bakery.

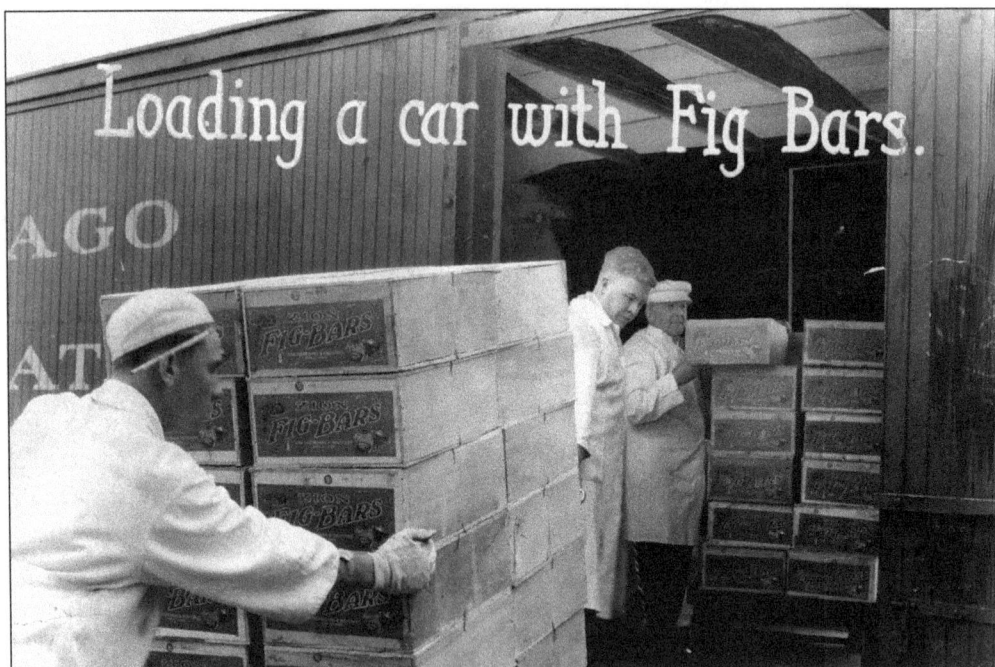

Zion Bakery was nationally known for its fig bars. In 1922, the bakery was producing more than one million fig bars daily. Crates of fig bars were loaded on to Chicago Northwestern Railway freight cars for distribution.

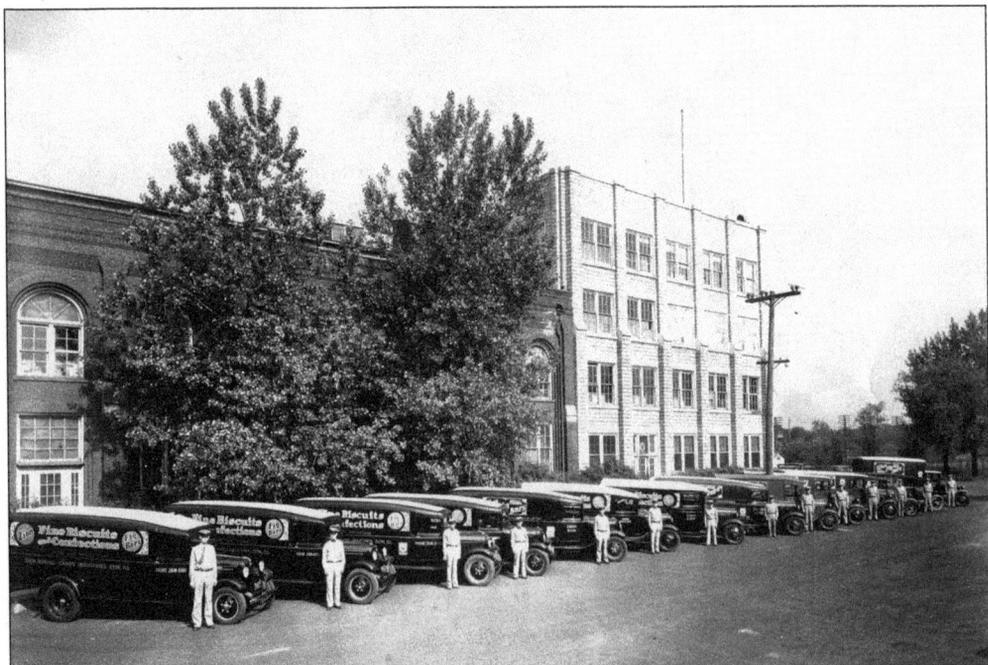

Zion Bakery had a large fleet of delivery trucks and drivers. They lined up for inspection in front of the bakery in 1931. Products were delivered daily throughout the Chicago metropolitan area. The side panels of the trucks advertise the bakery and its fine biscuits, confections, and fig bars. The printing on the doors prompted customers to "Phone Zion 600" to contact the bakery.

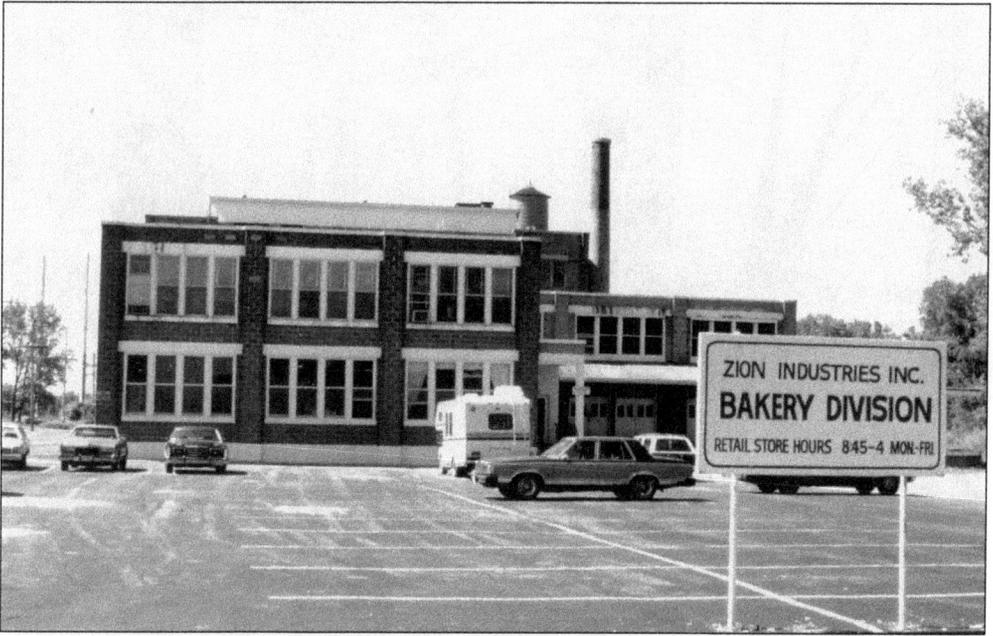

In 1988, the Zion Bakery closed after 85 years in business. A longtime Zion resident, upon touring the facility shortly before baking operations ceased, was disappointed to see a large vat of lard being used. Lard was one of the unclean foods and was on the restricted from consumption list.

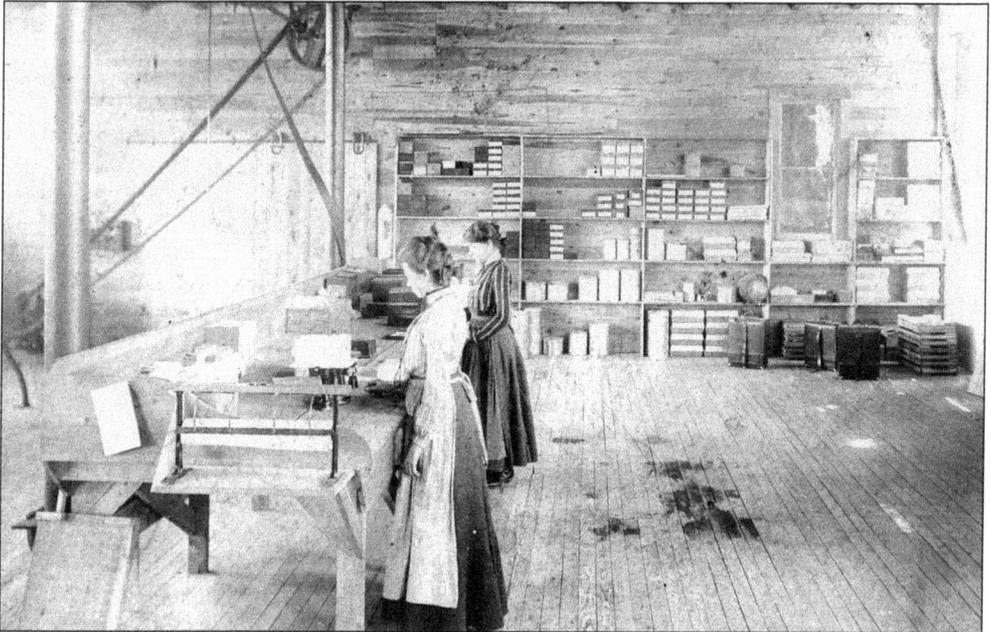

The Zion Candy factory produced fine confections. The factory was located on Twenty-ninth Street east of the Chicago Northwestern Railroad tracks. The "White Doves" and "Sparkling Beauties" candies were sold nationwide. In 1920, these ladies worked in the sample room weighing and packaging tasty treats produced by the candy factory and bakery. The candy factory closed in 1960.

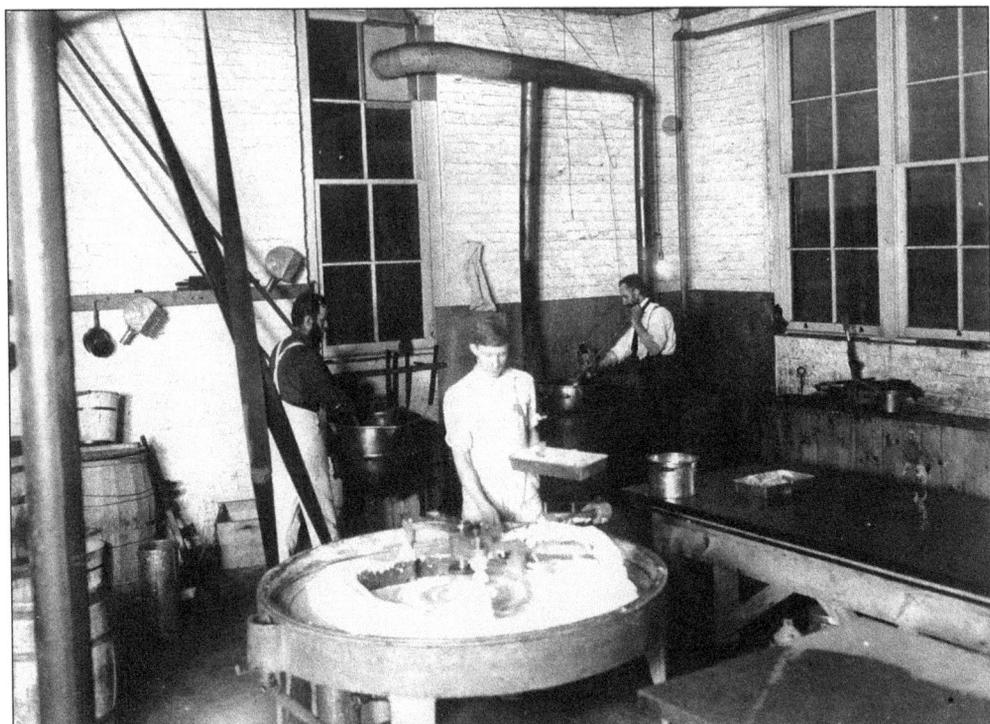

The Zion Candy factory must have been a "sweet" place to work around 1910. The man on the left stirs a kettle resting on top of a barrel-shaped stove, which is vented through the upper pane of the window.

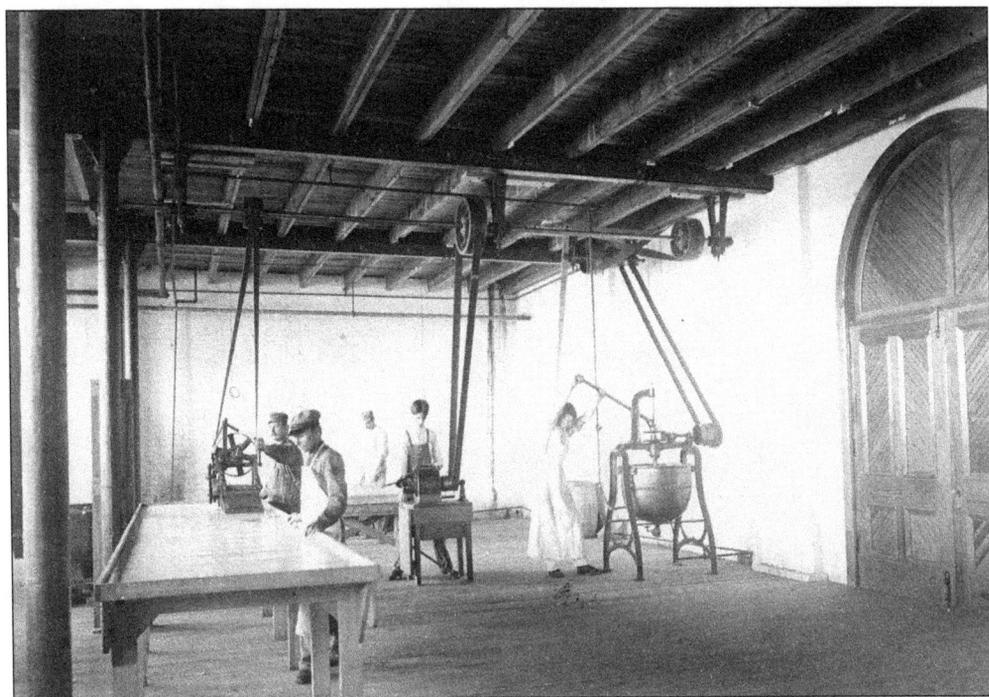

Large pulleys turn the paddles in the mixing room of the Zion Candy Factory.

Eight

LIVING PICTURES

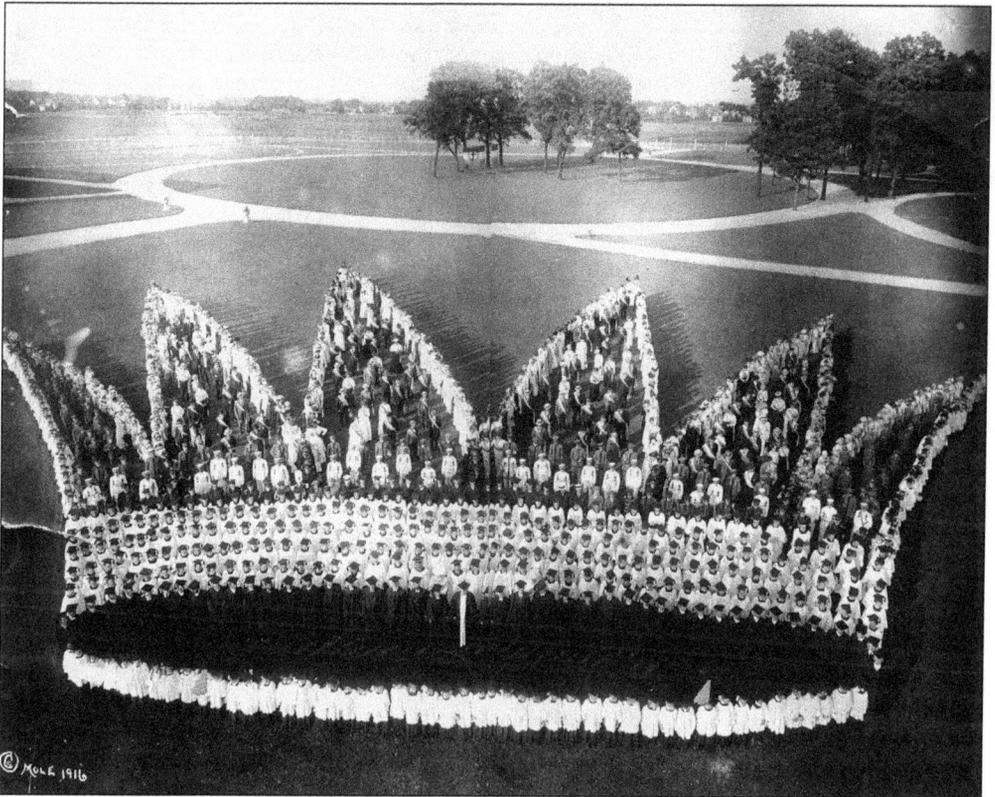

From 1913 to 1921, Arthur S. Mole, a professional photographer and Zion City resident, took "living pictures," so named because the photograph was comprised largely of people ingeniously arranged to form the image. He enlisted the help of John D. Thomas, director of the Zion White-robed Choir. Most of their photographs depict religious or patriotic themes. The White-robed Choir members provided the majority of the people needed to photograph this crown taken by Mole in 1916 on the temple site in Zion City.

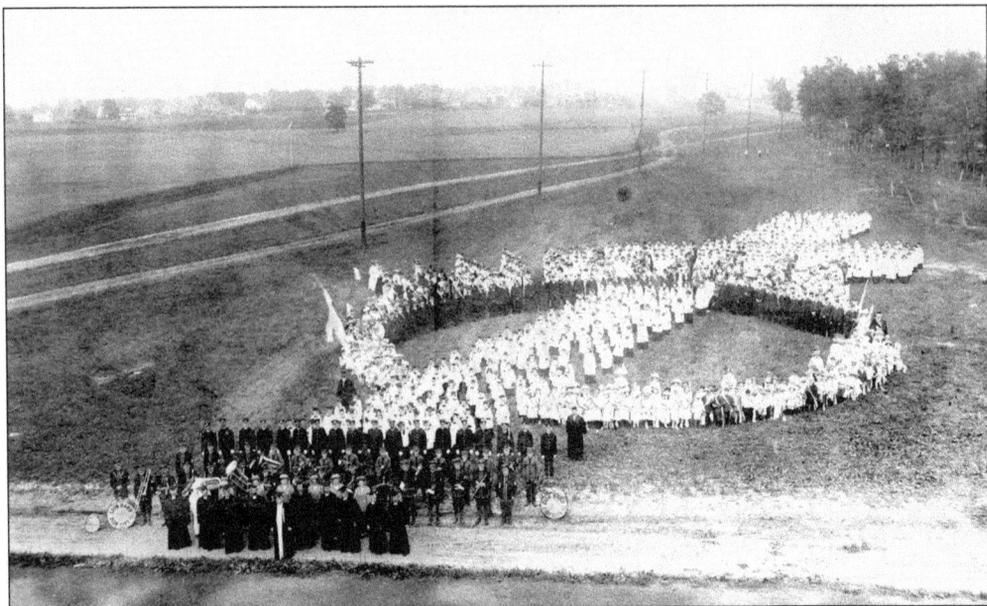

In 1916, photographer Arthur Mole photographed the first symbolic picture in which the Christian Catholic Church participated. The subject matter, a cross and crown, is comprised of church officials dressed in black robes, members of the White-robed Choir and women and children of the church. In the foreground stand members of the Zion Band, Zion Guard, and church officials. General Overseer Wilbur Glenn Voliva stands out front ('center), dressed in a black robe with white insert.

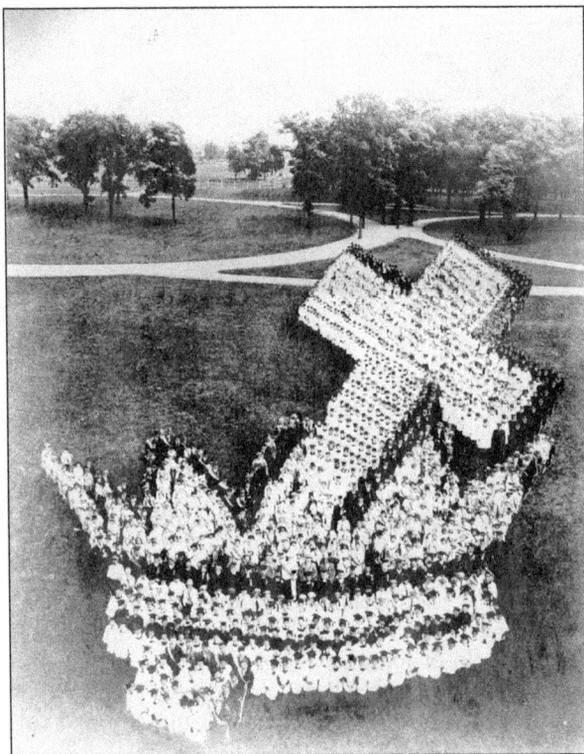

In 1921, Mole formed and photographed the crown and cross again. Both the cross and the crown are symbols of the Christian Catholic Church. It was taken on the temple site. Strategically placed White-robed Choir members, church officials, and parishioners form the symbols.

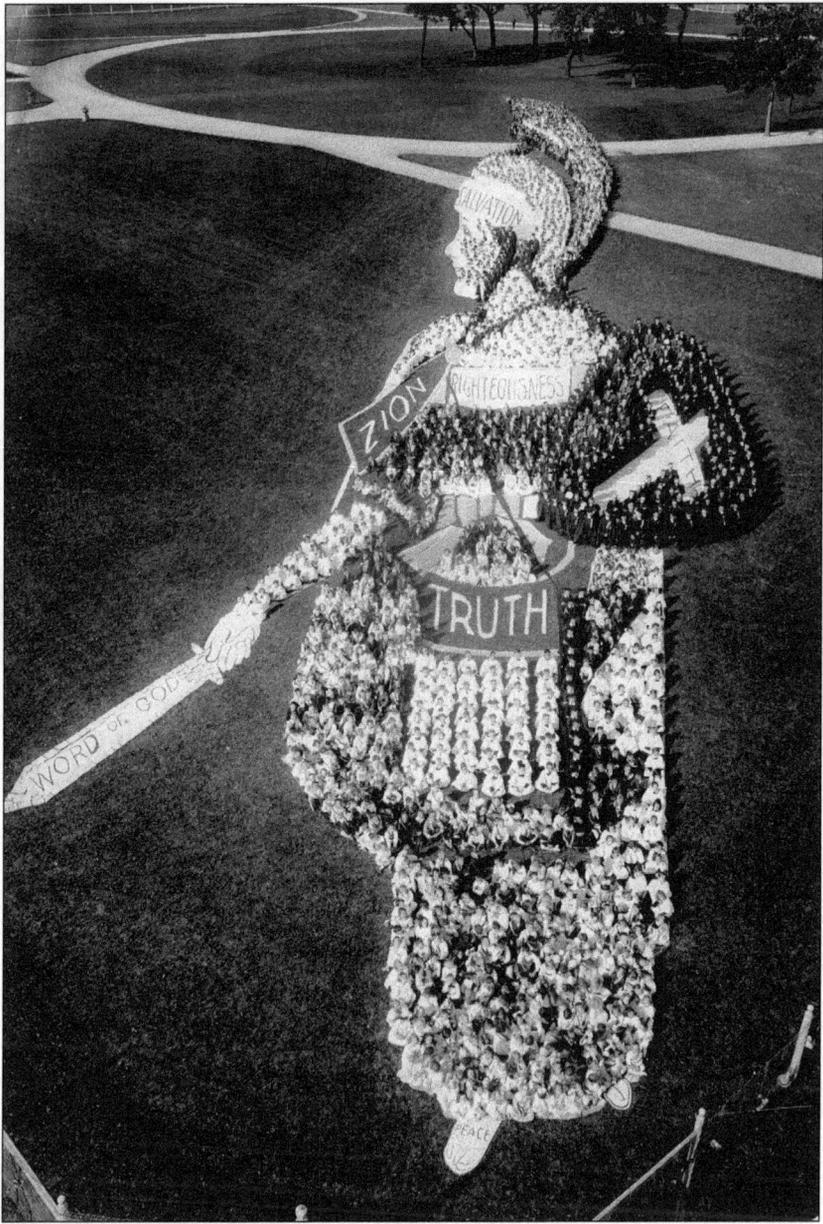

From the roof of the Shiloh Tabernacle, a "living picture" portraying the Christian armor as described in the Bible was taken on July 14, 1920, by Arthur Mole in celebration of the 20th anniversary of the consecration of the temple site. It is made up of over 2,000 people, including Christian Catholic Church general overseer Voliva, the church officers, Mayor W. Hurd Clendinen, city officials, Zion White-robed Choir members, Zion bands, Zion Guard, Shiloh Tabernacle ushers, the kindergarten and all grades of Zion schools, and others. The figure lay 372 feet long on the ground, and due to perspective, is actually one-third longer from the top of the helmet to the chin than from the feet to the chin. The face is 85 feet long. The length of an eye is 13 feet. The word "Salvation" is 16 feet high. The Zion badge is 16 feet long. A Zion band bass drum forms the button of the badge. Stacks of Zion's official paper, *Leaves of Healing*, make up the cross. The sword is composed of 125 open Bibles.

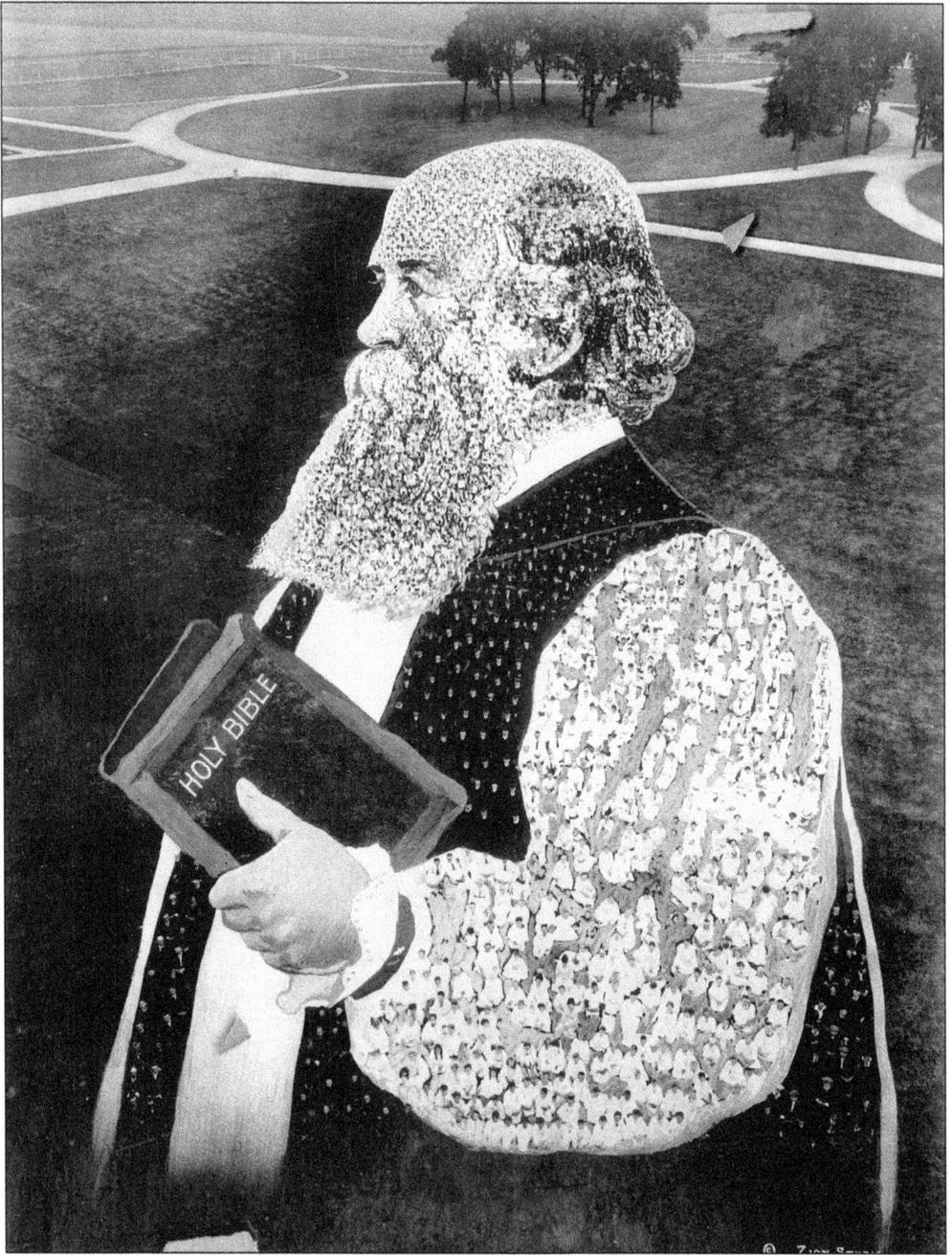

Dr. John Alexander Dowie, Zion's founder, is memorialized in this living picture. It was taken by Arthur Mole from a 75-foot tower on the temple site. The dark portion of Dowie's robe is made up of males dressed in black. Their faces and white collars make his robe look "flecked." His head and sleeve are made up of people dressed in white, some swaddled in fabric to add texture to his face and to demonstrate a billow in his sleeve. The sash around his neck consists of lengths of white fabric smoothed over the ground. The Bible, his hand, and his eyes are props.

The Zion City shield is the subject of this Mole living picture taken in Zion City. The White-robed Choir members form the outline of the shield. The white dove in the upper section is made up of appropriately dressed women and children. The cross in the left section consists of Zion band members. The crown and scepter in the right section are formed by Zion Guards and males wearing sashes. "Zion" in the lower section is made of young ladies dressed in white. Notice the shadow of the tower (right) upon which Mole stood to take the photograph.

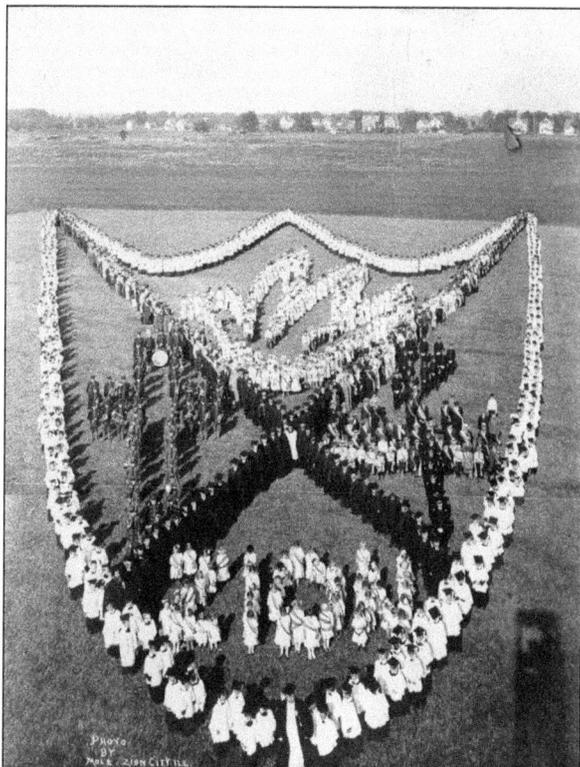

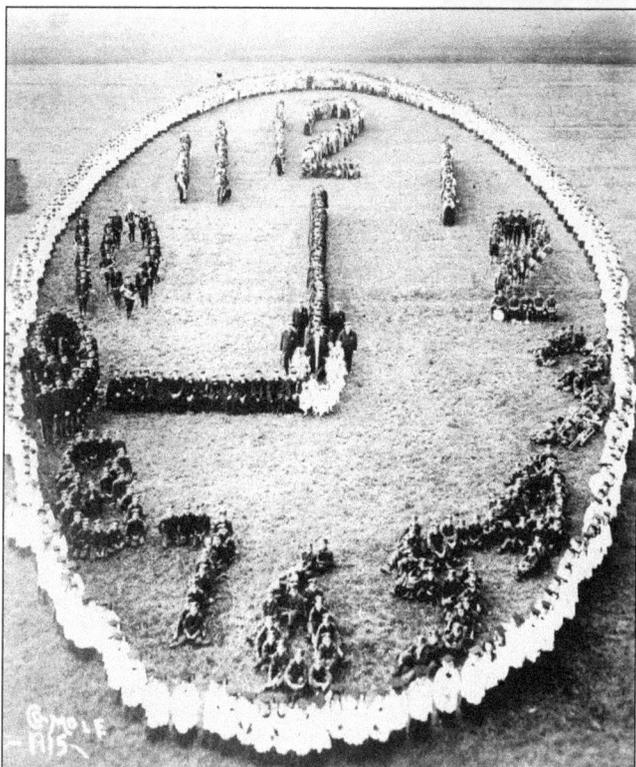

It was customary in Zion City for all activity to cease for two minutes of prayer at 9:00 a.m. and 9:00 p.m. when the Elijah Hospice (Zion Hotel) bell rang. Zion's hour of prayer is illustrated in this living picture taken in 1915 in Shiloh Park by Mole. Zion White-robed Choir members, church ushers, and Zion Guards form the clock set for 9:00.

Visit us at
arcadiapublishing.com

www.ingramcontent.com/pod-product-compliance
Lightning Source LLC
Chambersburg PA
CBHW050614110426
42813CB00008B/2553